W9-ANI-465

WITHDRAWN
FROM THE PORTAGE PUBLIC LIBRARY

Men,
Makeup, and
MONSTERS

St. Martin's Griffin
New York

Men, Makeup, and

MONSTERS

Hollywood's Masters of Illusion and FX

Anthony Timpone

RODMAN PUBLIC LIBRARY

38212002393384
Main Adult
791.43 T586
Timpone, Anthony
Men, makeup, and monsters
: Hollywood's masters of
illusion and FX

JAN 9 7

MEN, MAKEUP, AND MONSTERS: HOLLYWOOD'S MASTERS OF ILLUSION AND FX.
Copyright © 1996 by Anthony Timpone. All rights reserved. Printed in the United States of America. No part of this book may be used or reproduced in any manner whatsoever without written permission except in the case of brief quotations embodied in critical articles or reviews. For information, address St. Martin's Press, 175 Fifth Avenue, New York, N.Y. 10010

Book Design by Gretchen Achilles

Edited by Gordon Van Gelder

Library of Congress Cataloging-in-Publication Data

Timpone, Anthony.
 Men, makeup, and monsters: Hollywood's masters of illusion and FX
/ by Anthony Timpone — 1st ed.
 p. cm.
 Includes bibliographical references and index.
 ISBN 0-312-14678-7
 1. Cinematography—Special effects. 2. Film makeup. I. Title.
TR858.T56 1996 96-8578
791.43'024—dc20 CIP

First Edition: October 1996
10 9 8 7 6 5 4 3 2 1

For my wife, Marguerite, the editor's editor,
for her love and support

Contents

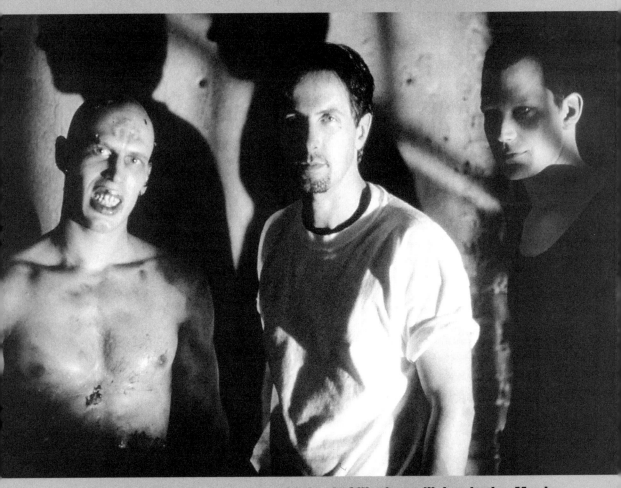

Frightmeister Clive Barker poses with *Lord of Illusions* villains Jordan Marder (left) and Barry Del Sherman.
(PHOTO: GARY FARR/COPYRIGHT UNITED ARTISTS)

Foreword by

Clive Barker

All cinema is, of course, illusion. Our eyes are deceived by the flicker of countless still images into believing that life is there, unfolding on the screen in front of us. That sleight-of-eye requires great technical skill if it's to be achieved effectively. Cinematographers, actors, directors—all have a place in the process.

But the life we see is sometimes of a very unnatural kind, and it's then that another species of illusionist is required, one who will put before the cameras creatures that no zoo has ever displayed, no biologist ever cataloged. These are the monster makers, who with latex, glue, and paint daily transform actors and actresses into lifeforms that astonish, appall and, on occasion, seduce us.

Having had the great pleasure of working with some of the best of these talents—most often with Bob Keen on the *Hellraiser* movies, *Nightbreed* and *Candyman*—I have nothing but admiration for them. The work they do is a complex mingling of art and science, vision and pragmatism. It is also a job that requires nerves. Often, even on the most organized of shoots, they are required to make spur-of-the-moment changes to accommodate the vagaries of the schedule (and the occasional neurotic performer), knowing that whatever decision they make will not only be scrutinized on the big screen, but very possibly examined by video enthusiasts with the benefit of slow motion and freeze-frame.

But if the creature they have imagined in their mind's eye is made to *breathe* on the cinema screen, something wonderful—dare I say, godlike?—may be achieved. In the collective mind of the audience, a new lifeform has been born. It may very well be a monstrous genus, but I'm sure you're not expecting me, of all people, to make any apology for that. The monstrous has as much claim to our fascination as the so-called beautiful; we may in truth learn more from the former than the latter. And have no doubt about it, when the monster makers are successful they haunt us with creatures that will lodge in our psyches until the day we die. *That* is the true reward of their passion and their patience. Without Jack Pierce, there would be no Frankenstein Monster as we know it. Without Dick Smith, the demon Pazuzu would be a list of profanities. Without Bob Keen and Geoff Portass, ol' Pinhead would not be the glacial, elegant tempter he is. The world, I believe, would be the poorer for the absence of such creations.

Given my enthusiasm for the beasts and their makers, it is a great pleasure to introduce the book you hold. I have known Tony Timpone for many years now, and there can be few men on the face of the planet so thoroughly immersed in both the craft and commerce of monster making. Not only is Tony a keen critic and enthusiastic celebrant of horror films, he is also knowledgeable about the business end of things. Who better, then, to draw the creators out on the subject of their triumphs and failures; to give you a taste of what it's like to be a professional monster maker, warts and all?

It is not always, as you will see, a wholly satisfying endeavor. Like most marriages of art and commerce, it requires self-control, and a talent for artful compromise. But sometimes, out of the confusions and conflicts that are an inevitable part of the process, out of the midnight brainstormings and last-minute accommodations, out of the politics, and out of the rage we all feel when the budget won't stretch or the schedule is cut, an indefinable, unplannable wonder occurs. A beast emerges that lives beyond the control of its creators, that belongs—in essence—to the audience which believes in it.

At that point, the monster makers have every right to sit back and take pride in their achievement. But as Tony will show you in the portraits he's painted, that's not the way the true monster maker works. By the time the world is cowering in front of their last creation, they're likely to be on to the next, working with latex, glue, and paint to bring the impossible lumbering and slithering and morphing into our lives.

As a director and producer, I look forward to keeping company with these extraordinary and obsessive imaginers more than any other part of the filmmaking process. As a writer, I am grateful for their power to turn my words into something believable. But it's as an audience member that I am most indebted to them, for those precious moments when the screen unveils a monster who will join the pantheon in my mind, and there remain to delight, appall, and astonish me.

Clive Barker, the best-selling author of *Sacrament, Weaveworld, The Great and Secret Show, Imajica,* and *Everville,* has written and directed the films *Hellraiser, Nightbreed,* and *Lord of Illusions.* In addition, he has served as the executive producer to the *Hellraiser* sequels and the *Candyman* films.

Acknowledgments

Many people helped make this book possible, and I am especially grateful to the following: my parents (Jean and Tony, Sr.) and in-laws (Virginia and Angelo), Clive Barker, my agent Matthew Bialer, Joan Baetz, David Barraclough, Michael Benson, Sergio Bonelli, John and Michael Brunas, Steve Chebba, the Creation crew, Tara Crocitto, Loris Curci, Robert DiTillio, David Dodds, John Dods, Rita Eisenstein, Eric Eskenazi, David Everitt, Anthony C. Ferrante (for his Stan Winston, Chris Walas, and KNB assistance), Tim and Jackie Ferrante, Nigel Floyd, Joe Fordham, Sylvia Gimenez, Michael Gingold (an excellent writer and editor), Paul Hallasy, Grace Houghton, David Hutchison, Norman and Steve Jacobs, Alan Jones, Vincent J-R Kehoe, Mark Kermode, Tim and Donna Lucas, Adam Malin, Linda Marotta, Stefano Marzorati, Ed Martin, David McDonnell (friend, writer, and editor extraordinaire), Kevin McDonough, Philip Nutman, Scott Pierce, Tom Rainone, Fred Raskin, Jack Russo, Mark Salisbury, Dan and Marie Scapperotti, Angus Scrimm, Justin Seremet, Marc Shapiro, the whole Starlog staff, Elaine Stuart, Gary Tunnicliffe, Michael Updegraff, St. Martin's editor Gordon Van Gelder (for giving me another shot), Jeff Walker, Bill Warren (for the *Species* stuff), Tom Weaver (for countless hours of help) and, of course, all the subjects of this book, who opened their doors to me.

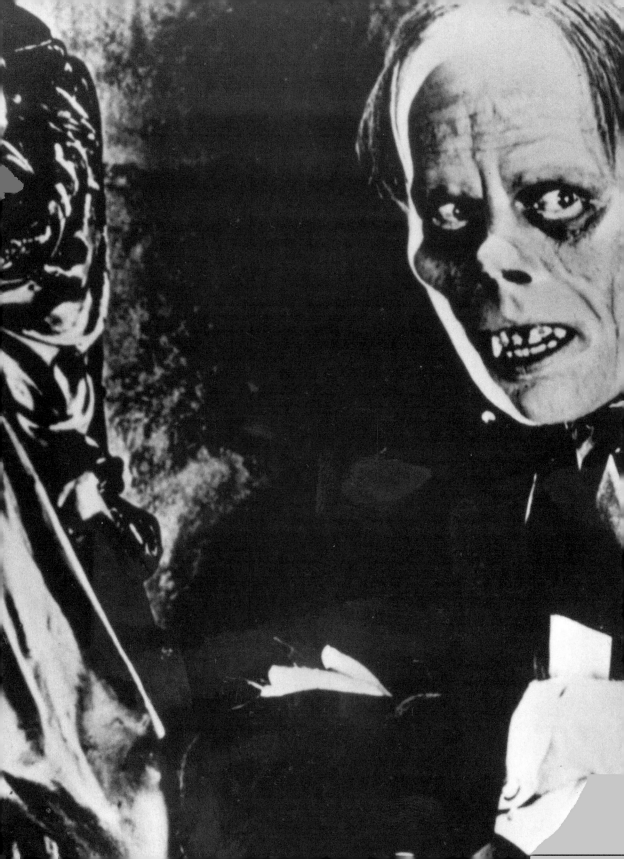

Lon Chaney, the silent era's man of a thousand faces, played his most famous role in *The Phantom of the Opera*. The makeup consisted of cotton and collodion cheekbones, a piece of fishskin glued to his nose, and a wigged skullcap.
(COPYRIGHT UNIVERSAL STUDIOS, INC.)

Introduction

Everyone wants to be a monster today—everyone in Hollywood, that is. The hottest stars in the business are hiding under gobs of makeup and tons of latex to play the screen's scariest characters. We've swooned as Tom Cruise donned serrated fangs and bloodred contacts to become the fearsome Lestat in *Interview With the Vampire*; gasped as Robert De Niro got all stitched up as the Creature of *Mary Shelley's Frankenstein*; screamed as Gary Oldman changed into a giant human bat in *Bram Stoker's Dracula*; and howled in fright as Jack Nicholson sprouted unsightly facial hair and large incisors in *Wolf*. Monsters are big business in Tinseltown and now, more than ever before, the makeup artist is emerging as one of the film industry's most valuable players.

And we're not just talking horror films here; without these talented artists, Robin Williams wouldn't have been able to fool anybody as *Mrs. Doubtfire* and nobody would have believed Billy Crystal as an eighty-year-old Borscht Belt comic in *Mr. Saturday Night* or Danny DeVito as the loathsome Penguin of *Batman Returns*.

Don't need actors? Fine. The special makeup FX artists can build you some, such as the earth-shaking tyrannosaurus and hungry velociraptors of *Jurassic Park* or Chucky the killer doll in *Child's Play*. The new generation of FX creators are limited only by their imaginations and production budget, while new advances in digital computer FX technology have enlarged the artists' canvas even more.

Before we look at the present, let's examine the past. Like millions of kids, I grew up with a fascination for monster movies. As a youngster, I raced home every day from grammar school and turned on *Thriller Theater* to watch the horrifying exploits of Frankenstein's Monster, Dracula, the Wolf Man, and all the rest. The illusions in these vintage Universal fright flicks tantalized me, stumped me, and prompted the eternal question:

How'd they do that?

Parental explanations ("They did it with mirrors") never held up under scrutiny, so I researched the answers elsewhere. Eventually, the black-and-white pages of Forrest J Ackerman's seminal *Famous Monsters of Filmland* magazine and, later, *The Monster Times* and the more sophisticated *Castle of Frankenstein* introduced me to the men behind the monsters—the makeup artists.

I learned that a former goat herder from Greece named Jack P. Pierce combined fuller's earth, layers of cotton wool, coatings of collodion and green greasepaint, a rubber headpiece, wires and mortician's wax eyelid caps to transform unknown actor Boris Karloff into the lumbering pile of mismatched body parts known as the Frankenstein Monster. The same crotchety makeup artist created the majority of Universal's beastly bullpen through various techniques: a special light-green greasepaint provided the fangless Bela Lugosi the proper clammy appearance as the undead Count Dracula; wrapping good sport Karloff in baked cloth strips and coating his costume with mud and glue brought the ancient Mummy to unlife.

Perhaps most impressive was the metamorphosis of tortured soul Larry Talbot into the Wolf Man. (Lon Chaney played the title role. His father, silent-screen star Lon Sr., carried the moniker Man of a Thousand Faces for his portrayals and self-makeups in such macabre benchmarks as *The Phantom of the Opera, London After Midnight*, and *The Hunchback of Notre Dame*. Silent actor/makeup artist Cecil Holland is also considered one of the makeup field's early innovators.) To create the Chaney changeling, Pierce pasted yak fur onto his subject's face and a short rubber snout. For the transformation scenes, Chaney's four-to-five-hour makeup was applied in twenty-one stages, his hands held down by pins and his head positioned in a brace, with camera dissolves bridging each step to complete the cinematic trickery.

Those creatures would not have been as scary or as memorable without the amazing contributions of Jack Pierce. His makeups have stood the test of time like no other's; more than sixty years since the start of their monster boom, Universal Studios continues to license the original Frankenstein, Dracula, Wolf Man, and Creature from the Black Lagoon (the latter the work of makeup men Bud Westmore and Jack Kevan) likenesses on countless toys, model kits, comics, cartoons, and so on. The strength of a good makeup or special effect can be gauged not only by its ability to enthrall you and stimulate your sense of wonder, but by its enduring popularity.

Throughout the 1930s and into the 1950s, horror movies were not the only motion pictures relying on special makeup. The studios depended on their in-house makeup departments for a variety of chores, most of which the casual moviegoer rarely noticed. Subtle alterations changed Caucasian actors into Asian villains (Fu Manchu) or heroic sleuths (Charlie Chan). Screen biographies called for actors to age convincingly onscreen or closely mirror their historical counterparts, with the

aid of facial paints, wigs, and rubber noses. Horror, fantasy, and science fiction films, however, drew the most requests for makeup artisans, with 1939's perennial favorite *The Wizard of Oz* (uniting the skills of Jack Dawn, Charles Schram, William Tuttle, Emile LaVigne, Josef and Gustaf Norin, among others) setting the standard for years to come.

Not until 1964 did the Academy of Motion Picture Arts and Sciences recognize the ingenuity and craftsmanship that goes into makeup, when they granted an honorary Oscar to William Tuttle for his whimsical *Seven Faces of Dr. Lao* creations. Four years later, makeup designer John Chambers's cast of simians for *Planet of the Apes* netted

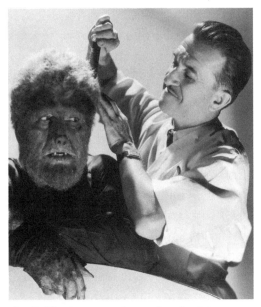

Jack Pierce spent nearly six hours applying yak hair a few strands at a time to transform Lon Chaney, Jr., into the Wolf Man. (COURTESY MICHAEL BRUNAS)

him the same prize. Following Chambers's popular *Apes* stints, British artist Stuart Freeborn's prehistoric human tribe in Stanley Kubrick's visionary *2001: A Space Odyssey* (1968) and his apelike alien Chewbacca for the immensely popular *Star Wars* (1977) brought the makeup industry further publicity and attention, prompting other productions to develop fantastical creatures for their storylines.

On the visceral side, *Bonnie and Clyde* (1967), *The Wild Bunch* (1969), and *The Godfather* (1972) ushered in a new era of violent cinematic bloodletting. Likewise, Dick Smith's literally head-turning (and vomit-spewing) makeup FX for *The Exorcist* (1973) and the shocking "creative deaths" popularized in *The Omen* (1976) and its sequels broke Hollywood's few remaining taboos. The role of the makeup artist began to change as well; these former "powder boys" were now using special FX techniques (puppet rigs, blood squibs, etc.) in their appliance work, thus creating a new job category: the special makeup FX artist.

The science fiction boom in the late '70s and the horror resurgence in the early '80s continued to capture the imaginations of moviegoers, addicting them to flashy special and makeup FX more than ever before. Previously overlooked or considered puerile by studio honchos who'd ignored the youth market in the past, genre

films arose as *the* ticket of choice, creating an unprecedented demand for FX designers and technicians. Genre magazines like *Fangoria, Starlog, Cinemagic, Cinefantastique,* and later *Cinefex* lovingly previewed this resurgence, and their detailed articles and interviews with the current breed of FX wizards spelled out the burgeoning technologies in exacting detail.

After decades of protest from the Makeup Artists and Hair Stylists Local 706 and others, the Academy finally added a semiregular Best Makeup category to their Oscar ceremony in 1981, nominating Rick Baker for his *An American Werewolf in London* transformations and creatures and Stan Winston for his robotic *Heartbeeps* characters. (Baker won.)

"Rick Baker has had a great deal to do with the boom of effects with *American Werewolf*," says artist Steve Johnson, one of Baker's assistants on the landmark film. "*American Werewolf* was one of the most influential films in this business. It spawned a lot of this stuff. In fact, everything to this day is based on the *American Werewolf* stuff; it still amazes me. Movies have been around since

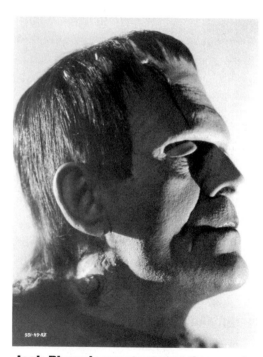

the turn of the century, and it took more than eighty years for people to figure out that you could duplicate a human head and screw with it or stretch it. Then *American Werewolf* came along and suddenly, everybody is doing that."

Interest in the makeup industry continues unabated today, as more and more movies have begun to rely on this brand of magic to enhance their narratives. Whereas in the past you could count the number of makeup artists on two hands, today's Los Angeles Yellow Pages lists page after page of qualified technicians, all competing for the same piece of the motion-picture pie. A telling example is the fact that the producers of 1973's *The Exorcist* allowed Dick Smith the rare opportunity to hire a few lab assistants (including promising newcomer Rick Baker) to complete his

Jack Pierce's greatest creation—and the most famous horror makeup of all time—is undoubtedly Boris Karloff as Frankenstein's Monster.
(COURTESY MICHAEL BRUNAS)

heavy workload on the film; 17 years later and now a well-established artist on his own, Baker needed to hire a crew of 80 (!) for *Gremlins 2: The New Batch.*

"There are many shops out here and a lot of people have specialties," says Johnson. "For instance, if they did *The Exorcist* today, a producer might say, 'Steve Johnson does nice ghouls and stuff, so we'll have him do the Regan demonic makeup. And Dick Smith does nice old-age makeup, so we'll have Dick do Father Merrin. And Stan Winston does mechanical heads, so we'll have him do the Regan head that spins around. . . .' It's become a very special-

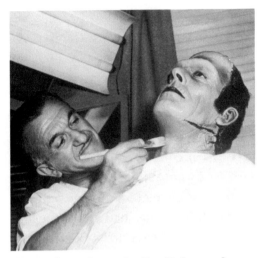

Pierce kept busy in the Universal horror bullpen for years. In one of his last stints, he makes up Glenn Strange for *House of Dracula*.
(COURTESY MICHAEL BRUNAS)

ized business these days. When I was coming into it, I saw Dick Smith in my mind's eye, a guy who, when he got a job like *The Exorcist*, had to do everything, down to the bruise on Ellen Burstyn's cheek. It's not that way anymore; times have changed."

As editor of *Fangoria* magazine, I am regularly inundated with reader letters that ask: "How can I become a makeup effects artist?" Before we tackle that question, let's review a few textbook definitions.

Production makeup is broken down into three major categories: (1) straight or "street" makeup; (2) character makeup; and (3) special FX makeup. Cosmetic makeup applied to an actor's face, ears, neck, arms, and hands is known as straight makeup (yes, the kind sold in any drugstore or at the Kmart cosmetics counter). Excluding false eyelashes, straight or "street" makeup is two-dimensional: liner, lipstick, blush, pigmented ointments, and similar products that can be painted on by the artist. Straight makeup is corrective in nature, enhancing beauty with highlights and shadow. Straight makeup ordinarily intensifies an aspect of the actor's own personality and appearance, in addition to helping define the character in a specific scene.

Two- or three-dimensional character makeup includes everything from the

Penguin's beakish nose to *Friday the 13th*'s facially deformed Jason; it transforms the wearer into a persona far removed from themselves. The Elephant Man, Freddy Krueger, Mr. Spock, *Hellraiser*'s Pinhead, the Wolf Man, and Cyrano de Bergerac fit into this category, too. A *prosthesis* or *appliance* is a piece of latex that is attached directly to the performer's face or body, the edges blended indistinguishably into the foundation level of the cosmetic makeup. In addition to the conventional makeup kit (a well-stocked one's contents include foundations, shadings and countershadings, cheek colors, beard cover, lip gloss, eye color, brushes, adhesives, powder, sponges and puffs, etc.), other specialty materials include baldcaps, scleral contact lenses, wire, plastic, etc.

Most character makeups begin with a lifecast of the actor, a relatively simple procedure that is the prerequisite of detailed prosthetic work. The process begins as the artist brushes a flexible moulage (similar to the powder used by dentists for tooth impressions) or a casting alginate onto the actor's face, excluding the nostrils. The subjects experience no discomfort beyond the fact that they must remain perfectly still to prevent distortion of the mask. Strips of water-soaked cloth are laid over the very delicate moulage to reinforce the negative mold, which is created after the moulage hardens in about four to seven minutes. A negative mold—one that goes in where the face goes out—is gingerly pulled off the actor's face; to loosen the mold, the actor may wiggle his cheeks a little. Once the mold is removed, plaster is poured in to fill it out. The plaster hardens, creating the positive cast.

The positive cast is covered with modeling clay such as Roma Plastilina, and the artist begins sculpting his design. This latest model is used to produce a new negative mold. When the mold dries, whipped-up foam latex is poured in to create the prosthetic pieces needed.

The third category of production makeup, special makeup FX, puts the visceral punch in horror films, from Freddy's chest of souls to *The Fly*'s man-into-giant-mutant-insect metamorphosis. Whereas Lon Chaney sported character makeup when he wolfed out in 1941, David Naughton's "bad hair day" in 1981's *An American Werewolf in London* was supplemented and enhanced by special makeup FX "change-O" heads.

A few of Rick Baker's unique mechanical devices, representing Naughton's warping head, hands, and back, did not involve the actor at all. Likewise, the puppeteered mechanical RoboCop and Terminator "insert" bodies caught close-

range fusillades without any danger to tough-guy actors Peter Weller or Arnold Schwarzenegger in their respective films. Critics frequently criticize genre movies as just showcases for FX, but countless low-budget horror stinkers are saved by the imaginations of their makeup teams.

Of the three makeup categories, special makeup FX emerge as the most specialized, closer to special FX manufacturing than makeup per se. These showstoppers call for expertise in sculpting, molding, painting, coloring, and casting, in addition to knowledge of creating foam and slush latex pieces, plastic appliances and shapes, frame constructions for figures, and manual and radio controls.

"Many kids today come up to me and say, 'I built this mechanical head,'" says KNB EFX Group's Howard Berger. "And I'll ask them if they've done any appliance work, and they'll say, 'No. I just do mechanical heads.' When you start drawing, you do a stick man. Well, you have to work your way up with makeup effects too. You can't start in the middle; you must start at the beginning."

Berger's clear advice emphasizes the first important step in becoming a good makeup artist—learning all there is to learn of your chosen profession. The greater variety to your makeup repertoire, the better chance you'll have in landing a job. Unlike in the past, the way to educate yourself in makeup is at your fingertips. The beginner or semipro can turn to how-to books, instructional videos, or magazines to polish their craft. Various colleges, universities, and makeup schools offer the classroom as an initial training ground.

Should you go to a makeup school? Some established artists, many of whom taught themselves their craft, criticize the various schools as being overpriced and gimmicky. Sure, you might learn the basics of the profession, but it doesn't mean you'll ever get a job out of the tuition. Others, however, recommend these training facilities as a good place to start, especially if you have little or no experience with materials, sculpting, etc. Either way, eventually you have to make your own connections in the "biz."

Courses in design, sculpting, and drawing and other art instruction will definitely benefit the novice. Study photography, too, as the skill will come in handy when building your makeup portfolio. The portfolio, a collection of 8"- x - 10" photos detailing your best work, is the essential calling card to getting your foot in the door with a hotshot artist, producer, or independent studio. In case your

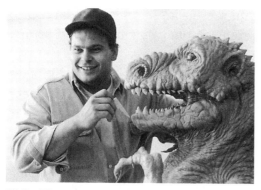

This *Timemaster* dinosaur, created by Gabe Bartalos (pictured), displays the artist's keen sculptural skills. (KAREN OGLE)

passion for makeup burns out or the opportunities to break in don't come knocking, plan for some other career to fall back on. In lean times, several makeup pros have turned to model kit and Halloween mask manufacturing to help make ends meet. If you enjoy other facets of filmmaking as much as makeup, then study production and shoot your own amateur films. This orientation might prove useful in the future; in recent years, makeup artists like Stan Winston, Kevin Yagher, and Chris Walas—to name a few—have segued into directing feature films. Finally, proficiency in writing and communications will assist you in the business end of your chosen field, so don't neglect the importance of these skills either. And with digital FX the rage in Hollywood these days (*Jurassic Park* having revolutionized the illusions business), learning as much as you can about computers will put another card up your sleeve.

Though several working artists have never set foot in a college classroom, an education never hurt anyone. "I wish to God that I had taken more courses in everything, it just would have helped," says Chucky creator Kevin Yagher. "It well-rounds you, when you're writing scripts or if you want to do anything beyond makeup, to have that education. If I had to do it over, I would have definitely finished college."

With portfolio in tow, it's time to network, and there's no better place to do that than at a horror, comic book, or science fiction convention (such as *Fangoria*'s Weekend of Horrors shows, held nationally). Professional artists routinely drop by to party and speak at the cons, and graciously take the time to talk with fans and beginners, thumbing through their scrapbooks, offering tips and guidance. Now and then, correspondence grows out of these informal encounters, leading to future employment. Steve Johnson, for example, found a job with Rick Baker's EFX shop shortly after meeting him at a Houston fantasy convention. A con's gala makeup/costume contest offers non-pros a chance to show off, and past winners have been approached by low-budget producers and makeup shops

for crew spots. Most people who break into the business toiling for large-size makeup departments start at the bottom—running foam, making casts of actors, cleaning shop, etc.

"Working in a shop environment made all the difference in the world," says Optic Nerve's John Vulich on getting started. "There's a healthy competitiveness which really helps. Seeing how there are other ways to do stuff other than your own, your work grows."

Luck plays a part in meeting your goals too. In one fortuitous case, Bryan Moore, a talented makeup artist who has contributed to TV's *Tales from the Darkside* and *Love and Curses*, met *Darkside* producer John Harrison in the video store where he worked. Moore impressed him with the shop's Halloween-decorated window that he put together, and soon thereafter, he called Moore and offered him a position on the Laurel anthology series.

Though the success stories and photos in this book leave you with the impression that a makeup career is a glamorous one, that's a bubble ripe for bursting. For the neophyte, the makeup FX market is hard grunt work, filled with long, frustration-filled hours dealing with short-tempered producers, fidgety actors, and impossible deadlines. When an effect fails to function, no matter what the reason, the finger inevitably points to you. In this high-pressured environment, people are customarily at their worst. With the increased demand for FX and the popularization of the craft, an unending number of hopefuls continue to plunge into this desirable, "fun" occupation, turning the makeup business into an extremely competitive, cutthroat field. Be prepared. But with enough talent, self-discipline, passion, and dedication, you can overcome these obstacles and achieve your goals.

"What keeps successful makeup people going is the fact that they were so obsessed with it from the start—they made a personal conviction to do it," says Kevin Yagher. "That's the real important key."

In *Men, Makeup, and Monsters*, you will meet a dozen artists who revel in their craft. Come inside their creature-laden labs for an examination of their individual specialties, tricks of the trade, and survival stories. Makeup FX can be a very tough business, no doubt about it. But it can be an extremely rewarding, creative, and satisfying one as well.

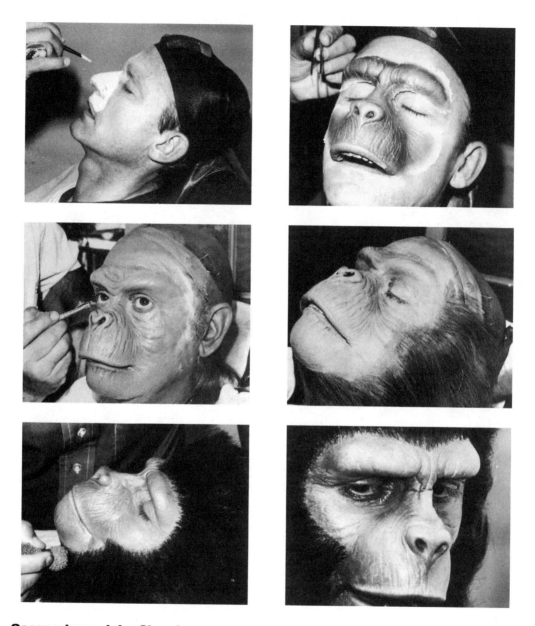

Oscar winner John Chambers goes ape on Roddy McDowall for the *Planet of the Apes* TV show. For the *Apes* films, Chambers innovated the use of rubber adhesives, premade appliances, and new glues and paints.

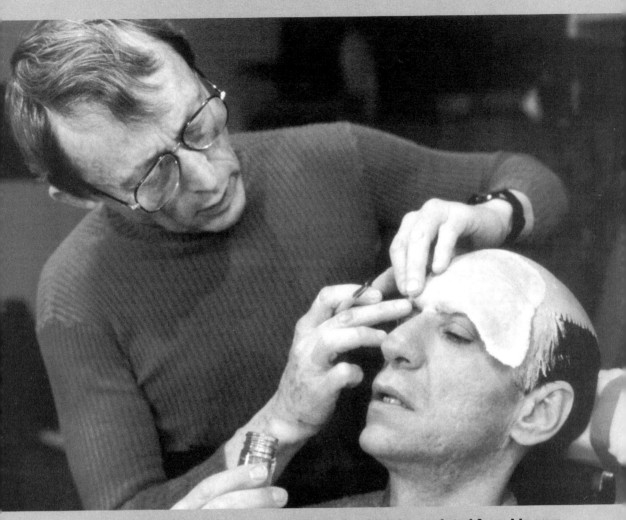

For *Amadeus*, Smith adheres forehead piece, which he sculpted from his own brow, to actor F. Murray Abraham. (ALL PHOTOS COURTESY DICK SMITH)

One

Dick Smith

New Techniques for Old Makeups

"Only one man—past, present, and probably the future—can wear the hat of the best, and he's Dick Smith," says Stan (*Jurassic Park*) Winston, no stranger to career praise himself. But that's just the kind of acclaim Smith's makeup brethren and former employees use to describe "the maestro." When the then sixty-three-year-old artist accepted his much-deserved Best Makeup Oscar at the 1984 Academy Awards ceremony for *Amadeus*, many wondered what took so long; finally, the man who had brought his innovative skills to such '70s movie classics as *The Godfather*, *The Exorcist*, *Taxi Driver*, *Little Big Man*, and *The Deer Hunter* was being honored by his peers. Considered the dean of makeup FX, Smith has inspired many of the field's top artists with his generosity, openness, dedication, and quality craftsmanship.

"There's not a day that goes by in my work that I don't use a technique or a formula or anything that Dick has come up with," says Kevin Yagher, a makeup artist who shot to fame in the late '80s with his work on the *Nightmare on Elm Street* and *Child's Play* series. "As a youngster growing up in Ohio, there wasn't a whole lot of makeup information. The only things I really learned were from interviews and articles on Dick Smith, who always shared so much detailed information. He's a very thoughtful and giving man."

Today's prospective artists have makeup guidebooks, instructional videos, magazines, and mentors like Smith to fuel and satisfy their curiosity. Smith himself, however, had no such fountains of knowledge to draw from when he first discovered his passion for makeup as a premed student at Yale University in the early '40s.

"Fifty years ago, when I decided to become a makeup artist, it was an entirely different world," recalls Smith, who was born in Larchmont, New York, on June 26, 1922. "For a Yale graduate like myself to choose this career was absolutely unheard of. I mean, no one even knew there were such things as makeup artists in those days. I only found out when I picked up a book on makeup [Ivard Strauss's *Paint, Powder and Makeup*] and thought, 'This would be neat.' But it seemed crazy to me

to make this decision because I had no obvious artistic skills and, on top of that, I didn't really believe that I had the talent to become a makeup artist.

"A while later, I did become a successful TV makeup artist—but there was a little voice inside of me that said, 'You know, you were just there at the right time in the right place,' that sort of thing," Smith continues. "It took me years, *years* to become a good makeup artist and to get to the point where I accepted that I was a top makeup artist."

Smith's talented hands have altered the features of Hollywood's greatest stars, including Laurence Olivier (for TV's *The Moon and Sixpence*), Marlon Brando (*The Godfather*), Robert De Niro (*The Godfather Part II, Taxi Driver*), and Dustin Hoffman (*Little Big Man*). But it is the FX artist's genre work that has garnered him the majority of his fans: the diabolical possession of twelve-year-old Linda Blair in *The Exorcist* (1973), which features Smith's head-spinning mechanical dummy, severe facial distortions, and vomit-spewing devices; the gruesome nose-and-eye knife slashing of an apparition in *The Sentinel* (1977); the female wraith of *Ghost Story* (1981); the dueling telepaths of *Scanners* (1981); William Hurt's flesh-warping metamorphosis in *Altered States* (1981); and the rapidly aging vampires and crumbling corpses of *The Hunger* (1983).

But of all his television and motion picture assignments, Smith's most acknowledged forte is his old-age work, a lifetime specialty that culminated with his transformation of the forty-two-year-old F. Murray Abraham into the bitter, seventy-five-year-old Salieri in *Amadeus*.

"The 'old Salieri' makeup I did for *Amadeus* perfectly embodies what I've learned in my career from 1945 till today," Smith explains. "I was sixty years old in 1982 when I created that makeup, and packed into it are all the things that I've discovered over the years."

Smith learned how to fabricate foam latex in the mid- '50s, after NBC hired the World War II veteran to run its fledgling TV makeup department. Foam latex appliances were first incorporated into Hollywood films in the late 1930s, most notably in 1939's colorful classic *The Wizard of Oz*. In those days, foam latex was rather stiff, glued on with spirit gum and made up with oily rubber mask greasepaint (RMGP).

Techniques barely progressed during the '40s and '50s: The foam was softer, but molds were not very precise or durable; spirit gum was still the adhesive of choice; and appliance makeup was just an RMGP base with some red liner (Red A) stippled on to put some warmth in the flesh. Very few makeup artists on either

coast could create foam latex appliances, anyway. Most used commercial foam formulas meant for mattresses, but Warner Bros.' George (*House of Wax*) Bau— an early innovator and one of the fathers of foam latex—manufactured and sold a special formula that produced softer appliances. Over the years, Smith utilized Bau's recipe and learned to improve its quality even further.

Foam appliance molds were made of U.S. Gypsum Hydrocals that expanded somewhat when cast. Thus, the edges of the negative and positive molds never fit together perfectly, and the edges of the appliances would come out too thick. The spots where the appliance ended on the skin would be plainly visible. Smith continued to grapple with these problems during his broadcasting tenure.

"In my television foam-latex work from 1955–1961, I tried many different dental stone materials, trying to find gypsums that did not expand so much," he explains. "The full-face masks I made for *Victoria Regina*, *Ethan Frome*, etc. were typical of the period—all in one piece from hairline to Adam's apple.

"In 1962, I made many small appliances for Tony Quinn as a scarred prizefighter in the movie *Requiem for a Heavyweight*," Smith continues. "My molds were quite accurate, but the appliance edges were still thick. Then I discovered that drilling an escape hole in the positive mold would relieve the hydraulic pressure of the foam and let the mold close completely. Those little holes were a big breakthrough."

Soon thereafter, Smith learned that U.S. Gypsum had developed a very accurate and durable gypsum for the auto industry called Ultracal 30, a superstrong product which soon emerged as the makeup artists' standard material for many years. During the 1960s, Smith tried using various medical adhesives for appliances, because standard spirit gum cracked under the stress of facial expression. Sloman's Medical Adhesive (a kind of refined rubber cement) fit the bill at first. But later, Smith found that a toupee glue called Secure held even more strongly, though the silicone-based adhesive was quite stringy.

"*Mark Twain, Tonight!* brought up two special problems," Smith says of the 1967 television special, picking up the story. "Hal Holbrook's face, neck, and hands were covered by foam appliances that would usually be made up with RMGP. But he had to wear a white suit and put his hands in his pockets many times during the show that was supposed to be taped without stopping. RMGP would ruin his white suit in five minutes. By mixing liquid latex into artist's acrylic paint, I came up with a rubproof flexible paint. It dried very shiny, so I had to powder it when it was still wet. It was crude, but did the job. It was the first paint that took the place of RMGP. Years later, I found that I could use just acrylic

paint—Liquitex—with lots of plasticizer to make it reasonably flexible.

"The other problem with the Twain makeup was that the plastic forehead that covered Hal's hairline, so his wig's hairline would look receded, had too little skin texture in it," Smith continues, describing the five-hour makeup that won him an Emmy. "Hal suggested that some liver spots would camouflage it. The spots added a realistic touch that I have used on most age makeups since, and made them fashionable among my colleagues."

That same year, Smith transformed actor Jonathan Frid into the one-hundred-fifty-year-old vampire Barnabas Collins for the TV series *Dark Shadows*, for a scene in which the usually handsome character displays his true age. All of Frid's features had to be

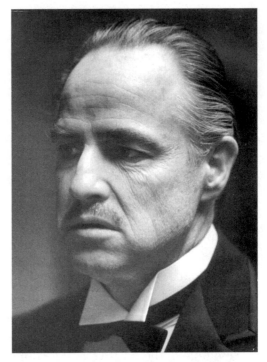

Those who felt that Marlon Brando had been miscast in *The Godfather* changed their minds once they got a look at Smith's classic makeup.

aged, but Smith hated masks that covered the whole face because they were awkward to glue on; moreover, foam shrinkage caused a tight fit. So he devised separate appliances for the actor's forehead, nose, upper lip, lower lip, and chin, as well as eyelids and bags, earlobes, and a large wraparound appliance that covered his neck and the sides of his face. Additionally, Smith designed the appliances to overlap each other slightly. This experiment made gluing on appliances so much easier and better that Smith and many of his associates have utilized this method ever since—with quality results. The *Dark Shadows* makeup also served as a preparation/rehearsal for Smith's revolutionary one-hundred-twenty-one-year-old makeup on thirty-two-year-old Dustin Hoffman in the 1970 epic *Little Big Man*.

Until *Little Big Man*, the sculpting of individual appliances—whether they covered all or only parts of the face—was done on copies of the appropriate section of the life mask. Unfortunately, this system made it very difficult to visualize what the face would look like when all the appliances were glued onto it.

For TV's *Dark Shadows*, Smith allowed soap fans to see vampire Barnabas Collins's true age.

Smith's thin eyelid appliances for Dustin Hoffman in _Little Big Man_ lowered with the actor's own eyes.

"Before sculpting Hoffman's old age, I coated his life mask with a thin urethane rubber, removed the resulting shell and tacked it back on lightly," Smith explains. "I sculpted the plastelene over it so that I could cut it into sections and remove them, plastelene and shell together. After the shell was peeled from the underside of the plastelene model, the model could be pressed onto a positive cast of the appropriate section of the face.

"This was an awkward way of breaking down a whole-face appliance makeup into a number of touching or overlapping appliances, but it worked. Later, I found I could do the same thing much more simply by applying a couple of coats of Alcote, a dental separator, to the life mask and drying it before sculpting. After finishing the sculpture, soaking the whole life mask in cold water reactivates the Alcote and even delicate plastelene models can be removed in sections and transferred to individual positive casts." Smith's "Alcote trick" is now common practice.

The Exorcist, 1973's screen sensation, cast forty-four-year-old Max von Sydow as the seventyish Father Merrin. Through Smith's genius, several innovations came about. Although appliances were used on the sides of von Sydow's face and around his mouth, Smith-formulated old-age stipple (aka stretch latex) was applied around his eyes and on his forehead, neck, and hands. The actor also needed a wattle on his neck, right below his chin. Rather than sculpt one, Smith applied copious amounts of old-age stipple on his own neck and molded it to arrive at both a more natural form and a better match for the stipple texture. From the mold, he cast a wax model of the appliance, which was used to make a foam latex appliance mold. "We refer to this as a 'donor,' " Smith notes. The artist glued on the appliances with a combination of spirit gum and a matting agent that prevented shine around the latex edges; for areas of largest facial movement around the mouth, he utilized Secure adhesive.

The three-hour Merrin makeup entailed Smith's most realistic coloring to date. He applied three different base colors of RMGP to von Sydow's forehead, cheek, and jaw areas. Then freckle and liver-spot colors were gently stippled on with sponges of various textures. Next, Smith added capillary colors (reds)— some by rubber stamps—and a few blue veins and other details. "It paid off," he notes. "Although tight close-ups were used without diffusion, most people did not realize Max was heavily made up."

Those fooled at the time included budding makeup artist John Caglione, Jr., a protégé of Smith's. "I was raving to Dick about the Linda Blair demonic makeup," Caglione recalls. "And he said to me, 'What did you think of Father Merrin?' I said, 'He was a nice old guy.' And he showed me the life mask of Max von Sydow—who was forty-four years old! He started pulling out these appliances and laying them up on Max von Sydow's life mask, and then I realized that the old man that I saw throughout the whole film was really a complete rubber face that deceived me."

Smith utilized similar aging techniques on Walter Matthau for *The Sunshine Boys* (1975). This time, he created liver-spot stamps to apply freckles and age spots to the actor's forehead that resulted in a quicker and superior job.

As a seventy-five-year-old blood-sucker in *The Hunger,* David Bowie left his glam rock days far behind.

Subsequently, while trying to formulate a silicone adhesive similar to, but better than, Secure, Smith learned that Dow Corning was manufacturing a new silicone glue called Medical Adhesive 355. Extremely powerful, even when diluted, and safer to use than any other glue, 355 has been a valuable tool to Smith and others ever since. Furthermore, a matted 355 can be painted on the surface of skin or an appliance to adhere short, chopped-up hair to create eyebrows or a few days' beard growth on the subject.

Additional breakthroughs came about in 1982. Smith began toying with yet another medical adhesive, this one

called Pros-Aide. "It is an acrylic latex emulsion, water-based, no solvents," Smith explains. "Pros-Aide formed a thin, flexible, sticky film that, when dry, could be removed by very few things. What immediately came to mind was the possibility of mixing it with artist's acrylic paint. I had never liked the acrylic paint and plasticizer; it cracked and didn't photograph right. So I mixed about equal parts of Liquitex and Pros-Aide and tried it on a foam latex appliance and my skin. It was fantastic."

Dubbing his new paint PA-X or Pax ("PA" for Pros-Aide and "X" for Liquitex's last letter), Smith first implemented his invention in *The Hunger*. "I could never have pasted the stubble beards over David Bowie's old-age appliances if they had been made up with RMGP. Pax has become tremendously popular. It is my greatest technical contribution," he says proudly.

This history now brings us to *Amadeus*, and the acclaimed makeup made possible by Smith's aforementioned discoveries. After Smith consulted with director Milos Forman and producer Saul Zaentz in the fall of 1982, the filmmakers agreed that the artist would be granted a relatively free hand in designing a convincing oldage makeup for fellow New Yorker F. Murray Abraham—without trying to make him resemble the real Salieri.

Work commenced on November 29, as the artist made molds of Abraham's head and hands. On January 15, forty-seven days later, Smith flew to Prague for a makeup screen test. Prior to this, he had done one makeup test in his basement studio with a still camera. A content Smith returned to Larchmont on January 20 after an extremely successful trial run. A week later, he flew back to Prague for *Amadeus*'s filming. Fortunately, Forman shot all of Abraham's scenes in his withered, elderly makeup at the same time, so the production only sought Smith's presence for one month.

"In studying Murray's life mask," Smith adds, "I saw that our foreheads were about the same size and shape, so I made a mold of my own wrinkled brow and used the cast in place of a sculptural model."

Regarding the Salieri makeup, Smith achieved one more important innovation. Unhappy with the quality of recent Ultracal 30 molds, he fabricated the makeup's two biggest negative molds out of an epoxy reinforced with fiberglass and aluminum bars. The smaller molds' ingredients included Ultracal mixed with water and acrylic cement adhesive (Acryl 60) for durability.

Smith's crowning achievement—F. Murray Abraham as the "old" Salieri of *Amadeus*.

In summation, Smith cites these integral discoveries as having benefited his *Amadeus* accomplishment: improved foam latex technique; mold design; overlapping appliance technique; the Alcote trick; 355 adhesive for appliances; matted 355 for wig and stubble beard; Pax makeup; liver spots and liver-spot stamps; detailed coloring and pigmentation of the skin; old-age stipple formula for the hands; and last but not least, a "donor" appliance. "It took me forty-one days to prepare the makeup but, in a larger sense, I spent over thirty years," Smith says.

Though currently enjoying a less hectic life in the warmer climes of Sarasota, Florida, Smith insists that he is by no means retiring. His most recent assignments have included old-age makeup consultancy jobs on *Dad* (1989) and 1992's *Death Becomes Her* and *Forever Young*. Less involved in the film industry these days, Smith has been keeping busy teaching a professional makeup correspondence course for the last ten years and doing seminars in such faraway places as Japan. He closely follows the new technologies and in particular feels that the use of gel-filled appliances marks a new era in old age makeups, citing Toronto-based artist Gordon (*Platoon*) Smith's "extraordinary" work on *Legends of the Fall*, Oliver Stone's *Nixon* and the HBO movie *Truman* as prime examples.

"To this day, when Dick talks about any [makeup] technique, you can tell there's a young excitement in his voice," says Kevin Yagher of his mentor. "And he wants the business to keep flourishing. He's always pushing for young artists to keep going."

Two

Rick Baker

Ape Man

If there's one person who should carry the title "Lord of the Apes," it's not Tarzan but makeup FX master Rick Baker. This Emmy- and Oscar-winning artist has achieved fame for a wide variety of screen accomplishments: *Star Wars*'s cantina aliens; his Academy-Award-winning work on *An American Werewolf in London* and *Ed Wood*; *Coming to America*'s multiple character makeups (including Eddie Murphy as an old, *white* Jewish man); and many others. But it is Baker's amazingly lifelike simians in the films *Greystoke: The Legend of Tarzan, Lord of the Apes* (1984), and *Gorillas in the Mist* (1988) that truly distinguish Baker's impressive oeuvre.

"It *really* grew out of my fascination for monsters—I liked monster movies," Baker begins, settled comfortably behind the desk of his North Glendale, California, office. The neat, modern workshop, like most FX studios, is decorated with the artist's best-remembered film props, including his beloved Digit suit from *Gorillas in the Mist* and a giant bust of the friendly Bigfoot from *Harry and the Hendersons*.

"I liked the whole makeup part of the monster stuff, I liked doing it, and I liked fooling people with makeup," Baker continues. "But people didn't buy me as a kid as Frankenstein's Monster; they didn't believe it. So I thought, 'I need to find something that's a real-life monster, that I can do.' And I had the misconception that many people do about gorillas, that they're the closest thing to a living monster that really exists. So I said, 'Well, that's a real-life monster. I'll do a kind of gorilla thing, and fool people with that.' *That* started a whole fascination with gorillas. I was looking at gorillas in movies, and then I was looking at the real thing and getting what information I could read about them. I was probably thirteen when I really started getting into the gorilla stuff."

Since the beginning of his career, Baker has specialized in producing realistic apes and apelike creatures for such films as *Schlock* (1971), *The Thing With Two Heads* (1972), *King Kong* (1976), *The Kentucky Fried Movie* (1977), *The Incredible Shrinking Woman* (1981), and *Harry and the Hendersons* (1987). Baker topped all of these, however, with *Greystoke* and *Gorillas in the Mist*; most audi-

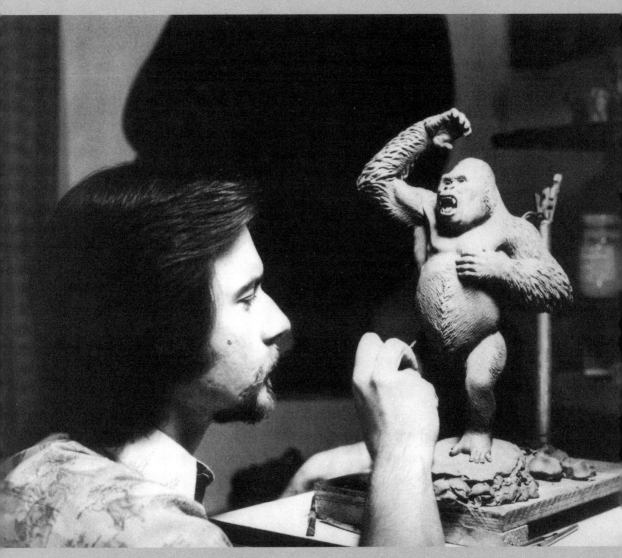

Rick Baker's love affair with the great apes began at an early age.
(ALL PHOTOS COURTESY RICK BAKER)

ences never realized that what they thought were highly trained simians were actually actors in Baker's meticulously designed ape outfits.

"I've probably done more gorilla suits than anybody, and I've probably done *better* ones than anybody," Baker says. "I don't know how many more I'm gonna do now. I always wanted to do what I considered to be the ultimate gorilla suit, to really make one that was just as real as it could be. I think I could still do better than what I did on *Gorillas in the Mist*, but it wouldn't be so much better that anybody would really know the difference but me. I'm pretty satisfied with the Digit suit; it was the suit I always wanted to make. I was hoping to make that suit when I did the Dino De Laurentiis *King Kong*, but I wasn't really allowed to make a suit like that. I always wanted to make a realistic gorilla, and most of the time when I made gorilla suits for films, they still wanted kind of a 'Hollywood gorilla,' not a real one. They want a biped gorilla, one who walks on two legs and acts like a man in a monkey suit."

Born in the quiet town of Binghamton, New York, and raised in Covina, California, since a toddler, Baker began toying with makeup at age ten. Three years later, encouraged by his artist/painter father, the avowed monster buff was already creating his own masks and lifecasts. He next progressed to turning his friends into vampires, zombies, and burn victims, much to the chagrin of their parents. Throughout these formative years, Baker's passion continued to grow, stimulated by informal encounters with maskmaker Don Post and monster-suit builder Bob ("Tracy the Gorilla") Burns, who shared the young lad's love for primates and pranced around in his own ape suit.

Not long after, Baker's skills improved "one hundred percent" when he visited the Larchmont home of his idol, Dick Smith, during a fateful summer vacation. He returned to California with a notebook filled with Smith's makeup recipes and FX secrets. "Dick gave me formulas for everything, many of which I still use today," Baker recalls. "He was like a god to me."

After a puppet-building stint at Clokey Productions, the stop-motion animation company that produced Gumby, Baker landed his first movie makeup FX job on *Octaman*. The Z-grade monster flick entailed fabricating the titular tentacled mutant, which Baker completed for about $1,000. Shortly thereafter, a fledgling filmmaker named John Landis offered the twenty-year-old Baker his first opportunity to "go ape" on the monster comedy *Schlock* (aka *The Banana Monster*).

Baker had already graduated from building gorilla heads to a partial suit; his

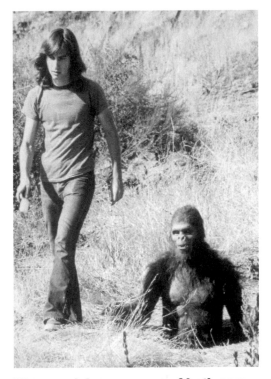

The auspicious careers of both comedy director John (*Animal House*) Landis and Rick Baker began with *Schlock*.

early pre-*Schlock* costume featured a simple ape head, as well as arms covered in overly shiny black fur purchased from a fabric store. Baker hid the rest of the body in overalls, thus avoiding the need for a more expensive head-to-toe fur outfit. The results impressed his contacts at Don Post Studios, who recommended Baker to Landis.

On a budget of "a couple of hundred bucks," Baker created the Schlockthropus, a missing-link ape man who thaws out in sunny modern California, sparking the requisite chaos. Director/writer Landis, who also portrayed the hairy creature, shot the movie on a tiring three-week schedule. Baker lists the following components comprising the *Schlock* suit: a four-piece foam appliance for the face; a hinged jaw; slipover hands; and crepe wool for hair. To complete the makeup, Baker glued the hair and a rubber chest piece to a pair of long johns worn by Landis.

"The first day, I thought I was going to have to kill myself," Baker recalls, "because all this crepe wool was just laid on the suit and we kept the suit on John the entire day. We shot in Agoura during a heat wave, like a hundred and twenty degrees. And John was sweating like mad—the hair was dripping wet and just falling off. We lost about half the hair on the first day! And it took a while to lay all that hair on there. So we started taking the suit off him between takes if we could, and fortunately it cooled down some. It was an experience."

Baker learned several valuable lessons on *Schlock*, like fabricating spare parts and suits for the occasional emergency. "I really wished I had a second suit," Baker says, "but I didn't have time to make one. The hands and feet started showing a lot of wear and tear real fast, and I didn't have a lot of time to repair stuff—especially when I was *the* makeup guy: The makeup took several hours to put on,

and we had to be ready at like six-thirty a.m. or some ridiculous time so John could start everything, 'cause he was the director as well. After he wore the damn thing all day, and after we 'wrapped,' we had to clean him up—which took more than an hour—and *then* we had to drive out to MGM to look at the dailies! He ended up getting a couple of hours' sleep a night. And in those couple of hours, *I* had to repair the stuff—patch the rips in the rubber, sew the suit back up, and so on.

"After three weeks of this, John and I both were dead," he continues. "John would fall asleep and *hallucinate* while I was making him up! His head would start to fall back and he'd wake up—it's really hard to do an appliance makeup on somebody who's falling asleep and their head's floppin' all around! Occasionally I'd say, 'John, wake up,' and he'd say [*excitedly*], 'Whose watches are those? The pile of watches over there—whose are those?' I'd say, 'You must be asleep still, John...!' "

They say two heads are better than one, and that's just what the producers of Baker's next film asked him to deliver: a two-headed gorilla for the bizarre transplant horror spoof *The Thing With Two Heads*. As with *Schlock*, the production failed to grant Baker the luxury of time.

"I built that whole suit on my own in two weeks," Baker says of his second professional gorilla. "When I look at how long we spend on things today, how long things take, I don't know how I did it. I sculpted two heads, the hands, the feet; I made the padding, sewed the suit together; I cast the stuff—I did everything in two weeks by myself. And it looks like it—it's a pretty shitty suit! But for two weeks and for no money, it was all right."

In 1975, Italian movie mogul Dino De Laurentis boldly announced his plans to remake the classic 1933 RKO film *King Kong* on a lavish $24 million budget. Though initially appalled that anyone had the gall to tamper with one of the most warmly regarded films of all time, Baker signed on to the questionable production, determined to create the ultimate gorilla suit. The remake, which abandoned the stop-motion techniques of the first *Kong*, presented Baker the opportunity to step up from the cheapie films that dotted his résumé. When asked about his Skull Island stint, Baker takes a deep breath, then confesses that he has spent the last nineteen years trying to put the memories behind him.

Evidently, problems started right from *King Kong*'s inception. The producers insisted that Baker follow their Kong designs and create a suit that resembled a missing link/Neanderthal Man–type being instead of the mighty ape of the earlier film. Equally wrongheadedly, De Laurentis and company pitted Baker against Italian special FX man Carlo Rambaldi, who tried simultaneously to come up with a

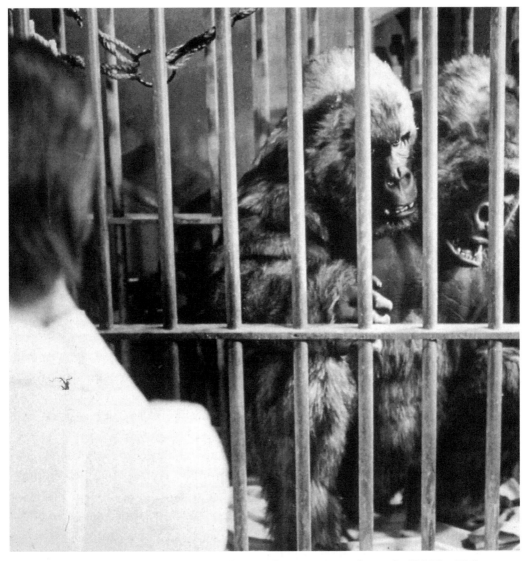

In his dues-paying days, it took Baker a short two weeks to build *The Thing with Two Heads*'s gorilla monster.

suit of his own, in addition to a giant forty-foot mechanical gorilla—which wound up never functioning properly and barely survived the final cut.

Toiling seven days a week, fifteen hours a day, Baker completed his test suit with the aid of one paid assistant and a friend. On the other hand, Rambaldi, with a crew of twenty, failed to meet *his* deadline. Though Baker ignored the imposed

design concepts and delivered a more traditional great ape suit, he not only won the job but talked the producers into letting him portray Kong as well.

"It turned out," Baker recalls, "that because my test suit [fit me] and because they shot tests with me, and because the other guys didn't really have a suit, they ended up saying, 'We might as well use Rick. He's stupid enough that we can keep him in the suit all day and he won't complain.' But they wouldn't let me play it the way I wanted to play it. Not that I could do the job that John Alexander did as Digit—he was brilliant. But I could have been a much more real gorilla than what I turned out to be. It was a biped thing, walking the stupid 'movie gorilla' walk.

"It was pretty torturous, too," Baker continues. "I had worked on enough films with people in rubber suits, and listened to actors complain about how awful it was. I thought, 'I'm not going to be like that. People are going to say about me, "Wasn't he a nice guy? He kept his mouth shut through the whole production." ' They really took advantage. I would put the suit on in the morning and wear it all day long; I'd only take it off at lunchtime. And I had these scleral contact lenses, because I felt it was very important to wear them so they weren't human eyes. You were supposed to wear 'em for a half an hour at a time, and I'd wear them all day long! But the end of the day, my eyes were totally fogged; I don't know how I managed not to die driving home on the freeways, because every light had a big halo around it and everything was just a blur. I would wake up in the morning and not be able to open my eyes, they were crusted shut. I did this for God *knows* how many months.

"Like I said, they really took advantage. They put me in the suit in the morning, and I might not work that whole morning. It was really ridiculous. Sometimes if they weren't using me, they would let me go sit in one of these tiny dressing rooms. And I'd sit there with my contacts and the suit on. Some days it was like, 'Boy, it's awfully quiet, isn't it?' I'd open the door and try to see through my lenses, look around and—they went to lunch! I've got a damn gorilla suit on and I can't get out of it! 'Somebody unzip me! I wanna eat!' "

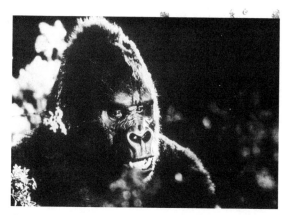

Baker donned his own ape suit to play the title role of *King Kong* in the 1976 remake.

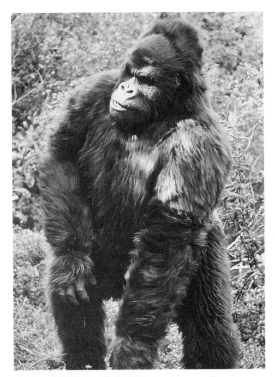

In a swipe at *King Kong*'s producer, Baker dubbed his *Kentucky Fried Movie* gorilla "Dino."

Nevertheless, Baker admits he enjoyed stomping around the miniature city sets, and his Kong suit boasted many technical advancements despite the creative interference. Rambaldi covered Kong's basic urethane foam-padded body (built up with polyfoam) with several sewn-together black bearskin hides and spray-painted the crudely-trimmed results. In retrospect, Baker calls it "a pretty disgraceful, ratty-looking suit," saved by the clever camerawork of Richard Kline. The artist fared much better with Kong's uppermost region. Baker fashioned four separate, fully articulated foam-latex heads to convey the big fellow's emotions: (1) a generic closed-mouth model for most happy/sad expressions; (2) an "angry" head, with a fixed enraged look; (3) a wide-open "roaring" head; and (4), a head for the blowing sequence in which Kong purses his lips to blow-dry a wet Jessica Lange. These lip and brow expressions were articulated by as many as eleven 40-foot external cables, which were attached to a mechanism in the head. The cables ran down the inside of the suit and out the feet, each manipulated by nearby levers. Anytime the costumed Baker walked, he dragged the weight of the cables around with him. (The heads Baker had designed in the past, including his Kong test version, were self-contained mechanisms that worked off the performer's jaw movements; when Baker opened the jaw, the lips would automatically curl up into a snarl, the head's sole gimmick.)

Regardless of his success with the cable-controlled, articulated faces, Baker considers *King Kong* a fudged opportunity. "How many times in my life was I going to have the opportunity to make a gorilla suit for a big-budget movie?" he asks. "They don't *make* big-budget movies about gorillas. This was one, and I really thought this was my chance. And it was blown."

Soon after his *Kong* debacle, Baker created a more modest suit for a brief

sequence in Landis's sketch comedy *The Kentucky Fried Movie*. Taking a swipe at his former boss, Baker nicknamed his new ape "Dino." A low-tech "rental suit" intended for loanout to commercials and other films, Dino featured a self-contained head mechanism like the Kong test suit.

A few years later, Landis paged Baker again for his planned satire *The Incredible Shrinking Woman*, which called for an amiable lab gorilla to befriend star Lily Tomlin. Landis later

The *Greystoke* apes boasted distinct personalities, conveyed through Baker's detailed costumes.

backed out of the project when Universal pared down the movie's scope, but Baker remained and moved closer to perfecting his dream ape. Sidney, *The Incredible Shrinking Woman*'s gorilla, sported three expressive heads and a self-contained one; a hand-knotted yak-hair suit; a sponge-rubber chest; and appropriate mechanical arm extensions that allowed Baker—who played the ape again (billed as "Richard A. Baker")—to show off his quadruped gorilla gait.

"I got to do a lot of things I hoped to do on *King Kong*," Baker says of Sidney's novel construction. "The suit had different densities of foam. I wanted the bony part to be hard, while the fatty part should be soft and mushy and the muscle part should be something else—so we made these different density things. The rib cage, for instance, was a hard section, so that when I moved to the side, you would see the definition of the ribs—not just a bunch of buckling kapok stuff. It had rigid shoulder blades, the stomach was softer—without the hair on it, it looked like a skinned gorilla. It was a fairly decent suit, much better looking—in person, especially—than Kong."

After collecting the first competitive Academy Award for Best Makeup on *An American Werewolf in London*, Baker began preparing for the largest—and most difficult—project of his career at that point, *Greystoke: The Legend of Tarzan, Lord of the Apes*. The scope of the Warner Bros. epic daunted Baker initially; original director/screenwriter Robert Towne insisted that Baker bring a ridiculous degree of realism to *Greystoke*'s ape tribe, right down to genuine bodily functions. The studio ultimately replaced Towne with director Hugh (*Chariots of Fire*) Hudson, who accepted Baker's more practical designs for Tarzan's adopted family.

Preferring a stylized look to natural authenticity, Baker followed his producers' suggestions that the apes be "their own kind of race." Situated on an entire soundstage at EMI Studios in England, Baker and his sizable crew spent ten months creating the ape suits—about thirty in all, six being the more complicated lead apes with special close-up heads. Surprisingly, Baker's small army of assistants on the $30-million production did not make the formidable workload any easier.

"The more assistants you have, the less work you're able to get done," he says. "When it's just you, you figure out what you're gonna do that day, you think about it for a little while, and then you go out and do the work. And nobody interrupts you all day. When you have assistants, you get a lot of, 'Is this what you want me to do?' And you have to find things for all of 'em to do, and they keep bringing you stuff to look at—and then suddenly you realize, 'The day's over and I haven't done anything except answer these guys' questions!' When I did *Greystoke*, at one point there were seventy or so people working in this building, all of them asking me questions. After the English crew went home, it was me and 'the boys,' the guys I'd brought from the States—Steve Johnson, Sean McEnroe, and Tom Hester—working most of the night. I was in this little room sculpting the lead characters, sculpting all night until I couldn't stay awake any longer. At the end of it, I was dead."

Baker sketched the lead ape characters with many distinguishing features (droopy ears, gray hair, etc.) in order to differentiate them, then sculptures were made over the ape actors' lifecasts. Like Kong, each *Greystoke* animal had cable-controlled heads capable of expressing different emotions (hooting, roaring, etc.). The suits were hand-tied with yak hair onto a lycra-spandex base body stocking that was stretched over a lycra-spandex muscle suit, comprised of different foam densities à la Sidney.

Over a six-month period, primatologist/ape performer Peter ("Silverbeard") Elliott trained a group of dancers, acrobats, and actors in simian behavior to portray the apes convincingly, all accenting Baker's convincing costumes. The performers simulated the animals' jaw movements on their own, and their real eyes were hidden behind full-scleral lenses. Baker earned an Oscar nomination for *Greystoke*, losing to mentor Dick Smith for *Amadeus*. Though proud of his work, he confesses that his fully articulated *Greystoke* suits departed only slightly from the innovations developed for *The Incredible Shrinking Woman*'s Sidney of a few years earlier.

"I don't think there was a major technological leap at all," Baker says. "The major accomplishment of *Greystoke* was just the sheer volume of stuff that we did. Sidney was one ape; on *Greystoke* there were twenty-five or thirty, as well made if not better made than the Sidney suit. They had mechanical arm extensions, articulated faces, a lot of 'em were self-contained, some were cable-controlled. I was able to finesse the facial mechanism more; the mechanism on the *Greystoke* apes worked better than Kong or Sidney's, and was capable of more subtle things. But it still was not real hi-tech compared to the stuff we do today."

Baker's workload became more manageable, but no less involved, on *Harry and the Hendersons*, a Steven Spielberg production about a friendly Bigfoot. Director William Dear felt that only Baker's designs could do this gigantic creature justice. "I did some drawings, and pretty much the first one that I did was what we ended up using," Baker reveals. "I was stealing from all the different apes. Harry is part man, part gorilla, part orangutan—probably more orangutan than anything. The interpretation of the orangutan is like the old man of the forest, and I thought it would be fun to do Bigfoot that way.

"Harry's pointed head lent itself to using servo motors," he continues, detailing the head's radio-control functions. "What I dislike about cable controls is the limitations of having these damn cables coming out of the suit somewhere, and the actor being pretty much tied down to only being able to use the articulated head in close-ups where they don't have to move very much. So I explored the concept of radio-control stuff. On the *Greystoke* apes, we wanted the heads to be as flat as possible and there was no place, no big crown to put motors in. Harry's pointed head was great; there was enough room between the actor's skull and Harry's skull to pack a bunch of servo motors. So we had an articulated head that could do any expression in any kind of scene. And the movie called for that, because he could only communicate with his expressions. They wanted him to be free to walk from room to room and make all these faces. The radio-controlled head made it work."

Baker outfitted seven-foot-two-inch-tall actor Kevin Peter Hall in a "cool" suit (a special vest worn under the costume that reduces the suit's temperature) that kept him as comfortable as possible during his long hours in front of the camera. Harry's enormous head contained special servo motors that, via three separate remote-control operators moving simultaneously, manipulated Harry's various expressions. Hall wore contacts to simulate Harry's eyes. The late actor also

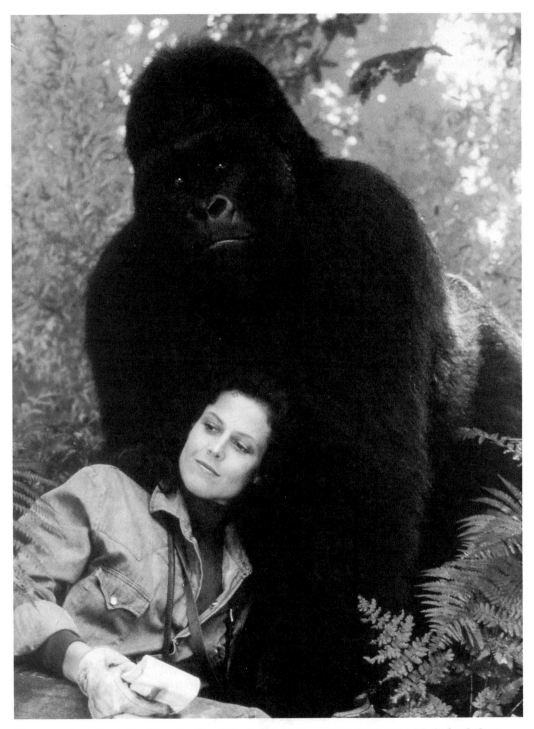

You can bet that *Gorillas in the Mist*'s Sigourney Weaver wouldn't feel that comfortable with the real thing!

worked Harry's jaw; when he opened his mouth, Harry did likewise. FX assistant Hester controlled the brows, and Baker and Tim Lawrence handled the lips. "During the course of a take, if I had an idea, I had to communicate it to Tim *and* to Tom *and* to Kevin. It was quite hard, but lots of fun," Baker says.

The artist collected his second Oscar for *Harry and the Hendersons*. "Harry was a magical experience for us because the character just worked so well, without rehearsal and basically without direction," he says. "The four of us who were performing Harry—somehow our brains linked together in some mysterious way and it just happened; it wasn't something that we planned. It was on the spur of the moment. We had a really good time."

For the barely released pseudo-documentary *Missing Link*, Hester of Baker's EFX studio supplied a primal man suit made of spandex that featured both a self-contained and cable-controlled head. Baker later journeyed to Africa for yet another ambitious ape assignment, *Gorillas in the Mist*, director Michael Apted's biography of anthropologist Dian Fossey (played by Sigourney Weaver in the film). Many credit these ape suits as Baker's crowning achievement. The work represented nearly two decades' worth of experimentation, both in and out of the lab. (In his primate research, Baker once donned an ape suit to "communicate" with Koko, the famous gorilla who speaks in sign language.)

Baker credits the success of *Gorillas in the Mist*, for which he also served as associate producer, to the skillful editing of Stuart (*Lethal Weapon*) Baird. The editor flawlessly cut together footage of authentic and Baker apes—lensed in separate African locations—into a cohesive whole. The footage of Baker's creations outweighs the real gorilla shots, though most moviegoers never noticed the difference.

"They got some amazing real footage, but they couldn't make a scene out of it," Baker says. "Stuart had a really tough job; they had thousands and thousands of feet of this incredible gorilla footage, and they said, 'Here you go. Try to make a movie out of this.' He would look through all this stuff: 'Well, here I got a silverback walking from here to here. And I got another one coming from here. If I just had a shot in between there of one doing [whatever action was required], then I could use them.'

"Then he'd show me the footage and tell me what he needed in between, and we'd go shoot it," Baker continues. "My only advice was that, if he was going to mix 'em, mix 'em with big spaces in between: either have a sequence with all real gorillas or one with all fake gorillas. Don't have real gorilla–fake gorilla–real gorilla–fake

gorilla shots. Well, he ended up doing real–fake–real–fake a lot, and it worked. I was amazed. It worked a hell of a lot better than I ever thought it would, and a lot of it was because Stuart is a brilliant editor."

Baker also praises Digit performer Alexander for his definitive interpretation of the film's most prominent gorilla. "I thought that a lot of the times we'd use the [ape] heads, it would be a close-up of Digit pretty much just standing there, and we'd just have to operate the face," Baker explains. "But it turned out we had *very* specific things to do: At the beginning of a shot, we had to match the position of the real ape in the footage that had just ended, and we had to end the shot with the expression that the real ape had on his face at the beginning of the next shot. And John was called upon to hit very exact marks and very exact positions, in heads that weren't designed for him to see out of; he was virtually blind inside of 'em. And he did it, take after take after take." (Alexander wore the Digit suit again, but with a different head, for the comedy *Baby's Day Out.*)

The artist and his team devoted ten months to perfecting their test suits. Without *Greystoke*'s volume of apes, Baker had ample time to concentrate on *Gorillas*'s two main suits, Digit and Simba, which held all the "trick parts." The difference between Harry and Digit's radio-controlled heads, as well as those devised for Kong, Sidney, and *Greystoke*, was the addition of radio-controlled eyes. The mechanical orbs better matched the real gorillas' than any scleral lenses of the past. Encased in the motor-driven head, the partially blinded Alexander could only see out of the mask's nostrils and open mouth.

The movie's newborn apes were acheived in several ways: a chimp in a gorilla costume; a hand-puppeted version with radio-controlled eyes and face; and the most complex one, a totally mechanical ape operated by a "slave system" through which, via remote control, the fake baby imitated the moves of a nearby operator.

Baker's personal *Gorillas* highlight was shooting in Kenya. "It was really weird," he recalls. "We were eleven thousand feet up in the mountains in the jungle, but we were in this hi-tech editing room. And we'd lose track of where we were; we'd open the door and there would be lions roaring, all sorts of weird, exotic animals! *Gorillas in the Mist* was a neat experience."

As a teenager, Rick Baker pored through back issues of *National Geographic* and zoology books to soak up as much knowledge as possible on what he believed were the closest things to a "real-life monster." The silly B-movies he watched as a kid perpetuated this inaccurate image—one that the adult Baker has

helped to debunk with his stunning film work. After meeting these mighty beasts in captivity and in the jungle, he realized that they are one of the planet's most peaceful animals. Baker has been granted the opportunity to indulge his fascination for the great apes during the course of his career, and with *Gorillas in the Mist*, he finally satisfied his creative predilection to build the best ape ever.

"If I were to die today, which I hope I don't, I would be happy that I made the suit that I always wanted to make," Baker says as he points to the still-impressive Digit, now displayed in his office. "I don't have the strong desire I once did to try to make the 'ultimate' suit; if I never make a gorilla suit again, I'll be happy. I'd rather do something different. I've made enough gorilla suits in my life now, but I'm not saying I'll never make another one."

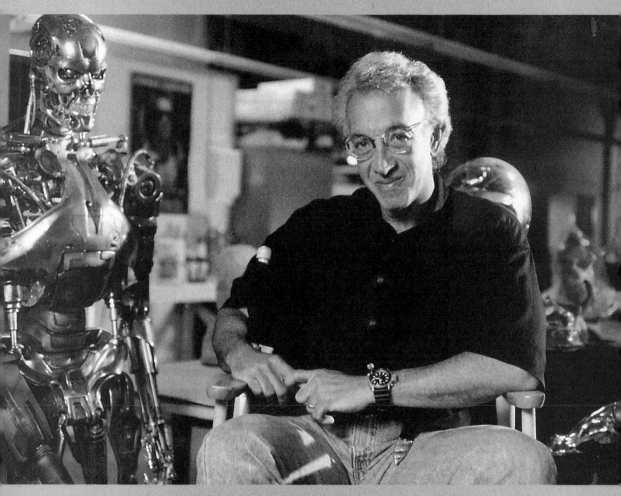

FX giant Stan Winston poses with his *Terminator 2* endoskeleton.
(COURTESY STAN WINSTON)

Three

Stan Winston

The T. rex of Makeup Designers

Makeup FX designer Stan Winston has worked on many of the biggest creature and special FX movies of the last ten years, from *The Terminator* to *Jurassic Park* to *Interview With the Vampire.* He has accomplished every level of makeup and special makeup FX in his repertoire, from centenarian old-age makeups (*The Autobiography of Miss Jane Pittman*) to full-size robotic figures (*Jurassic Park*). He has won enough awards (including four Oscars and two Emmys) to fill a broom closet and has toiled for the industry's top directors and stars. Just don't call him "the best."

"Number one, I don't believe that, I don't believe that I have the reputation of being the best," Winston says. "And if the reputation is there, I would question everyone who thinks it, because I don't believe that creature exists, I don't believe 'the best' of anything exists. I have been extremely fortunate; I am surrounded by many of the best, which helps me be successful and be fortunate enough to have been involved in terrific movies, but when you say 'the best,' what does that mean? The best *what*? The best artist, the best sculptor, the best painter? Absolutely not, no way. People who work for me are better than me! I have done work that has been well-received or has been in the biggest and most successful movies, and that is because I have been involved with wonderful directors, I've had wonderful people working with me and there have been wonderful screenplays there. It's very nice to hear someone call me 'the best,' but it ain't true."

Lest you believe that the fifty-year-old Winston has a self-esteem problem, he proudly points to his many screen accomplishments during a tour of his company, Stan Winston Studio, located in California's suburbanish San Fernando Valley region. His 22,000-square-foot shop could also stand on its own as a museum of the fantastique if Winston ever wanted to turn it into a tourist mecca. A long diorama displays his many creations: zoologically sound penguins from *Batman Returns*; the terrifying E.T.s of *Aliens* and *Predator*; the hyperactive, taloned velociraptors of *Jurassic Park*; the red-eyed, metallic endoskeleton of *The Terminator*; and the towering Pumpkinhead, from the film on which Winston

made his directorial debut. His floor space serves as a three-dimensional résumé, though it's likely Winston rarely has to sell himself to prospective producers; they come to him.

At the time of this initial interview, Winston is just coming off his grandest film to date, Steven Spielberg's $900 million–grossing smash *Jurassic Park*. To protect the security of his future, top-secret projects, visitors are asked to sign release forms swearing that they won't divulge the wonders found within Stan Winston Studio. Today is slightly less hectic than usual, though Winston's calendar is still filled with appointments. His daughter is home from college, so he's looking forward to some quality family time. Settled in an expensive leather chair in his office and dressed down in jeans and sneakers, Winston begins his talk with a review of his past.

Though he may be a giant now, Winston's humble beginnings were not unlike those of other makeup FX artists or even the backgrounds of his seventy or so current employees. "I've been a fan of all of the science fiction, horror, and fantasy movies since I was a child," the gray-haired and -bearded Winston says. Raised in Arlington, Virginia, he began shooting his own monster movies on Super-8 at age thirteen. He continued his hobbies of drawing, painting, and sculpting when he attended the University of Virginia, majoring in fine arts and minoring in drama—quite a switch from his original predental curriculum! And although he created his own makeup and that of his stage troupe, Winston headed out to Hollywood in 1968 to be an actor.

While waiting for someone to embrace his thespian talents, Winston applied for an apprenticeship with Robert (*The Shaggy D.A.*) Schiffer at Walt Disney Studios' makeup department and was one of two chosen from 200. "I learned a tremendous amount," he recalls of his 6,000-hour tenure with Schiffer. From there, Winston "begged" for a job on Ellis Burman's makeup crew to provide the background creatures for the 1972 TV movie *Gargoyles*. He won the gig, as well as an Emmy for his contributions. *Gargoyles* led directly to another TV success, *The Autobiography of Miss Jane Pittman*, which teamed Winston with Rick Baker to age actress Cicely Tyson from nineteen to a hundred and ten (Winston handled the last-stage makeup). After collecting his second Emmy for *Pittman*, and earning another nomination for the much-praised *Roots* (more old-age makeup for a number of characters), Winston felt the itch to make the leap to the big screen and work on similarly high-caliber productions (his early '70s horror quickies *Bat People*, *Mansion of the Doomed* and *Dracula's Dog* notwithstand-

ing). Character makeup (Rod Steiger as the famous comedian of 1976's *W. C. Fields and Me*) and fantasy creations (1978's *The Wiz*) from this period attest to Winston's evolving talents and his desire to stretch himself as a well-rounded makeup designer.

"Everything that I do, I carry on," he says. "Every movie I make is research and development for the next movie and is based on something I've done previously. Though I do all these creature shows now, I don't miss the old-age *Pittman*-type makeups and W. C. Fields from my past, because I'm still doing it. It's what makes me a makeup artist today."

Winston first began experimenting with mechanically articulated faces for *The Wiz*'s flying monkeys, which he continued to perfect in his Wookiee masks for the now-forgotten *Star Wars Holiday Special*. He refined his skills further on the 1981 robot comedy *Heartbeeps*, utilizing full-face gelatin appliances on actors Andy Kaufman and Bernadette Peters. This makeup advancement earned Winston his first Oscar nomination. His skill with robotic creations and a recommendation from Dick Smith soon brought the artist to the attention of director James Cameron, who hired Winston for his modest $6.5 million futuristic thriller *The Terminator*.

Terminator's significant workload—sequential deterioration makeups for title cyborg Arnold Schwarzenegger, insert puppet heads and arms, plus a full-size endoskeleton robot—led Winston to employ his first large-scale crew, thus establishing Stan Winston Studio as an all-service makeup FX facility.

Cameron, an on-hands designer from the start, envisioned the endoskeleton as a metallic warrior, with a sort of insectoid look. Cameron wanted to avoid any man-in-a-suit connotations, so when the cyborg loses its superstructure of synthetic flesh, he turned to Winston to supply a detailed, full-sized robot with moving cams, pistons, and joints.

Originally, most of the endoskeleton's scenes were to be accomplished by the Fantasy II FX company's stop-motion experts. Winston, however, had another idea. "Initially, what Jim had come to me for was to create the makeup effects for Arnold as the Terminator and all of the Terminator effects," he reveals. "The robot [was] going to be done basically with stop-motion animation, and through my conversations with Jim, we decided we could do a lot of that by building a full-size Terminator, an animatronic, cable-actuated and rod-operated puppet. Therefore, the technique by which Jim brought the Terminator to life on film changed.

"Actually, much of the screenplay hadn't even been written when Jim first approached me with *The Terminator*, but he already had a design for the Termi-

nator robot, which is what excited me about the whole thing. The technique eventually changed—it became more real time and less stop-motion, which they also used in some shots."

The artist first converted his director's endoskeleton sketches to miniatures, followed by full-size mockups carved in clay, to nail the final design. The endoskeleton was sculpted in pieces—arms, chest, pelvic girdle, etc.—then cast by the crew in fiberglass and assembled. Throughout the film's production, Winston bonded with collaborator Cameron, and the two became close cinematic comrades.

"The fact of who Jim Cameron is allowed our mindset to be very similar," Winston says. "On *Terminator*, he had a strong conceptual understanding of what had to go into what we were doing. He is a brilliant artist; it was his concept, his drawings on *Terminator*. And because he was an artist and understood it, it made the relationship one that was creatively charged. He wasn't someone I had to explain to why something would or wouldn't work. He is a director who is part of the team, because he understands and has the ideas and the artistic know-how. By *having* that feeling of how far you can go, Jim has the tendency—as a great director would—to push it beyond what we think we can do, and try and do what we *haven't* done."

Winston next moved on to his first major creature show, Tobe Hooper's ill-advised remake of *Invaders from Mars*. Besides building the film's snail-like Supreme Intelligence (a combination of hydraulics, radio-controlled and hand-puppeteered mockups), the FX designer focused on giving the two Martian Drones a look far removed from the ratty man-in-a-suit mutants of the original. Inspired by conceptual artist William Stout's sketch of an alien's knees going in the opposite direction from a human's, Winston came up with the idea of putting two people—a body builder and a little person—back-to-back in an oversized 160-pound foam suit. The backward-walking body builder carried the little guy as a human backpack. Based on this concept, Winston designed the Drones from the inside out, wanting the lumbering beasts to be fun and silly, yet also capable of gobbling up some poor slob in an instant.

The interior of each suit, which resembled an airplane cockpit, had fans and radio headsets installed inside for the performers, a miniature camera that peeked through the nose, and a TV monitor for the body builder to watch his outside actions from within. The two suits also sported radio- and cable-controlled functions that allowed for snarling, blinking, and other facial expressions. Engaging a system of cables and levers, the dwarf used his legs to operate the creature's

mouth and his arms to manipulate its smaller appendages. Meanwhile, the strong-man in charge of the motor movements held ski poles down inside the suit to manipulate the Drone's oversized third and fourth limbs. Winston's aliens featured all the practicalities of man-in-a-suit constructions, but the unearthly, four-footed monsters did not resemble anything terrestrial at all.

"*Invaders from Mars* was more a creative use of human function than a technical breakthrough," Winston says. "When I started drawing the Drones, the big thing was to come up with a man-in-a-suit concept that would never read as a man in a suit, so that it would almost look like a full-size stop-motion animation puppet, because it was obviously *not* a man in a suit. So we took away all those elements that we're familiar with—the bend in the leg, the placement of arms, body structure. That's basically what I did: draw the human form backwards, bent over, using the arms as only the first part of the extension for the walking legs. And then placing a little person on that person's back, in a backpack, to add limbs and function. The feet would work the mouth, and the little arms would be extended tendrils. So it wasn't so much a technical breakthrough but more of a fun creative achievement, and I'm very proud of it. They look like strange alien creatures. The one thing about that show which has carried on through a lot of the stuff we've done is the use of video for an actor in a suit, to be able to see what he's doing outside."

The creature maker already had plenty of research and development behind him when *Aliens* came along. The sequel continued the action of Ridley Scott's 1979 *Alien*, but whereas the earlier classic only featured one monstrous menace, the Cameron-scripted and -directed follow-up introduced an army of the space monsters, as well as a new addition to the gang, the dinosaur-sized Queen. Like those for *Invaders*, Cameron's initial Alien Queen plans dictated that two stunt-men help operate the fourteen-foot-tall creature from within a huge suit, while Winston pushed for double-jointed legs to give it more nonhuman, insectlike qualities (sort of a cross between a T. rex and a praying mantis).

"The final Alien Queen was pretty much Jim Cameron's design," says Winston, whose work on the Cameron films and *Jurassic Park* has been extensively chronicled in *Cinefex* magazine. "He had drawn a design of the Queen before we started. Then, the only thing that I was not crazy about in Jim's original design was the configuration of the legs, which was a little humanoid, the bend in the knee. I drew an Alien Queen which reversed the legs. I did a few sketches keeping the insect feeling, and Jim did sketches, and we would confer on those. Then Jim

did another drawing which used the reverse leg and knee. That ended up being the final one. So that tiny structural aspect came from a concept drawing of mine, but the actual design of the Queen herself was Jim Cameron's, as was the final drawing. We then translated that two-dimensional drawing to the three-dimensional sculpture in miniature."

Soon after, seven of Winston's sculptors began work on the miniature, a complete quarter-scale prototype. The model also served as a maquette for sculpting the full-sized, fourteen-foot-tall, twenty-foot-long version of the Queen. In addition, molds from the prototype were drafted for use by FX artist Doug Beswick, who built a quarter-scale cable- and rod-actuated Queen puppet for certain scenes in the film.

The inside of Winston's giant, four-limbed Queen was made of a tough fiberglass understructure to hold the two stuntmen, who were positioned back to back. Two of the men's arms controlled the Queen's smaller appendages, and its longer forearms were manipulated by the performers' other arms wielding long ski-pole-type instruments. The legs were puppeteered externally by Winston's staff, while the principal part of the Queen's head was hydraulically and cable controlled to allow for full head and neck motion. Face, lips, and jaw movement also worked off independent cables, and hydraulics and wires allowed the partially mechanical tail to whip around. Another tail (for the impalement of the android Bishop) and cable-controlled arms (with greater six-finger dexterity) were manufactured for inserts as well. The outside body was cast in lightweight polyfoam. The weight of this giant contraption was supported overhead by a crane arm, which connected to the Queen midway down her back and well out of camera sight.

The rest of *Aliens*'s eight-month workload probably seemed a breeze to Winston and his forty-member crew with the Queen completed, but the FX wizards still faced the challenge of recreating—and improving upon—the H. R. Giger creature designs of the first film, which none of them had worked on. For the Alien warriors (essayed by limber dancers and stunt players), Winston's shop created twelve black leotard suits (abandoning the original's full-rubber costume) and glued on light-foam rubber pieces. Undercranking the camera, Cameron shot the warriors performing dynamic, non-anthropomorphic action by suspending them on wire harnesses to bounce them off walls and ceilings. Additionally, Winston's

For *Aliens*, the FX team supplied about fifteen drone suits, which director James Cameron ingeniously shot to look like an army.
(COPYRIGHT TWENTIETH CENTURY-FOX)

team built a much thinner eight-foot-tall puppet, with a fully articulated cable-operated head and torso for close-ups. The redesigned eight-fingered facehuggers gained more mobility and greater functions than their predecessors due to the addition of more sophisticated mechanics. A cable-activated facehugger functioned underwater and another pull-toy version could scurry across the floor on a wire. The revamped chestbursters appear more animated in the sequel as well and gained a tiny set of arms.

"We were able to improve on all of them, or rather refine them," Winston says of his *Aliens* assignment, which netted him his first Oscar, "because the concepts were *there*. If we go in to do a sequel where we're gonna redo something, we must remain legitimate to the original concept. The H. R. Giger designs were incredible. The original artwork *did* allow us the ability to refine, study, and say, 'Well, we can do this better. We can refine these details.' For example, we took the [existing] design of the facehugger, did not change it but refined certain things sculpturally, with painting and coloration, things like that. Within the script, the facehuggers had to do much more. So we increased the amount of character there by allowing it to do more. We actually took that character and extended its ability to act. The same thing with the chestburster. We added more movement.

"We refined sculptural and paint elements on the drone Aliens, too," Winston continues. "There was a shell over the top of the head; well, we took that off and refined the insides and kept that exposed, sculpturally. But any novice eye and ninety-nine percent of the audience would see exactly the same character, the same design. To *our* eyes, we see the difference, the refinement. We allowed for more freedom of movement, so that these things could do more than the rubber suit in the original *Alien*. We gave the existing designs the capability for the actors to create better performances and to create these characters."

Winston designed another unfriendly outer-space monster a year later for the Arnold Schwarzenegger/alien grudge match *Predator*. The 1987 hit needed a worthy adversary for the muscular hero, and the filmmakers found it at Stan Winston Studio after another makeup shop's attempt at a creature suit failed to pass muster. Though he had just come off a few extraterrestrial scare shows, Winston says his creativity was in no way limited by previous films.

"I *never* feel that," he says testily. "I don't feel that today, I won't feel that in ten or fifteen years. As long as your imagination lives, you can come up with something new and exciting, and that's what we're all about. The Predator has

nothing to do with the Drones, which were aliens, or the Aliens, which were aliens—it's an entirely fresh and new concept. What it allows us to do is free up our imaginations. We look at our past and everything we've seen that has excited us and everything that's dramatic, and put them together and remold them and come up with something new and fresh. And we're just re-dressing them. There's really nothing *brand* new about any of those characters that we've talked about: Their total appearance is new, but every element of a [Martian] Drone is based on some form of reality, some muscle structure and bone structure that exists in nature. Much of the Aliens, especially the warriors and the Queen, are based on insect life, and then moved around to create this new image.

"*Predator* is a combination of humanoid elements—a wonderful Rastafarian character, a warrior—yet with an insectlike face; the mandibles were an interesting, brand new concept. But the well is by no means dry. All it does is give you more to take from in the future."

Apart from its unique design and built-in accoutrements, the Predator's suit, manufactured for towering actor Kevin Peter Hall, did not feature any major makeup or FX innovations. "We have used all of the technology with a man in a suit now," says Winston, who multiplied the number of alien hunters for *Predator 2* three years later. "We've of course come up with ways of building suits that hold up better, that are flexible; we know how to keep people cool now—we use cool suits, which are these [temperature-regulated] racecar-driver suits. If you look at the Predator, and just look at it technically, there's really basically no difference between the Predator and Rick Baker's *Harry and the Hendersons*: a man in a suit with an articulated mask. And the articulation is based on servos and radio control, and the suit is rubber with mesh netting intrinsic to it; everything else is cosmetic, it all has to do with design. We did wonderful little mechanical effects with the Predator, like the scoping gun on his shoulder, the extruding knives for his wrists; those are all fun elements."

Steve Wang's airbrushed paint scheme—based on insect and reptilian life—added to the Predator's otherworldly complexion. Also impressive is the fact that Winston and his team delivered the complete space hunter costume—from design to construction—in just five weeks! "I'm surrounded by wonderful artists, painters, and sculptors," he notes. "Everybody becomes creative, they're involved in the design element, the sculpture, the painting, the technical, the servos, everything. It's so important to realize that the work of Stan Winston is collaboration."

Johnny Depp's makeup in *Edward Scissorhands* was a prime example of director Tim Burton's trademark character design: white face, dark eyes, and wild hair. The scissor hands were basically gloves with seven blades for each hand.
(COURTESY STAN WINSTON)

Winston trusted his crew's abilities so implicitly that he felt confident enough to let them do their own thing when he assumed directorial duties on *Pumpkinhead* in 1987. Directing FX on *The Terminator* and second unit on the action-packed *Aliens* adequately prepared him for the director's chair. "It was *time*," Winston says of helming his first movie, the tale of a vengeance-seeking backwoods demon. "And *Pumpkinhead* was perfect for me because it was a small film, it was the right type of project to get my feet wet in. The principal character was something that was going to keep my studio [Tom Woodruff, John Rosengrant, Alec Gillis, Shane Mahan, and Richard Landon] busy, so that I could direct the film, which is what I am about as far as directing. I *won't* direct something that I cannot create a new fantasy character in. It was the natural progression. These people wanted me to design the character for the movie, so it was a natural opportunity for me to say, 'Well, I'll be happy to do *Pumpkinhead*—*if* I direct the movie.' "

Winston adds that his career departure went smoothly. "I placed a little bit more responsibility into the hands of those people who I've *always* given responsibility to—artists, designers, etc. It was very easy, because again it was a very easy transition. I wasn't asking anyone in my studio to do what they hadn't done before; I simply gave them more creative input, or rather, creative freedom to design their own character. In this case, my hand never hit the paper. I didn't do any of the drawings for *Pumpkinhead*, and it's probably best that I didn't, 'cause

they did a wonderful job and my input was that of a director." A few years later, Winston directed another film, *The Adventures of a Gnome Named Gnorm*, which teamed cop Anthony Michael Hall with a three-foot-tall mythical creature.

The work of Winston and his studio on Tim Burton's *Edward Scissorhands* in 1990 garnered the shop yet another Oscar nomination. Although only responsible for the creation of the title character (lead Johnny Depp's scar appliances, bizarre leather costume, and long fingerblades) as opposed to the monster-packed efforts of the past, Winston bristles when asked if the offbeat fantasy film was an easy gig.

"It was just different," he says. "It wasn't a picnic, it was an interesting challenge, because I had to dispense with reality, which is very difficult for me. My designs, and what we do in the studio, have a tendency to really go for what is real. Tim Burton is totally free, not really as concerned with reality as he is with the overall fantasy image. The most difficult thing for me with *Edward Scissorhands* was totally letting go of reality, because nothing about it makes any sense. From a makeup design, he is very theatrical, he's not real-looking, but it works. There's nothing that makes any sense with those hands, but they work. We designed him from head to toe. The challenge was to take the director's cartoonish vision and totally vibrant imagination and bring that to three dimensions, make it work on an actor and have it be Tim Burton, as the Terminator is Jim Cameron. It may not have been as difficult technically, but artistically it was very challenging. We *make* it challenging."

None of his previous cinematic experiences could prepare Winston for the gargantuan enterprise known as *Terminator 2: Judgment Day*. The Cameron-directed sequel—one of the costliest, biggest, and most complicated science fiction adventures ever attempted—welcomed in a new era in special FX technology, uniting the brand-new medium of computer-generated imagery by Industrial Light & Magic, large-scale model and miniature work, visual pyrotechnics, and Stan Winston Studio's Terminator makeups and animatronic puppetry.

"I didn't foresee anything being an *enormous* problem," Winston says of his shop's unprecedented *T2* workload. "What ended up being the biggest challenge of *Terminator 2* was the body of work. It was enormous. There were some pretty amazing effects that we did on *Terminator 2*, and when you look at the cumulative effect of it, how *many* things we had to do, it was an *enormous* undertaking. We had like three hundred gags to do in that show, so, just by volume, it made every effect more difficult because you couldn't just spend all of your energy on

figuring out how *this* effect was going to happen; you had to spread all that energy out over the period of making this film. It was mind-boggling. And we *did* it."

To help depict the film's epic battle between good and evil cyborgs warring over the future of mankind, the components of Winston's *T2* FX plate were broken down as follows: creating prosthetic appliance makeups for returning star Arnold Schwarzenegger (reprogrammed to play nice), showing his gradual deterioration and cyborg understructure; building animatronic Arnold duplicates to take the more dangerous brunt of point-blank gunfire and other abuse; fabricating a plethora of physical FX and puppets for the "liquid metal man" T-1000; and building new full-sized endoskeletons to allow the robots even greater articulation and mobility than before.

The closest Winston and company came to reusing anything from the earlier *Terminator* was when the team constructed four updated endoskeletons: two radio-, rod-, and cable-controlled hero versions capable of much body movement and facial and head articulation, as well as two posable nonarticulated background variants. The endoskeletons were cast from the original's mold, though the construction differed with the substitution of lighter-weight materials (urethane resins reinforced with fiberglass cloth as opposed to the first's nearly hundred-pound epoxy and steel fabrication). Certain parts were machined out of aluminum instead of steel, which cut the endoskeleton's weight in half, and its hands were modified as well. Though the updated puppets were easier to operate, they were also more fragile than their forebears.

"You saw a Terminator endoskeleton like you never saw it, you saw him standing there like you never saw him in [the first] *Terminator*," Winston says proudly. "In *Terminator 2*, he was much more alive, he was a complete, standing full-animatronic robot, and that first shot is like something nobody's ever seen, when that foot comes down on that skull in the future war and you pan up and here's this big endoskeleton looking around at the terrain. It's all real life—this is no stop-motion, it's a full-standing, living robot. That's pretty awesome. On *T2*, we had that type of [thing] every step of the way!"

The T-800's facial deterioration throughout the film, revealing the cyborg underneath, was accomplished through three stages of prosthetic appliances on actor Schwarzenegger, the last featuring exposed metal skull, robotic eye, open chest piece, and robotic arm stump. To take direct SWAT bullet hits to the face, several head-to-hips Arnold puppets were built and intercut with footage of the action star. One radio-controlled puppet with an elastic steel spine was even

mounted onto a complicated walking rig and connected to a puppeteer's shoulders with a Steadicam camera harness and an aluminum boom arm. When coordinator Shane Mahan walked in the rig, he initiated the puppet movement. Mahan controlled the puppet arms with the aid of two rods attached to the elbows. Three other crew people offered synchronized cable-articulated assistance from the sidelines, supplying hip, shoulder, neck, and head motions.

These T-800s and endoskeletons were a piece of cake compared to the technologies necessary for pulling off the T-1000 (Robert Patrick). The seemingly indestructible creation came together in a marriage between Winston's puppets/prosthetics and ILM's revolutionary computer-generated morphing programs.

"Of course, making the real-time, real-life aspects of the T-1000 was going to be a major challenge," Winston recalls. "We had to create the illusion of liquid metal in real time, not given the computer-generated aspect of it. There was a part of it that was computer-generated, but a great deal of what you saw, that illusion of liquid metal was *real*-time puppets. That was the challenge, because we had no concept of how we were going to do it. Another major challenge was the exploding T-1000, where he shatters like glass."

The Winston shop's scores of T-1000 gags ranged from metallic-surface, trigger-activated latex splash wounds to various fiberglass or aluminum sword and crowbar arms to "cleaved" and "splashed-open" puppet heads and a full-figure "Pretzel Man." The T-1000's "Splash Head," the result of an Arnold shotgun blast to the face, was accomplished through the use of two articulated foam rubber and urethane puppets. Built with a fiberglass core and segmented on both sides at the jaw line, the hinged head sprang open on cue for the back view. For the front, another, more elaborate puppet was hinged under the ears to split in half. A double wore a Splash Head appliance (attached above and in front of the stand-in's real head) for one shot, while computer-generated images closed all the "wounds" seconds later. A mechanical head-and-shoulders "Donut Head" puppet was also built for similar carnage. Three full-size puppets filled in for T-1000's final "Pretzel Man" appearance, beginning with a foam rubber replica of actor Patrick, sculpted as if a grenade just went off in his abdomen. A system of springs and pneumatic rams sprang the puppet open into a splayed position. The second version featured more mechanization (gimbal mounts, puppeteering rods, and radio control) to allow for wilder movement and articulation, while a simplified, weighted foam version performed the T-1000's swan dive into the molten steel vat.

Taking home *two* Oscars for his *T2* tenure (in both makeup and visual FX cat-

egories), Winston notes that he could not have achieved the film's wizardry without the "wonderful artists and technicians" on his fifty-plus person crew (coordinated by John Rosengrant, Shannon Shea, Shane Mahan, and Richard Landon). What also made the unprecedented six-month shoot a smoother operation was his intuitive collaboration and friendship with Cameron.

"Jim's wonderful," Winston says. "He and I are very close friends, so I have to say all the nicest things [*laughs*]. Jim is an intense director, he's extremely creative, he's got a very strong 'vision.' Sometimes it's a little rougher working with someone who wants exactly what he wants. There are two sides of the spectrum when it comes to directing: There are some directors who know exactly what they want, and that's what your job is to give them. The other side is the director who's got a feeling for what he wants but he wants you to give him options, then to let him make the choices. And it ends up being his choice, it ends up being his direction, but is not as intense on that vision. Jim is one of those people who has a real strong feeling of exactly what he wants, so therefore it makes it a little more difficult, but fortunately I have found over the years that we think a lot alike. So it's easier for me, because I understand what he's looking for, than it may be for someone else."

For *Batman Returns*, Winston again collaborated with eccentric auteur Burton to produce another stunning character makeup, the despicable Penguin (Danny DeVito). The makeup artist and his design support team sought to give the deranged villain a cartoon quality consistent with Burton's warped sensibility. He wanted the Penguin's most pronounced feature, his nose, to have a bird's beak physiognomy, reflecting the unreal nature of the project. Winston himself sculpted the one-piece prosthetic appliance (fine-tuned by Mahan), which stretched from DeVito's forehead down to his upper lip. This makeup concept echoed Winston's crow creations from *The Wiz*. The Penguin's rigid appliance appeared as if it was a natural extension of DeVito's face.

To apply the makeup on DeVito throughout the film, Winston brought in his *Edward Scissorhands* associate Ve Neill. The Penguin's makeup, as a matter of fact, harked back to that previous Burton fantasy figure, with its pale complexion and dark circles under the eyes. For the Penguin, the right tone was achieved with Tuttle rubber mask greasepaint, which was put down over a previous Pax-paint layering matching DeVito's natural skin tone. Greasy hair extensions, rotted dentures, deformed three-finger hand appliances (sculpted by Greg Cannom) and costumers Bob Ringwood and Mary Vogt's fat suit completed the transformation,

but it took the "brilliant" DeVito, according to Winston, to make the character come alive on screen.

"The Penguin's a wonderful character, but that's Danny DeVito," he praises. "What takes any makeup over the top is the performance by the actor. No makeup exists without the performance. Makeup is icing, it's an added layer, it's a little something that helps an actor be what he has to be. A really fine actor can do it without makeup. It's just a color, a set dressing. I'm very proud of the design on Danny as the Penguin, I think it's wonderful; the costumer's design was brilliant and he was a wonderful character. What took it over the top, however, was Danny DeVito, no question."

Besides the lead villain, Winston's company was also tapped to create the fowl fiend's feathered army—thirty animatronic penguins, which performed functions that the film's real birds could not, like firing rockets off their backs and marching in formation. Hitting nature books for detailed reference, the FX team fabricated ten each of the following penguin species, according to scale: eighteen-inch black-foots, thirty-two-inch kings, and forty-inch emperor penguins. The vacuformed bodies and fiberglass underskulls were overlaid with synthetic fur. Each of the animatronic birds required 194 mechanical components and ten exterior cables to make them waddle and do their thing. One joystick controller handled the penguin's head movements, while another performed the neck turns. Separate radio-control functions worked the eyes, beaks, and wings. Puppeteers with special backpack rigs "walked" the birds from below the stage. To further fill out the beaked armada, six articulated suits were built for dwarf performers, who played the elder penguins with the aid of radio-control capabilities.

"The big challenge with the penguins was the opposite of Danny as the Penguin, which was again dispensing with reality as a concept of Tim Burton's," Winston explains. "With the animatronic penguins, we couldn't dispense with any reality, we were totally strapped to reality. The challenge was to make 'real' penguins that could perform, that could stand side by side with real penguins and, from an audience's standpoint, be indistinguishable. I'm very proud of the accomplishment because with the exception of maybe one shot at the end where little people in suits walk with Danny DeVito down to his death, most everything that you saw, where they were real penguins and animatronic penguins, *no* one could pick them out. The *penguins* didn't even pick them out. The puppeteers did a terrific job, and they worked. Cosmetically, we did a lot of research, there was great research and development for us as far as building real, acting characters that are based on life."

The rest of Winston's brachiosaurus from *Jurassic Park* was completed through the art of computer-generated imagery.
(MURRAY CLOSE/COPYRIGHT UNIVERSAL CITY STUDIOS)

From birds to mammals, Winston and his boys returned to the zoo for the 1995 summer hit *Congo*, which called for the creation of a tribe of killer gray apes, fierce but friendly mountain gorillas, and one of the film's lead actors, the baby gorilla Amy. For this Michael Crichton adaptation, Winston expanded upon the groundwork laid by Rick Baker and fabricated a variety of ape costumes that were filled by trained performers. And for the 1996 remake of *The Island of Dr. Moreau*, Winston Studio went prosthetics crazy in outfitting a tribe of human/animal crossbreeds.

When asked what his favorite assignment has been at this stage in his illustrious career, it's no surprise that Winston answers *Jurassic Park*, a dream project for any FX artist—creating the lifelike dinosaurs from Michael Crichton's best-selling book. Winston has hyped his *Jurassic Park* accomplishments more than any other. The subsequent accolades that greeted the box-office sensation, including a fourth Academy Award for Winston's incredible FX, are more than warranted.

"In *Jurassic Park*, for the first time in history, you saw real, full-sized, dangerous dinosaurs on screen," he says. "In the book, John Hammond wanted to create an amusement park and re-create dinosaurs for everyone's pleasure. What we have done is what Hammond wanted to do. We created a world of dinosaurs so that everyone could enjoy them."

Winston first made contact with Steven Spielberg in December 1990 to express his strong interest in creating *Jurassic Park*'s dinosaur FX, and it would be two years spent in intensive preproduction before the $56-million endeavor even went before the cameras. Once hired, Winston immediately assigned his ace concept artist, Mark "Crash" McCreery, the choice job of designing the assorted prehistoric animals to be seen in the film.

After dinosaur computer tests at ILM showed that the cutting-edge visual FX company now had the technology to create flesh-and-blood animals on their keyboards, the production abandoned the antiquated stop-motion route to focus on melding Winston's giant-size animatronic dinosaurs with ILM's byte-sized ones. To keep the dinosaurs' look consistent, Winston's shop visualized all seven species featured in the film and built one-fifth-scale models of each as reference tools for both themselves and the computer programmers.

Back at the shop, Winston and company literally raised the roof to accommodate the twenty-foot-tall, forty-foot-long, four-and-a-half-ton T. rex.
(COPYRIGHT UNIVERSAL CITY STUDIOS)

"All the dinosaurs in *Jurassic Park* were designed at Stan Winston Studio," the FX boss says. "Not all of them were developed here. There was a combination of live action and computer animation. The seven that we did were: the *Tyrannosaurus rex*, one of our key characters in the film; the velociraptors, which are the nastiest and the meanest of the dinosaurs, as well as a hatchling velociraptor; a triceratops and a baby triceratops, which was not kept in the script; a brachiosaurus; a spitter, which many paleontologists would say is a fictional dinosaur, though ours was based on a dilophosaurus. We also designed a gal-

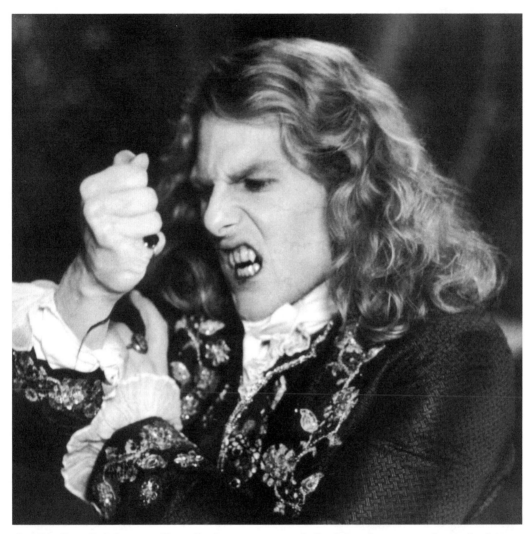

**As the fiendish Lestat, Tom Cruise wore a subtle, translucent makeup in *Interview With the Vampire*.
(Copyright Geffen Pictures)**

limimus and parasaurolophus. The gallimimus and the parasaurolophus only come to you by virtue of computer animation. The triceratops and the dilophosaurus only come to you by virtue of live action. The T. rex, brachiosaurus and velociraptors shared technologies. All of our dinosaurs were state-of-the-art involving new robotic technology."

Winston and his gang stuck with the established dinosaur record in crafting his gigantic beasts, right down to putting pivot points for all the bones in the right

joints, based on fossil evidence. He met with renowned paleontologists like Jack Horner and Don Lessum, and incorporated into his designs the current theory that the behemoths evolved into birds.

"It was very important for all of us from the very start to have a great deal of respect for the reality, for all the research that had been done by paleontologists," Winston says. "When we started to design the dinosaurs, it was very important for us to be as paleontologically correct and dramatically accurate as has ever been seen before. We spent a great deal of time and energy digesting all the existing research and also studying real animals, and combined that with our own artistic instincts, so that we didn't fall out of the scope of what a paleontologist would consider real."

With the designs sewn up, Winston and his staff of over seventy (supervised by art and mechanical department coordinators John Rosengrant, Shane Mahan, Richard Landon, and Craig Caton-Largent) next set out to bring their pen-and-ink drawings and full-color renderings into three dimensions. As usual, maquettes were sculpted from McCreery's artwork, then rigid foam maquettes were created and then cut into sections and projected to five times their size to serve as a guide for the sculptures of the full-size models. The life-size versions were sculpted in Roma clay over sectioned plywood armatures.

The first dinosaur at bat was the sick triceratops, which Winston had to ship to the film's location in Kauai, Hawaii. As with all their creations, Winston's triceratops was mechanized, with cable and radio controls. The infirm animal was able to move its legs and face. The FX artists also fitted the dinosaur with a hinged, expanding rib cage to facilitate its belabored breathing. Each large-scale dinosaur's fiberglass frame was covered in foam latex skins, a preferred covering due to ease in patching, painting, and joining seams. The animals were painted with airbrush sprayers.

For another plant-eating dinosaur, the earth-shaking brachiosaurus, the Winston shop built the mighty beast's fifty-foot full-size head and neck section, with cable- and radio-actuated rigs allowing for facial interaction. ILM filled out the rest of body with computer imaging. "Whether you can pick out a shot [as being either animatronic or computer-generated]," Winston says, "is ultimately not as important as the fact that, historically, those dinosaurs were as real as anybody had ever seen them."

The film's cute but deadly venom-spewing spitter was entirely the creation of Winston's team. One full-size mechanical predator was conceived, with colorfully painted cowl and hopping legs. Three individual interchangeable heads allowed

the spitter specific functions—one with folded frill, the second with the frill opening, and the third head with open rattling frill, swelling glands, and flying venom.

Jurassic Park's FX wizards united various techniques to make the eight-foot-tall raptors the movie's most-feared "*Jaws* on land." Sharing screen time with ILM's more ambulatory computer generated raptor shots were two totally mechanical puppets, men in raptor suits (with cable assistance for the arms), an insert puppet head worn as a backpack by an operator and stalking feet and a mechanized tail for inserts. "As far as being real characters, the raptors are on the top of my list," Winston says. "But there are certain things that can't be done live-action. Then we turned to CGI."

As convincing as the raptor and fellow dinos were, none could compare with the film's pièce de résistance, the *Tyrannosaurus rex*. Standing twenty feet tall, forty feet long from head to toe, and weighing nine thousand pounds, the T. rex took eight artists sixteen weeks to sculpt from three thousand pounds of clay, and then they had to break it down into twenty-five separate mold pieces. Winston's crew invested two years in perfecting the full-scale mechanical dinosaur king, whose closest relative sizewise from the designer's past bullpen would be the Alien Queen. To make this monster move, Winston consulted hydraulics engineers, adapting some of their technology from giant robotic theme park attractions, but taking it even further. The traditional radio-controlled technique drove the big gal's eyes, which could dilate on camera. "I was in awe of the T. rex on the set," Winston says.

Computer hookups also played an essential part in the T. rex's mobility; a waldo T. rex armature (one-fifth scale) was built that could be acted manually, its head, torso, tail, and arm movements electronically translated by computer connections to the big-scale mechanical robot and matched instantaneously. Additional puppeteers simultaneously worked the eyes, mouth, jaw, and claws. "The T. rex was hydraulically controlled and had a computer interface to give him life-like, smooth dynamic moves," Winston notes. "When anybody's ever built a big robotic effect in the past, like King Kong in the Universal tours, it's a slow-moving organic thing and it takes a week to program that movement that it does over and over again. With the T. rex, it had to do one movement this minute and another movement the next, and we had to create an interface to allow her to perform instantly with speed, dynamics and on the spot. And she worked."

To give the T. rex six-point motion ability, the robot was mounted on a custom-made flight simulator platform (dubbed the "dino-simulator"). The anima-

tronic actor was built from tail to head; fifteen-foot insert legs (the design inspired by an eagle's taloned feet) were also created, as well as a close-up head with greater facial nuances. The task of moving the hefty rex rig fell to special FX pro Michael Lantieri, who designed the support structures and a hydraulic crane to hold and transport Winston's hefty beast. When in action, flashing red lights warned the crew to watch out when the dinosaur went into action. "She took direction most of the time, but [because of the size] she was very dangerous and could have killed somebody if she got out of control; we had to be very careful with her," Winston says. "There were enormous problems to work out in order to create a kind of animal that big, that had to move fast, that had to take direction and act on the spot." ILM again came in for shots of the T. rex walking, running, and chasing prey.

Winston lays all of *Jurassic Park*'s incredible success and worldwide popularity at the feet of its wunderkind director and fellow dino nut. "If you liked the movie it was not just because the dinosaurs were neat, you liked it because Steven Spielberg directed it," Winston says. "It's his energy that allowed us to do it all. From the start, Steven Spielberg instilled in us a need to do something that had never been done before. He wanted to see as much live action [dinosaurs] as possible. We also saw a brand-new vision from computer technology, and then they came together seamlessly to create something…that's pretty amazing."

Witnessing the revolutionary magic and unlimited potential of CGI on *Jurassic Park*, Winston jumped on the bandwagon in 1993. Partnered with director James Cameron and former ILM chief Scott Ross, Winston entered the ring with a new company, Digital Domain, to offer computer FX for the entertainment industry. Their first high-profile jobs: Cameron's *True Lies*, Neil Jordan's *Interview With the Vampire* (complementing his shop's makeup, as well as supplying other visual sleight of hand), and Ron Howard's *Apollo 13*. The designer maintains that there will always be a future for special makeup FX regardless of the advances in digital imagery.

"I don't think any technology will necessarily drop out," Winston says. "As all of entertainment and films have continued to refine technically, creatively, artistically, and dramatically, makeup has always, always been there, and will always be there. We aren't doing anything new. We are refining techniques, but we aren't thinking thoughts that haven't been thought before. Great fantasy characters have been there since day one of films, and they will be there until there are no more films. The future is only limited by our imagination."

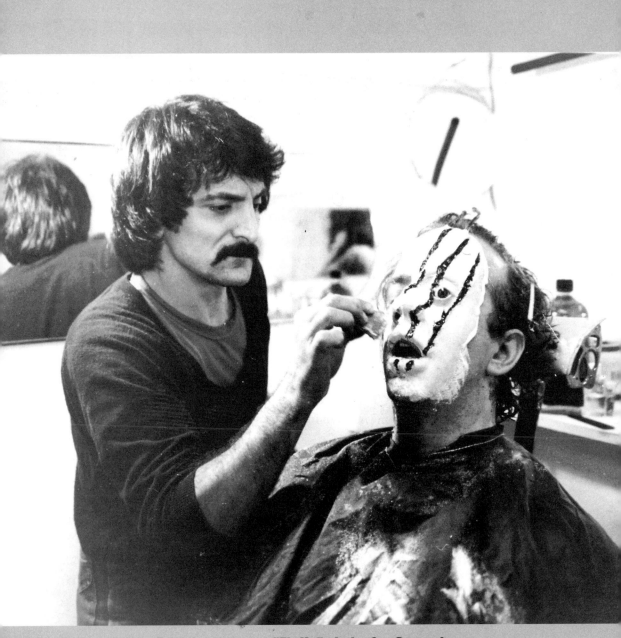

Gore guru Tom Savini prepares a "Fluffy" victim for *Creepshow.*
(ALL PHOTOS COURTESY TOM SAVINI)

Four

Tom Savini

A Matter of Splatter

A twelve-year-old Italian boy sits inside the Plaza Theater, his eyes glued to the screen. He's a middle-class Pittsburgh native who has spent most of his life in movie houses just like this one, watching countless swashbuckling adventures and B-monster flicks. But today's movie is different. Unexpectedly, it brings a revelation to the youth.

"A metamorphosis happened—a mental metamorphosis," the adult Tom Savini now recalls. "Until that time, I would go to movies, to see things like *Creature from the Black Lagoon*. Those creatures were all real to me—and that's what scared me. Then when I saw *Man of a Thousand Faces*, not only did it introduce me to Lon Chaney, it was also the first movie that showed me the making of movies—him preparing for the Phantom, him doing the makeup for the Hunchback. A smarter kid, you'd think, would have realized that before then, but I was just engrossed in the magic of movies. *Man of a Thousand Faces* showed me that people have to make this stuff. And to me, Lon Chaney became a hero—my son's name is Lon. I just wanted to be him when I grew up. From that day on, almost all my time was spent in the basement, playing around with makeup."

In person, Savini is a soft-spoken, gentle man who still resides in the same Pittsburgh home in which he grew up. This modest abode boasts its own little mad lab in the basement, where he tinkers with the tools of his craft. Most of Savini's day is spent watching some of his two thousand videos, fielding phone calls for future projects, and answering queries from the occasional fans who target him for advice. Born on November 3, 1946, the boyish Savini enjoys gymnastics and fencing (in his backyard, no less!). He settles his athletic frame onto a sofa to discuss his career, underneath a giant framed poster from *Man of a Thousand Faces*.

In addition to special makeup FX, Savini has turned his passion for movies into a lucrative career as an actor (most notably, as the character Sex Machine in *From Dusk Till Dawn*); as a stuntman; and as a director, having helmed the 1990 remake of *Night of the Living Dead*. But to horror fans, he is best known as the

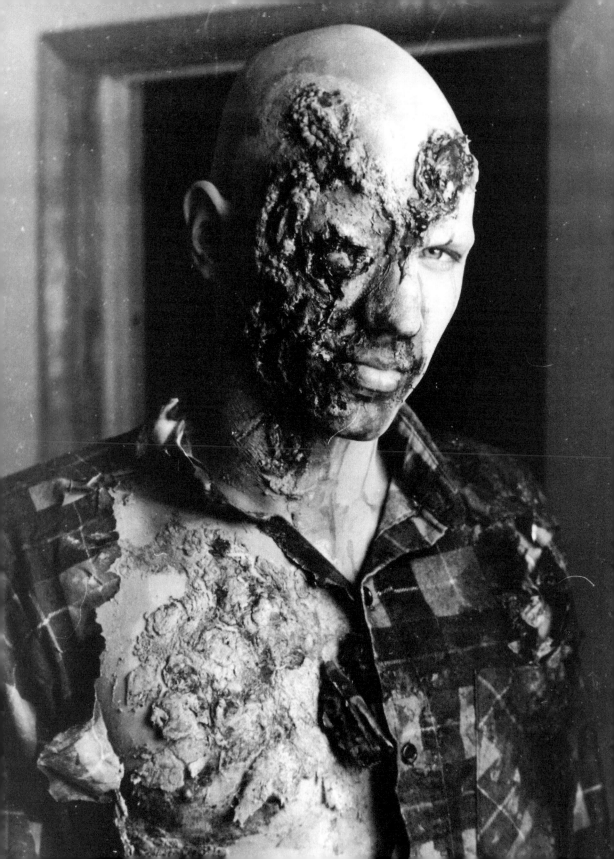

"King of Splatter," a label he earned—and now tries to shrug off—for his trendsetting gore FX in the films *Dawn of the Dead* (1979), *Friday the 13th* (1980), *Maniac* (1981), *Creepshow* (1982), *Friday the 13th—The Final Chapter* (1984), *Day of the Dead* (1985), *The Texas Chainsaw Massacre 2* (1986), *Two Evil Eyes* (1991), and many more.

Prior to Savini's work on *Dawn of the Dead*, realistic screen slaughter had rarely gone to the unrated extremes it would soon reach in the early '80s with Savini's guidance. Via his macabre tricks, heads were severed, scalped, axed, exploded, and pierced. Machetes hacked off limbs, fangs tore through chunks of human flesh, and blood bags sprayed gallons of grue. Zombies, ghouls, demons, hideously disfigured maniacs, and other assorted Savini-created monsters racked up endless body counts.

"Some people would be impressed, others would say, 'God, you're sick. You're *sick*,' " Savini says in discussing how people have reacted to his specialized occupation. "And I would have to say, 'Look, I didn't *write* this stuff. My job is to create the stuff as realistically as possible, but it's in the script that I get.' But they would attribute it to me. And I read some reviews of other movies—movies I had not worked on—where they would say, 'The Savini-like effects in this movie were...' If there was splatter and you had to associate a name with it, my name got associated with it. As far as 'splatter king,' 'king of gore'...well, that's what I *was* doing. I was doing *Friday the 13th* and *Dawn* and *Day of the Dead* and *Maniac* and *Prowler* and things like that, so I kind of deserved it. I was glad that my name was getting out there, although I guess in the back of my head I felt, 'Most people just don't realize that when they're seeing all this splatter and stuff, there's a lot of sculpture involved, a lot of face casts, a lot of very artistic things.' You're not just splashing blood on rubber. Deep down I would feel that, which made me long to make the transition to creatures—something I always wanted to do."

As a young teen trying to alter his features with makeup, Savini would raid his mother's cosmetics. Coming across Richard Corson's essential book *Stage Makeup* and the popular magazine *Famous Monsters of Filmland*, as well as paying visits to a downtown Pittsburgh costume shop, set Savini on the track to fulfilling his dreams. By age fourteen, he already owned his own makeup kit.

"I learned by experimenting, by screwing up—by winding up going to grade school with nose putty in my hair, because I didn't know any better," Savini

This *Dawn of the Dead* zombie proved so popular that the film's ad campaign revolved around it.

laughs. "I put chewing gum on my face once, because my cousin said that when they did a werewolf makeup in Hollywood, they used spirit gum. Well, I thought he said *Spearmint* Gum!"

Savini secured his first makeup job at age fourteen, dressing as Dracula for a traveling monster show. "They paid me in milkshakes and a handful of silver dollars," he recalls. A year later, he nabbed an unsalaried position on Chilly Billy's *Chiller Theater* program, where he made up the campy TV horror host for both the show and personal appearances. During his junior year in high school, Savini met the one person who would have the most impact on his career, Pittsburgh horror auteur George Romero. The director, who was four years away from making his first film, the seminal *Night of the Living Dead* (1968), was visiting neighborhood schools to cast a dramatic film. By then an aspiring actor with several school plays and musicals to his credit, Savini auditioned for Romero. Although the proposed film never got off the ground, the director remembered Savini when the time came to launch the more commercially viable *Night of the Living Dead*.

But after showing the maverick independent filmmaker his makeup portfolio, Savini was facing down real-life horrors as a combat photographer in Vietnam, having earlier enlisted in the U.S. Army. His passion traveled with him. "My drill sergeant in basic training heard me talking about collodion [a liquid plastic that dries and shrinks on the skin, forming phony scars] and wanted me to scar up his face to scare the next batch of recruits coming in," Savini recalls. "I had my makeup kit with me when I was in the army, stuff like spirit gum, collodion, hair, teeth molds, etc. Believe it or not, I was able to buy some dental materials while in 'Nam. When I was there, I sent away for a Don Post Frankenstein mask, and I would put beards and scars on guys I was stationed with for fun."

These playful endeavors soon gave way to the tragic reality of combat and its gruesome aftermath. The images of war ingrained themselves into Savini's subconscious; they would emerge years later in his distinctive illusions of cinematic mayhem. "My job was to photograph the damage and aftermath to property and people. I remember one particular attack on our base: When it was over, they had cleared our guys out right away, but the Viet Cong were still lying around everywhere. They would move [the bodies] with speaker wire after rigor mortis set in. They wouldn't physically touch them with their hands.

"It very rarely had an effect on me, because I felt a safety behind the camera lens, if you can imagine that," he continues softly. "It was almost like looking through a viewfinder into another world, like a magic world, or a movie—some-

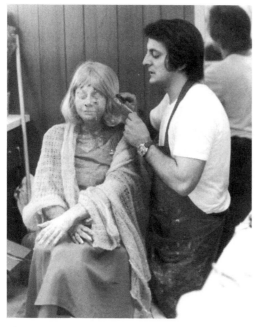

Vietnam vet Savini earned his makeup stripes on the shocker *Deranged*.

thing that wasn't real. That's what my brain was telling me. I think everybody who was there had to turn off certain emotions, you just had to click them off for your own mental health.

"Once I was walking along and changing film, and I *almost* stepped on an arm. An arm, severed from the elbow down…and it was clenched in a tight fist. I remember looking at it and it was dusty, it had some road dirt on it, and there wasn't any blood around it. I could see the viscera coming out of the elbow, and it was like an effect. If I had to make it, it would look exactly like what I just saw! I paused, and I took a picture of it—and I actually kind of studied it a bit. So I've seen the real stuff. If I have to make my [makeup] stuff look real, I've got to make it look like what I saw."

When he returned from Vietnam, Savini admits that he was "pretty messed up for about a year." Once on his feet again, he was stationed in North Carolina and hooked up with a repertory theater group. In addition to performing everything from King Arthur in *Camelot* to Ben Franklin in *1776*, Savini applied his own makeup and held the title of makeup director for three regional theaters.

During this early-'70s period, Savini earned his first makeup film credits on director Bob Clark's Vietnam allegory/horror film *Deathdream* and the true-life psycho yarn *Deranged*, which Clark produced. For the former, he assisted Alan Ormsby in creating a rotting ghoul makeup. On *Deranged*, the artist's first solo assignment, Savini built a houseful of exhumed corpses out of dowel rods, chicken wire, latex, cotton, and plastic skull kits.

Shortly thereafter, Savini returned to Pittsburgh to teach makeup at Carnegie Mellon University. An even more important opportunity awaited him when he learned that George Romero was preparing to shoot a modern vampire tale called *Martin*. "I heard he was doing a vampire movie, and I went to audition for the vampire," Savini recalls. "He said, 'No, we already cast that, but are you still good

in effects?' I had my portfolio with me and I showed him. He was walking from room to room as I was just flipping pages, and he said, 'Yeah, I think we can use you.' He hired me a couple of days later. I was in college. I ended up doing the effects, playing a part, and doing stunts."

On *Martin*, Savini devised his first splatter effect for a scene in which the razor-wielding title sociopath slices open the arm of a female victim. To accomplish the bloody trick, which made use of the actress's real arm, Savini filed down the sharp edge of a razor blade with a grindstone. Actor John Amplas positioned the dulled razor between thumb and forefinger. Concealed in the palm of the same hand was a rubber-bulb syringe filled with fake blood, its tapered tip hidden behind the blade, away from the camera's eye. The actor performed the simple gag by squeezing the blood from the syringe as he "slashed" down the woman's arm.

For Romero's next opus, the no-holds-barred *Living Dead* sequel *Dawn of the Dead*, the producers added new components to Savini's job description; he delivered countless gore FX gags, hundreds of zombie makeups, bullet hits, and other scenes of carnage, in addition to furnishing several dangerous stunts and portraying a motorcycle-riding thug. At the time, it was his biggest film and remains one of his fondest movie experiences.

"It was one of the most memorable, fun times doing a movie I've ever had," Savini raves. "Just think about it. You went to a shopping mall at seven o'clock just before closing time, and you went into this big room with hundreds and hundreds of people getting ready to do scenes—zombies. And they had an assembly line of people, friends of mine, paying 'em twenty-five bucks a day to make up zombies who would then walk around the mall. Then I would jump on a motorcycle and be Blades, or do a stunt, or get hit by a car, or be many different zombies who were going to have stunts involved with them. Do makeup, do effects, dive over a banister into a fountain—it was the first experience like that for me."

While a separate team dabbed on gray water-based cake makeup and blood spatters, Savini spent time improvising stunts and more elaborate FX setpieces. "A third of *Dawn of the Dead* was improvised," he says. "We'd be sitting around thinking of ways to kill a zombie. We'd go to George and say, 'How 'bout if we drive a screwdriver through some zombie's ear?' 'Yeah, OK, great!' So a couple of hours later, we'd actually do it: We'd grab some soda straws and paint them silver, saw a screwdriver in half and execute it for George. He was great; he would let us improvise effects like that."

The face that launched eight (!) sequels: Ari Lehman as the young Jason Voorhees in the original *Friday the 13th*.

Perhaps Savini's most gruesome film, *Maniac* presented scalpings in clinical detail.

Savini further details the screwdriver effect. "We had two screwdrivers of the same length," he explains. "We cut one down so that only about a third of it stuck out of the handle. Then we took the soda straw, painted it silver, and that screwdriver would now slide into the soda straw. What you would first see was a real screwdriver being grabbed out of the guy's belt and head toward the ear. Now, the close-up would be of the half-screwdriver collapsing inside the soda straw, like a retractable blade. Then the last thing we did was take the half-screwdriver and affix it to the inside of [actor] John Harrison's ear with mortician's wax. During the screwdriver-in-the-soda-straw stage, we would pump blood through a tube, down the hand of the guy holding the screwdriver, through the soda straw, so blood would actually flow out of the ear. When those things cut together, you got the impression that the screwdriver went in and blood came out."

A crowd-pleasing scene in which the top of a zombie's head is sheared off in

sections by a helicopter's spinning rotor blades required the most preparation. "I asked a friend of mine who had an exceptionally low forehead to play the part," Savini explains. "Then I built up his head maybe an inch or two taller, hoping that it would still look normal because he had a low forehead. So I built up a huge domelike forehead on him and I cast it in foam latex, and then I cut it apart in five sections and connected all the pieces with fish line, so that if I pulled on the top of his head, the first part would come off and it would grab the second part and it would unravel. I had blood tubing going up his clothing into the foam that was still *on* his head. We would be below pumping the blood into the forehead, and another guy actually ran with the fish line in his hand and unraveled the top of his head. The helicopter blades were animated in later; the helicopter was never running at the same time."

Other deceptions were accomplished more simply, cheaply, and spontaneously, like the actor who wore a false foam-latex chest filled with a slaughterhouse's animal innards for a zombie munch-out. Rarely did the film's restrictive budget interfere with the artist's macabre vision. "I would definitely say, based on my experience in twenty-four films, that limitations always make you more creative," Savini says. "If it's a budgetary limitation, it forces you to think more creatively. Then, when you produce, it gives the same effect perhaps—but maybe even *better*, it's more visceral. Without putting so much money and so much effects work into it, just the suggestion of what's happening storywise makes it better. Limitations always make you more creative."

Savini lived up to that credo again on his next film, the notorious sequel-spawning sensation *Friday the 13th*. Lensed in Pennsylvania's Pocono Mountains on a sparse budget, the Sean Cunningham-directed shocker created quite a stir—and much controversy over its explicit violence—during its successful summer 1980 release by Paramount Pictures. The quintessential "body count" film, *Friday the 13th* tells the now-familiar tale of a group of camp counselors being massacred one-by-one by a mysterious killer.

Friday the 13th's brutal murders incorporated many of the techniques Savini learned from his Romero films. For the scene in which actor Harry Crosby (Bing's grandson!) is discovered dead with arrows protruding from his eye and neck, Savini adapted the old five-and-dime-store gag—a cutaway arrow attached to a half-inch tin strip that was hidden behind an appliance on the actor's face. And for the equally gruesome ax-in-the-noggin affair, Savini used a real ax splitting a false head, and then cut to a false ax attached to the actress's real head.

The film's most popular effect, however, occurs when a pre-*Footloose* Kevin Bacon is attacked while lying in his bunk. The assailant, hidden under the bed, suddenly grabs Bacon and drives an arrow through the mattress and out the front of the victim's neck. Savini explains how he pulled off the scene: "It was a very simple thing. Again, it all stems from: 'What would *I* need to see for *me* to believe that it's really happening?' I knew I had to see Kevin lying there *before* anything happens to him, to establish him and where he is and what he's wearing. The necklace was my idea and so was the shirt, because I knew I would have to transfer those to a fake body and it would make the fake body look more real if it had the same necklace and shirt. So we cast him from the neck down, about to his chest level, and in his plaster cast we brushed foam latex. Then we backed it up with some plaster. We eventually cut a hole out of the plaster where the arrow was to appear; we glued an ice bag to the back of that plaster, and I fastened an arrow in the ice bag. So it was all sealed, the arrow was actually inside the ice bag. Then we also sealed a tube going into the ice bag, where we could pump blood into it.

"We put a hole in the bed, we put this fake body on the bed, we attached Kevin Bacon to it, right under his jawline—'cause, don't forget, we cast him from the jaw down, so we had his neck and shoulders. So we could glue the top of the fake neck underneath his jaw and make it look like that was his real neck. He was actually sitting under the bed, sitting straight up, with his head attached to a fake body that looked like it was lying down on the bed. Now, on a cue from Sean Cunningham, we simply pushed the arrow up through the foam latex from the top, while my assistant pumped the blood. And that was that. Very crude, very primitive."

Two days after *Friday the 13th* wrapped, Savini traveled to New York to begin work on William Lustig's unrated bloodbath *Maniac*. A typical slasher film that Savini now dismisses as "sleazy," *Maniac* details the sordid maimings of an overweight mama's boy (Joe Spinell), who scalps and kills beautiful women during nighttime prowlings. In a scene mirroring New York's infamous Son of Sam murders, Savini got into the act and played a lovers' lane victim of the serial killer—he executed both the effect *and* himself!

"Here I was, firing a double-barreled shotgun with live magnum pellet ammunition through the windshield of a car and a fake head of myself, with four or five cameras rolling!" He laughs. "That was not in the script: I had this mask I had made of myself, and while we were there I suggested to Lustig that I should play a part and should blow my head off with a shotgun. So we did: I played Disco Boy. I took that mask of myself, and I lined it with a thin layer of plaster of Paris. Then

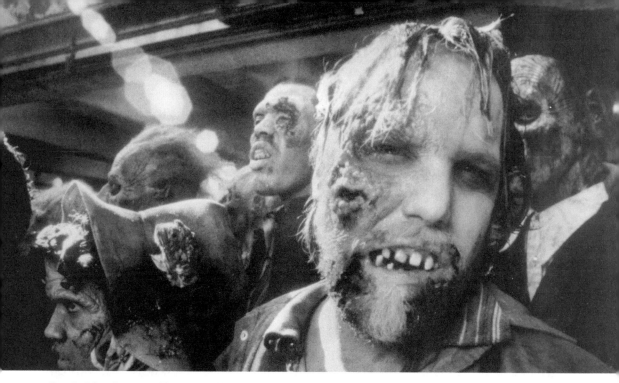

Savini had a small crew of technicians to create the large army of zombies for George Romero's *Day of the Dead*.

we filled it with eight prophylactics filled with blood, and shrimp dip, vegetables, apple cores—we just stuffed it with all this shit. Then we set it on a dummy and sat it in the front seat. I became Joe Spinell: I dressed up in his costume, jumped up on the hood of the car with the goggles on my face and fired both barrels at the same time, through the windshield at my head. It was very weird looking down the barrel of the shotgun at *me*, and then *blasting* me."

With the stalk-and-slash boom at its height in the early '80s, Savini segued from one *Friday the 13th* clone to another, taking credit for the deadly deeds perpetrated in such films as *Eyes of a Stranger*, *The Burning*, and *The Prowler*. Though he appreciated the steady paychecks, he soon grew weary of the slasher craze. "Guys were calling me and saying, 'I've got this great script, and the murder weapon is a Swiss army knife, and there are all these people trapped in this building, and the killer kills all these people with a different part of this Swiss army knife'—the screwdriver, the corkscrew, the scissors, whatever. The movies got out of hand. On a few of mine, I didn't even have to cast some of the actors; I just used the old appliances, the cut throats that I had from other films." At this point in his career, Savini realized that splatter films were rapidly growing stale and unoriginal. "The *Friday the 13th* films became just sequences of bloodletting," he

adds. "No plot, no characters, nothing. It was just, *you wanted these people to die.*"

As the nation's screens ran red, various parental and conservative groups *saw* red and decried the high levels of gore that were now commonplace in the new breed of horror film. More and more, Savini had to defend himself and his livelihood against critics who felt that the youth of America were being desensitized to violence.

"It used to be that death was pretty," he theorizes. "When the Lone Ranger would shoot somebody with this very loud .45 caliber Western revolver, the bad guy would simply go [*softly*], '*Oh!*' and fall down. There was no squib, there was no nothing, it was kind of pretty. Then, when I was defending the slasher movies, I was saying, 'In these movies, you see an explosion of blood, the way it really is. You make death hideous and ugly and a horrible thing, and you make it a turnoff to people'—which is actually *anti*-violent, it shows how horrible death and slashings and gunshots really are."

With all the heat coming down on the genre, Savini breathed a sigh of relief when Romero sought his services again for the old-fashioned horror anthology *Creepshow*. Backed by a Stephen King script and classy actors of the caliber of E.G. Marshall, Hal Holbrook, Leslie Nielsen, and newcomer Ted Danson, *Creepshow* returned Savini to his roots, creating monsters, zombies, and ghouls. A heftier budget afforded him the opportunity to utilize sophisticated technologies in bringing these creatures to life.

With the assistance of two crew members (Darryl Ferrucci and Jessie Nathans), as well as the research guidance of California makeup artist Rob Bottin, Savini first tackled *Creepshow*'s fearsome furball fiend "Fluffy." After the production approved his apelike design, basic sculptures of the creature's feet, chest and hands were made and subsequently cast in foam latex. The team next fabricated a foam latex suit and fitted it with two thousand dollars' worth of yak hair.

For the head, assistant Ferrucci wore a custom-made fiberglass helmet, to which Fluffy's fiberglass skull was connected. The creature's skull featured a spring-loaded jaw with an inner chin cup Ferrucci could use to open the mouth. The skull was also rigged with cable-controlled, hinged mechanisms above both eyes, on the sides of the upper lip, and in the middle of the lower lip, thus allowing Fluffy's eyebrows and lips to snarl realistically. A foam latex mask was stretched over the skull and attached to the mechanisms at key points. Condoms, hidden under the latex, were inflated by an air pump to make the cheeks puff in and out. "You add hair, paint it, and there you go," adds Savini.

Creepshow's highlight occurs during the "They're Creeping Up on You" segment, in which a horde of cockroaches burst out of the lifeless Marshall's head and chest. Savini orchestrated the effect in two stages. First, air bladders were placed under Marshall's robe to make his chest swell as if engorged with insects. The remainder of the scene employed a full-size dummy of the actor. A foam latex mask was placed over the fiberglass-understructure head, and a fitting was inserted inside the mouth to spew roaches on cue with the aid of a large, bug-filled Plexiglas syringe. Bloody tissue paper covered a hole in the dummy's chest, and the crew pushed roaches through in similar fashion.

According to Savini, the toughest part of toiling on *Creepshow* was handling the cockroaches. Would you believe the King of Splatter has a bug phobia? "While we were testing the E. G. Marshall thing, the trapdoor was left open in the throat, in front of the syringe that the roaches were in, and the roaches came up and touched me," he shivers. "I suddenly appeared on the other side of the room, like a jump cut. I don't remember how I got there; it was like an out-of-body experience! Bugs drive me crazy!"

Savini faced another phobia of sorts when the time came to shoot *Creepshow*'s belated sequel. Though he did not supply *Creepshow 2*'s makeup FX (Everett Burrell, Howard Berger, Mike Trcic, and Greg Nicotero took over that department), the Laurel production hired Savini to portray the film's host, an old, E.C.-inspired spook called The Creep. This time, a reluctant Savini sat in the makeup chair.

"I hate that stuff," he says of the laborious seven-hour makeup process. "My worst nightmares are of being sticky—being sticky between your fingers, under your armpits and behind your knees. And here my whole head was encased in that thing! But we did it in one day, and when it was over, I insisted on taking a shower right there in the portable trailer, and not waiting to get back and take the makeup off in the hotel. If you've never had it done to you, it's the creepiest feeling you could imagine. But it made me know how *I* have made people feel, going under the makeup."

With five guest appearances on *Late Night with David Letterman*, Paramount Home Video's *Scream Greats* documentary on his career, and countless profiles in national horror magazines like *Fangoria* boosting his celebrityhood, Savini's skills were in great demand in the mid-to-late-'80s. As an FX artist, he supplied battlefield bloodshed to *Invasion U.S.A.* and *Red Scorpion*. In addition, he delivered voluminous violent moments to brand-name slayathons *Friday the 13th—The Final Chap-*

ter ("I gave Jason life, so I wanted to be the one who killed him") and *The Texas Chainsaw Massacre 2*. On the latter two fright shows, Savini supervised considerable FX crews, relegating many of the day-to-day chores to a band of talented newcomers. "I was still making molds and I was still hands-on, but I was mainly directing the group, conducting the 'bloodbath symphony,' so to speak," he says. As an actor, Savini appeared in two little-seen terror opuses, *The Ripper* and *Heartstopper*, low-budget efforts he refuses to recommend. And as a writer, he penned *Grande Illusions*, a photo-filled guidebook to his cinematic tricks.

The living dead reared their rotting heads again in 1985, when Romero closed his zombie trilogy with *Day of the Dead*. Once again, Savini signed on for the apocalyptic gut-muncher, supervising a small army of dedicated assistants. Though it was the most ambitious of Romero's *Dead* films, a few FX failed to live up to expectations, like the prologue's fully articulated "Dr. Tongue," a jawless ghoul. "I wanted a zombie at the beginning of the film that was unlike anything you'd ever seen," Savini says. "Of course, it was shot badly; it was shot against the sun and you never saw the face. But that was my body; we cast me, and Dr. Tongue is actually me. It was actually a big hand puppet: In the movie, Everett Burrell, wearing huge knee pads, would hold him way up and walk on his knees to make it look like the puppet was walking. And, of course, there were four or five of us operating cables, which were connected to make the jaw open, the eyes move, and the brow furrow."

Other illusions came off brilliantly, such as that of the despicable Captain Rhodes (Joe Pilato) being pulled apart by ghouls; except for Pilato's head and arms, the actor was hidden under the stage. And two gruesomely impressive "gut spill" gags were accomplished with the actors partially hidden under trick tables.

Even with *Day*'s subsequent critical and box-office drubbing, the Pittsburgh stiffs still weren't out of Romero and Savini's systems. In 1990, Romero bravely decided to produce and script a remake of his original *Night of the Living Dead* and entrusted the directorial reins to longtime friend Savini, who had earlier proven his prowess behind the camera helming episodes of Laurel/Romero's *Tales from the Darkside* television show.

The slavish new version, a bloodless and uninspired redux, remains a significant sore point with its now-bitter director. Creative differences with his producers prevented Savini from putting more than "forty percent" of his vision on the screen. "Directing *Night of the Living Dead* was the absolute worst experience of my life," he sighs. "I don't think a day goes by where I don't think of that experience. I don't think of it as a failure or a mistake; every failure is an opportunity to

learn. I now know a thousand things that I will never allow to happen when I'm directing a film again. Or things I won't do. Or better ways to do them."

Fortunately, the disappointing *Night of the Living Dead* has not soured Savini from helming other projects. Though he fell short of duplicating the "intoxicating experiences" of helming his well-received *Tales from the Darkside*s with his first feature film assignment, he's actively pursuing new directorial assignments. In the meantime, Savini has returned to the FX biz with work on Italian buddy Dario Argento's decapitation-maniac-on-the-loose thriller *Trauma*, the creature-heavy *Necronomicon*, and the violent *Killing Zoe*. For a change of pace, the artist contributed a few goofy monsters and FX to public TV's *Ghostwriter* series, a favorite of Savini's young daughter Lia.

"The most amazing thing about Tom was always his persona on set," says Greg Nicotero, Savini's former assistant on *Tales from the Darkside, Day of the Dead*, and other projects. "There'd be a hush in the crew when Savini would make his grand entrance. He always had everything worked out in his head, to a T. And to this day, he's still the best manipulator of sleight of hand. People don't give Tom the credit that he deserves, the fact that he's the one who came up with all those gags that played for ten years in movies—*Dawn of the Dead*'s exploding head, *Friday the 13th*'s arrow in the neck, etc. Now every kid in America knows how to do it."

Savini enjoyed a major acting comeback in 1996, turning in supporting roles in the Quentin Tarantino-scripted/Robert Rodriguez-directed vampire extravaganza *From Dusk Till Dawn* (as the scene-stealing Sex Machine) and *The Demolitionist*, a supernatural-tinged revenge thriller helmed by FX artist Robert Kurtzman. The performer is particularly happy with his latest career digression. "This is the kind of thing where you hope you don't suddenly wake up and you've been dreaming," he says. Savini foresees his future in film as a continued mix of acting, directing, and makeup. In mulling over his past accomplishments, he feels that his best work looms ahead of him.

"Maybe it's because I'm in my living room looking at this poster of *Man of a Thousand Faces*, but I'd like to be remembered as somebody who went for that, and kind of made it a little bit," Savini says, calling up the memory of his hero, Lon Chaney, again. "I haven't yet made the film that I would want to be remembered for. If I died today, I'd certainly be remembered for twenty-five films and that would be it. What I would *like* to be remembered for has not happened yet."

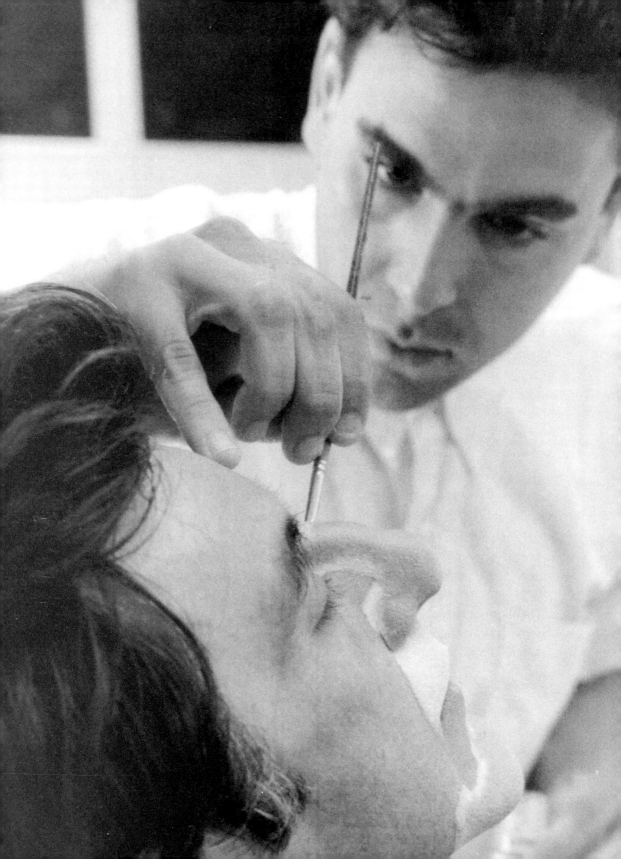

A Rogues' Gallery of Character Makeups

Dick Smith has inspired countless artists in the makeup business either directly or indirectly, and John Caglione Jr. is no exception. Having worked with Smith throughout the '80s on several FX-heavy horror and fantasy films (*Starman, Scanners, Poltergeist III*) and gangland dramas (*The Cotton Club*), Caglione speedily developed into one of Smith's most accomplished pupils.

In the art of character makeups, Caglione is today one of its finest practitioners, a fact bolstered by his Academy Award for Best Makeup on 1990's *Dick Tracy* and a notable streak of convincing old-age makeups accomplished for *Chaplin, For the Boys*, and *Shining Through*. The thirty-eight-year-old Caglione appears poised to follow directly in his mentor's footsteps as the industry's premier makeup artist, an assertion he modestly denies.

"First of all, no one will ever take over for Dick Smith. In forty-five years of doing makeup, I don't think anyone's touched him. He is the heavyweight champion of makeup," the six-foot-four-inch-tall Caglione begins softly, seated comfortably in his living room. His Oscar rests on a nearby coffee table, while Puccini plays in the background. After his wife, Helen, escorts their two young daughters out for the night, the interview continues.

"Any makeup artist who is as passionate about the work as I am would love to have a career like Dick's," Caglione avers, "where he got to do a lot of different things, had lots of time to prepare, and he did them to the best of his ability like nobody else. I just want to be able to call myself an all-purpose makeup artist—one who can sculpt, mold, and apply prosthetic makeups, as well as corrective and beauty makeup, whatever the order is—and to keep doing it for the next thirty years."

The makeup bug first bit Caglione some twenty-five years ago. Raised in Troy, New York, he grew up a monster nut, and at age nine, discovered that the faces of his favorite Universal Pictures creatures were the creation of Hollywood makeup man Jack Pierce. His youth followed the pattern of other successful FX

John Caglione begins work on *Dick Tracy*'s Al Pacino.
(ALL PHOTOS COURTESY JOHN CAGLIONE JR.)

Caglione's subtle makeup allowed Woody Allen to become *Zelig*'s human chameleon. (KERRY HAYES)

brethren—making up friends and family into the frightful fiends of his favorite horror flicks and putting on his own monster shows in the basement. When the adolescent Caglione played army with his buddies, he exploded blood bags on his chest. For grade school show-and-tells, he made up his classmates as accident victims and performed first aid in graphic fashion. His family encouraged his creative enthusiasm and joined the act, too.

"My parents were really great; they never bought us masks for Halloween, they always made us up," Caglione recalls fondly. "They spent hours making up

my brothers and sisters and me. Halloween was a special thing for us, a time for bonding and lots of laughs. It got to be just for fun."

Caglione decided to turn his hobby into an occupation after witnessing Dick Smith's phenomenal possession makeup FX in 1973's *The Exorcist*, which frightened the hell out of the teenager, like millions of other kids who snuck into the R-rated feature. Impressed with the artistry behind the film's disturbing images, Caglione sent a fan letter to Smith, who promptly wrote back, inviting the lad to his Larchmont home. As Smith disclosed the secrets of his craft (especially Max von Sydow's old-age makeup) to the wide-eyed amateur, Caglione set his future course. "It was at that moment that I really knew that I wanted to be like Dick Smith and make up famous faces for movies," he says.

A long-lasting friendship began to grow between the two through calls, letters, and tapes. As Smith openly shared his extensive knowledge with the student, Caglione absorbed the revealing information like a sponge. The development of the aspiring artist impressed Smith so much that he recommended Caglione to NBC for a newly created apprenticeship position in their New York City makeup department. This professional career boost enabled the recent high-school graduate to hone his makeup skills in all categories.

"I was there for five or six years," Caglione recalls, "and I did everything out of the building; I did the local news, soaps, *Live at Five*, etc. The great thing about working at NBC was that I became a makeup artist first. I had to work out of a makeup kit, report to the makeup department, and go to the makeup room. A lot of people today, they start out making molds or mechanical eyeballs and stuff for people, but I was lucky. I came into it as a makeup man, doing beauty makeup, doing *Saturday Night Live* sticking on coneheads; anywhere they put me at NBC, I went. I didn't go to art school, I learned on the job, and I'm ninety percent self-taught. NBC was really my formal apprenticeship, my break in the business."

During this period, Caglione also began freelancing his services to feature films, beginning with 1981's *Scanners*. For the David Cronenberg head-blower, Caglione built a burned corpse for Smith, who was the film's makeup designer. The same year, he joined Michele Burke's makeup team and traveled to Montreal for a grueling stint on the prehistoric drama *Quest for Fire*.

After NBC, the artist continued shopping his services to a number of low-budget East Coast horror films. Titles like *Basket Case*, *Friday the 13th Part 2* (working on Carl Fullerton's crew), *C.H.U.D.*, and *Amityville II: The Possession*, for which he

created *Exorcist*-style possession makeups incorporating bladder techniques, began filling out his résumé. On *Amityville 3-D*, Caglione built his first full monster suit and played the demon himself while submerged in dirty well-water at Mexico's Churubusco Studios. "I did my share of slasher films," he says without contempt, "but I'm just not known for it."

Woody Allen's *Zelig* (1983) offered Caglione the opportunity to create several peculiar character makeups. In this acclaimed mock documentary, Allen portrayed a character who exhibits chameleon abilities and can physically and psychologically transform into those around him. In Caglione's hands, Allen became an Asian, an American Indian, a fat man, and a black jazz musician. The makeups required numerous trial-and-error runs, subtlety, and patience with the eccentric Allen.

"The biggest challenge on *Zelig* was getting a life mask of Woody, who's claustrophobic," Caglione laughs. "I didn't want to cause too much anxiety for him [*laughs*]! It was tough for him; he'd never worn extensive makeup before, and you know how confining it can feel. Here he's got this big, hairy Italian guy on him—I'm over six feet tall—and I'd come in with my rubber pieces in the morning and be on top of him gluing on these prosthetics every day. It was a great experience for me, not for Woody."

For Allen's chubby persona, *Zelig*'s most complicated effect, Caglione fabricated foam-latex fat hand appliances, a forehead piece and a big "bullfrog" neck and large belly, in addition to traditional body padding. The American Indian makeup started out more detailed, with extended cheekbone appliances lending a chiseled look to the comic, but Allen demanded the makeup be scaled down to a simpler hawk-nose prosthetic, makeup shading, and other highlights to denote a ruddy complexion. The black jazz player, however, entailed the greatest number of alterations.

"The black jazzman was my first makeup test on Woody," Caglione recalls. "I did a lot of appliance work on him, and the bad thing about that was I lost Woody in the makeup. That was my first major lesson about doing character makeup: It's much tougher to split the difference, to keep the actor's look in the makeup but still make a transformation into a different character. So I started to learn about doing more subtle things with makeup. In the end, he just wore appliances for his nose and around his mouth, a whole paint job, and a wig. And we even made brown contact lenses for him. But I learned that less is more on that job, that just millimeters make a difference in appliance makeup—instead of going too far."

Following *Zelig*, Caglione reteamed with mentor Smith on Francis Ford

For the forgettable *Poltergeist III,* the makeup artist blended eight pieces of rubber onto Kane actor Nathan Davis's face.

Coppola's *The Cotton Club,* a gangster movie for which Caglione keyed the makeup that enabled actor James Remar to resemble closely real-life crime kingpin Dutch Schultz. Prior to this, Caglione hired gifted New York illustrator Doug Drexler and made him a partner in the company. Under the Caglione & Drexler banner, the duo would go on to supply makeup FX to a host of mainstream movies, including: *Year of the Dragon* (lots of squibbing FX and hoodlum violence); *Heartburn* (a pregnant stomach appliance for Meryl Streep); *Manhunter* (a cleft palate and "dental flipper" that purposely slurred villain Tom Noonan's speech); and the megahit *Fatal Attraction* (a "slashed" gelatin palm and wrist appliance for Glenn Close's suicide attempt).

The duo also engineered the hauntings in *Poltergeist III,* which needed assorted specters and fright FX to fill out its running time. Under the consultancy of Dick Smith, Caglione and Drexler faced a double challenge in conceiving the evil Reverend Kane. To match this carryover character from the previous installment, the artists had to re-create Kane's gaunt countenance and the features of Julian Beck, who had portrayed the character earlier but had subsequently passed away and been replaced by Nathan Davis. For his makeup turn, Davis wore eight delicate, carefully blended foam-latex pieces, contact lenses, dentures, paint, and a wig.

"Good casting was important," Caglione says of the Kane makeup, "so we got an actor who was close to a lookalike of Beck. Then it was just a matter of making some appliances to bring him a little closer to Kane. He never looks identical to Julian Beck, the first Kane, but we tried to get him in that ballpark, and there was a certain degree of technical difficulty in it because it was appliances that blended to flesh. It's easier to do an appliance makeup where the whole head is

foam—foam on foam—but it's really tough to do an appliance makeup where the appliance has to blend into flesh. So on that basis, it was real tricky to do every day. It turned out pretty good. Just getting that job done on time was a miracle—that's what I remember from *Poltergeist III!*"

Caglione cites the elaborate "Pee-wee" creature from the forgotten 1987 horror comedy *My Demon Lover* as one of his favorite makeups. The makeup involved fourteen rubber facial pieces, a gaggle of horns, and electrode-shaped finger appliances. The makeup took five grueling hours to apply. "He was fun," Caglione says, "because we tried to make him like a Warner Bros. cartoon monster, and we kind of loosely based him on Rob Bottin's *Legend* makeup. So we gave him those ram horns and tried to make him funny. He was a cute monster."

For *Dick Tracy,* the production avoided the makeup extremes seen in this early Pruneface sculpture.

Despite these garish, FX-heavy accoutrements, Caglione feels that the monster was more character makeup than special effect. "We tried to come up with a persona for him, what kind of a guy he was. He was a monster who tried to look cool but was always like a nerd; he never quite fit as being a monster. Pee-wee was particularly a lot of fun, but complicated to do, too."

Caglione confidently carved a niche for his company on the East Coast in the mid-to-late-'80s. But although he won respect for his work, many of his films failed to attract audiences and industry attention. He yearned for that one big project to show off his abilities—a career-defining assignment like Smith achieved with *The Exorcist* and Rick Baker accomplished with his ape films. Finally, Caglione received that big career lift when the script for *Dick Tracy* came across the transom.

With Warren Beatty slated to star and direct, *Dick Tracy* called for an endless parade of cartoonish character makeups to transfer creator Chester Gould's

comic-strip gangsters to colorful celluloid. "My whole career pretty much led up to *Dick Tracy*," Caglione notes.

Through an entrée with costume designer Milena Canonero and production designer Richard Sylbert (both *Cotton Club* co-workers), Caglione and Drexler informally interviewed with Beatty at his Beverly Hills home to discuss the project. Much to their surprise, Beatty welcomed their feedback on the screenplay, then asked the two to return the next day with an FX budget proposal.

"It was really quick," Caglione recalls of the casual confab. "We met with Warren, and that night he said, 'I want you to go home and break the script down, come up with a budget and come back [tomorrow] and give me your proposal.' So that's what we had to do. I had to hustle for it, but it was definitely worth it. I was ready for that kind of job; it was a great appliance job, and I knew that for any makeup artist who got *Dick Tracy*, it was a nice feather in their cap because it was a real makeup showcase. And I got very lucky. I always felt that *Dick Tracy* could be my *Wizard of Oz* in a way. There was a lot riding on this job, and a lot of people behind me."

Though every major FX artist in Tinseltown was actively campaigning to nab the *Dick Tracy* assignment, Caglione and Drexler won out over such heavyweights as Oscar-winner Rob (*Total Recall*) Bottin. Without a moment to spare, they set about moving their Brooklyn makeup studio to a new 750-square-foot location in Van Nuys, California, in September 1988. In less than four months, they had to relocate, build and staff a new shop, design a multitude of prosthetics, and begin applying the makeups on set. A tall order, indeed, but one filled in record time nonetheless.

Design-wise, Caglione and his crew were granted "total freedom" by Beatty, and mostly relied on the general guidance of Sylbert and his art department to keep their creations in line with the film's unique production scheme. To prepare their designs, Caglione simply turned to the original, very abstract Gould comics, which he incorporated as his "bible" while sketching the likes of Pruneface and Mumbles. The late Gould's family overwhelmingly approved of C&D's renditions.

In designing the broad makeups, Caglione and Drexler first sketched three-dimensional, well-rounded character faces that served to flesh out and embellish Gould's old line drawings. After presenting a series of follow-up clay maquettes, the artists received the go-ahead from the production and enlisted sculptors to create life-size character models. The makeup men later sat in on casting sessions for the movie's supporting players, pointing out the actors whose features would

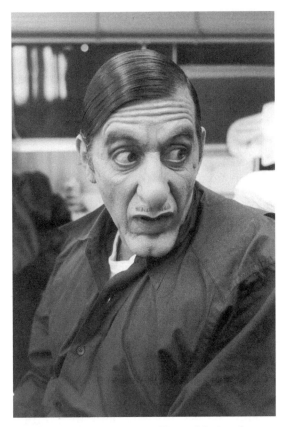

Method actor Pacino slipped into character while sitting in the makeup chair.

help enhance the makeups. Following nonstop life-casting sessions, the fabrication of each actor's individual character prosthetics began. In addition, nonspecific latex noses, ears, and chins were created as facial supplements in case Beatty decided on a whim to change a player's physiognomy during a scene.

"At first, in our early discussions with Warren, he wanted me to do everyone as a character," Caglione reveals. "Even he wanted to have a whole rubber face on! I talked him out of that concept. He wanted more of a broad cartoony look for each character, and I was the one who told Warren that we should split the difference between fantasy and reality. In our design, we attempted to hug the line between both, sort of a half a turn of the screw into fantasy, but not a cartoon head. That was my target for *Dick Tracy*, to just give it a half a kick into fantasy—so that Flattop wasn't a big cartoon head standing next to Dick Tracy/Warren Beatty, who wasn't wearing any prosthetics. We tried to design the characters so that they could almost fit in a real situation, standing next to Madonna or Warren Beatty. That was the design ethic on *Dick Tracy*."

Caglione had to come up with a system in order to juggle a team of assistants and have their makeups remain consistent. "Everything went through me," he says. "Doug and I used the great Disney animators as an example, where they had many people drawing for them, but [the final result] looks like one guy's hand drew everything. That was important to us on *Dick Tracy*, that it appears that the looks of all these characters came through one hand. Everybody had ideas and concepts and designs, but early on before anyone was even hired, I did a lot of

sketches of the characters as guidelines. For instance, if [assistant] Greg Smith was sculpting a character, on his sculpture board he had drawings and small concept sculptures that he could follow that were already pretty much in the ballpark of the character, This made it easier for everyone to see my vision, and expedited things—instead of everyone just running around, slinging clay. It went so well, it really did."

Many of *Dick Tracy*'s bad guys were completely covered in latex, such as the foul Steve the Tramp and the maniacal Flattop. Others, such as Itchy, wore only a few prosthetic pieces that were gingerly blended onto the actor's skin. As with any massive character makeup, the subterfuge was to cover the performers' faces in such a way that the audience would accept the heavy appliances as natural and not be distracted by them.

The technicians created brand-new appliances each morning for their subjects, because the thin pieces could only be worn once. Hundreds of the foam-rubber prosthetics were mass-produced from the plaster molds built from the

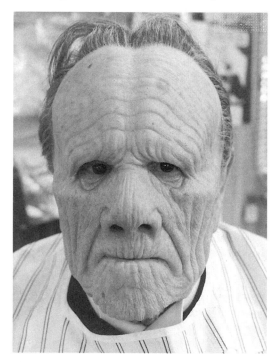

The makeup man's inspiration for Pruneface (R. G. Armstrong) came straight from the old *Dick Tracy* comics.

initial sculptures. Upon request, the crew manufactured the exact duplicates by pouring liquid polyurethane foam inside the molds.

Once they adhered the makeup to the actors' faces, the concerned artists took it upon themselves to police the cast in order to preserve the delicate appliances during the long shooting days. Dubbed the MPs—the makeup patrol—these well-meaning crew members tailed the costumed actors between takes, insuring that no one fell asleep on top of their malleable head pieces or binged at the craft services table. (Chicken grease and certain other food types and liquids can dissolve a piece of latex faster than many solvents.) High temperatures could also melt the phony faces, so

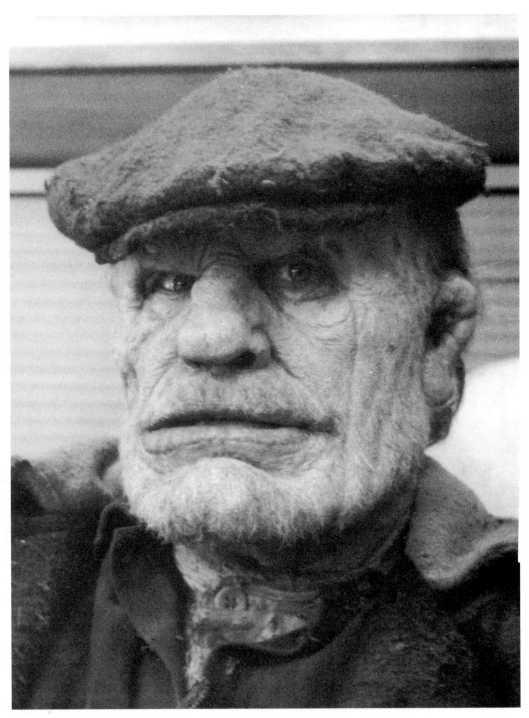

Steve the Tramp fit *Dick Tracy*'s Depression-era millieu to a T.

the thespians were kept out of prolonged sunlight when the thermometer rose past 90 degrees.

Reviewing his rogues' gallery, Caglione proudly cataloged his many outstanding *Dick Tracy* makeups (some eighteen custom characters in all) from his scrapbook. Each of the vile villains presented a degree of technical difficulty of their own. Much of the project's appeal, adds Caglione, came from the all-star lineup who sat calmly in his makeup chair for hours on end. He enjoys discussing the details of his *Dick Tracy* character makeups and begins with the film's most sinister hood.

Flattop (William Forsythe) "He had a forehead piece, sides-of-the-face pieces, a neck appliance, a nose appliance, an upper lip and lower lip and chin, rubber ears, a rubber flat head, and an appliance for the back of his neck. He wore twelve to fourteen appliances every day, and I put that makeup on him fifty-five times for the film. That was probably the biggest makeup job to do. In the beginning, it took about three and a half hours, and Doug and I would do him in the morning. We got that down to about an hour and a half. Every time we did it, we'd work out the bugs—it got to be like knitting after a while.

"He was painted with four or five makeup colors, and I would do gold glitter on his eyelids, like high fashion makeup on his eyes, and give him eyeliner and a very painted, stylized look for his eyes."

Rodent (Neil Summers) "The Rodent was just one piece, like *Planet of the Apes* or the way they did the Penguin (Danny DeVito). We made the brow piece with the ratty nose and the upper lip, and we got a great guy, Neil Summers, to play it. He had this great face. It was an appliance that blended into a really great face."

Mumbles (Dustin Hoffman) "It was a baldcap and a wig on Dustin, and eyelid appliances, rubber lips, and a rubber chin. That makeup took about two hours to put on. It was fun, because at that time Dustin was studying to play Shylock for *The Merchant of Venice* in London, and he was learning his lines on *Dick Tracy*! That's one of the fringe benefits of being in the business, to enjoy a moment like that."

Itchy (Ed O'Ross) "He wore a nose tip, an upper lip, and a lower lip, and the rest was just makeup. He was pretty easy."

The Brow (Chuck Hicks) "That one's pretty much self-explanatory [*laughs*]! He wore the brow, and he wore these cheekbones that were built into the brow. Then he wore a lower lip and chin…wig…all that stuff."

Influence (Henry Silva) "Henry wore a forehead, cheekbones, nose and lips, chin, and rubber ears. He was really worried about people recognizing

him in the makeup. It was funny, the first morning we put him in the makeup to shoot the film, he was really getting pissed off because he was afraid that no one would recognize him. We tried to design Influence kind of like Henry Silva still, 'cause he's got that real rugged face, and he was moanin' and groanin'. He walked out of the trailer and there was a wardrobe lady coming into the makeup trailer, and she said to me, 'Isn't that Henry Silva?' Thank God somebody still recognized Henry [*laughs*]! He wore six pieces."

Shoulders (Stig Eldred) "He had a great face to start with. The only thing really about Shoulders's makeup was that, in the comic strip, he had an upper lip like Elvis. We got this guy who had an incredibly great, scarred face, so I made a brow appliance for him to make his eyebrow go up, kind of like John Belushi, and I made a nose and an upper lip to get that Elvis thing happening, and a lower lip. That was it for him."

Pruneface (R. G. Armstrong) "He was tough; his whole face was rubber. It's a lot of rubber on his face, but we broke it up very simply. He wore droopy earlobes and then he wore a forehead, and a nose and upper lip, and then a full wraparound neck appliance for the sides of his face and his neck, and then a chin and lower lip. It was five pieces."

Lips Manless (Paul Sorvino) "When you build up that much around the mouth, you have to almost do the whole face; you have to compensate for the rest of the face. So we made a forehead, sides-of-the-face pieces, a nose, an upper and lower lip and chin for him. So Sorvino's whole face was rubber, except for his ears and his neck. That was a lot."

Numbers (James Tolkan) "He was like almost nothing, and I think that the straight makeup people really took care of him more than we did. The only thing special on him was that he had a mole on his cheek, and he wore a wig or something."

Steve the Tramp (Tony Epper) "A rubber festival—a real rogue. Cauliflower, slush latex ears, and a full foam latex face. We found out on Steve the Tramp that chicken grease is the best remover for foam rubber makeup. He was the first character that we shot on *Dick Tracy*, and we started out with the scene in the shack where he's eating the chicken like an animal. He's eating this greasy chicken, and within fifteen minutes his lips were hanging off! That was pretty frightening. But I really, really enjoyed sculpting him."

Little Face (Lawrence Steven Meyers) "Big job, 'cause we really had to trick the scale on that thing. He had a large head in reality. The shot of him

that they used in the film was wrong, 'cause they shot him very close. They should have widened the shot, so it looked more real, that it was a normal size head but with the face shrunken down. He had false shoulders, the whole head was enlarged; the brim of the hat was the size of a small coffee table. It turned out OK. He's only on screen for ten seconds, if that—it took all of three and a half months to create, for about eight seconds of film!"

Big Boy (Al Pacino) "Big Boy was a nose, an upper lip, and a chin, and then a whole paint makeup on Al. It was beautiful making up Al Pacino, he's got those beautiful big eyes that I used to love making up every morning.

"He'd come in the morning as Al Pacino, very low-key and quiet, really nice, and then he'd get in the makeup chair and I'd start putting the makeup on him. And throughout the makeup, he'd close his eyes, and every time he'd come to, he'd be a little bit more like Big Boy. Toward the end, when I'd get the mole on his cheek, he'd know that I was just about done with the makeup, and he'd look up at me and he'd be in that Big Boy voice, saying, 'Who are you? I gotta get outta here!' And he would be Big Boy all day long. One of the best compliments I ever got from an actor was from Al Pacino, when he said that the makeup let him be crazy, which was nice to hear.

"He was a cross between Richard III, Groucho Marx, and Hitler, just a weird conglomeration of characters."

In all, Caglione holds high praise for the smoothly run film. The production managers conveniently staggered the actors' call times to allow the most difficult makeups (Flattop and Pruneface, for example) to be applied first. When the second wave of players traipsed in, the makeup mavens would be waiting, brushes in hand. By nine a.m., the whole gang was ready to roll.

Regarding any particular technical innovations that came about during *Dick Tracy*'s experimentation and application stages, Caglione mentions none. "It was the same old thing, like playin' the blues, but it's just coming up with different chords or something, a variation on a theme," he says. "We did some nice texturing on the appliances, and the detailing was really cool on some of the stuff, but it's still sculpture and paint. We might have come up with a cartoony, semi-real look in a film that I don't think anyone's ever done before, except for maybe Jack Dawn's beautiful character makeups on *The Wizard of Oz*."

A box-office smash, *Dick Tracy* rounded up over $100 million during its summer 1990 run. In addition, Caglione and Drexler's "variations" won them the ultimate recognition of their peers—the Academy Award for Best Makeup in 1991.

"It was wild," Caglione recalls of collecting his Oscar. "I'll never forget it. I had an instant flashback to when I was thirteen and starting out, looking in a mirror, putting putty on my face. I could almost smell the nose putty. Just to be nominated was an honor, but to win was an incredible thing."

The Disney organization kept Caglione busy following *Dick Tracy*'s wrap, with the comedies *Three Men and a Little Lady* and *True Identity*. On the former, Caglione put a gross prosthetic nose and other ugly features on the handsome Ted Danson (masquerading as a vicar), a makeup he pulled together practically on the spot. For *True Identity*, however, much research and testing went into the silly yarn's race-change makeup that transformed black British comic Lenny Henry into a white Italian Mafioso. After Caglione sculpted all the makeups and Drexler fabricated the molds for this farce, Michele Burke applied the work throughout lensing.

"In designing the makeup, I tried to make him look like an Italian hitman from the Bronx," Caglione reveals. "We did several makeup tests on Lenny, but I narrowed it down to a forehead appliance, a nose, and an upper lip appliance. Then all the rest was clever painting and a nice wig. But it was tricky because not one bit of black skin could show."

After these broad character makeup assignments, Caglione next jumped into Smith territory for a trio of films (*For the Boys, Shining Through,* and *Chaplin*) that showcased his strengths in old-age design. Any makeup artist will tell you that there's nothing easy about taking the beloved face of a popular star and aging them past their prime. The tough part is envisioning what the ravages of age can do to even the most famous mug and making these withered visages appear natural and real.

"It's the biggest order on the menu," Caglione says of old-age work. "Take Bette Midler, for example. First of all, she's a very famous face, so already you have one big strike against you, because everyone knows her face. Change one line on it, and you're dead already. It has to look real. And everybody has their own perception of how people age, and sometimes you can be wrong. It's a kind of makeup that's open to so much interpretation."

On *For the Boys*, a musical drama that charts the ongoing relationship between two bickering USO performers, Caglione aged Midler and James Caan over five decades during the course of the film's action. Caan, a "live wire" who hated to sit still for his lengthy makeup preparation, ranges from forty-one to ninety-three in

the film (he previously endured minimal makeup for a *Dick Tracy* cameo); Midler, then forty-five in real life, ages from her twenties to eighty-five as the perky Dixie. In her case, except for an uncovered nose, upper lip, and chin, Midler sported multiple latex appliances to appear as the eighty-five-year-old woman.

"She had rubber earlobes and a forehead that went up to the middle of her head," Caglione reveals of the three-hour makeup that Burke helped apply, "and then she had a full wraparound neck appliance with the sides of the face and bags sculpted into it. I put some old-age stipple on her lips to make them wrinkled. Then she wore complete top-of-the-hand appliances and a hump for her back, a wig, thin contact lenses, and teeth stains. I prepainted all those pieces in advance. Bette was terrific, really great. She wore that makeup for three weeks, every day."

For the Boys's tragic Vietnam sequence, however, tested Caglione's abilities the most. The scene takes place in bright sunlight, the bane of even the finest facial makeups. "It was tricky because she's in broad daylight, and in most cases with appliance makeups, you try to have the benefit of clever lighting and shading," the artist explains. "So we had to be really careful. She's in her sixties there, so there are little appliances on the sides of her face and her neck and old-age stipple, trying to keep it kind of subtle. Old-age makeup is the toughest thing to do, and I admire Dick so much for being able to pull it off so well for all these years."

Compared to Midler, Melanie Griffith got off easy on the World War II spy drama *Shining Through*. In the film's present-set narrative wraparound, Griffith's plucky heroine reminisces about her past derring-do. Caglione added a few small appliances to the actress's face, as well as a neck piece, then finished off the job with old-age stipple and paint. For his turn, co-star Michael Douglas underwent latex applications for the sides of his face and a lumpy "waddle" piece for under his neck.

Richard Attenborough's *Chaplin* follows the life of the legendary silent-film comedian. In the lead role, twenty-six-year-old actor Robert Downey, Jr., appears from the ages of nineteen until Chaplin's eighty-third year. Recommended by Smith to the producers, Caglione designed the actor's makeup stages at ages sixty-four, seventy-four, and eighty-three. With only six weeks to work before shooting, Caglione designed everything in advance in L.A., manufacturing about twenty-five neck and forehead appliances for the entire European shoot with no tests.

"I actually took the seventy-four-year-old makeup and added appliances to it to make it eighty-three," Caglione says of the *Chaplin* makeup that Jill Rockow

subsequently applied. "Usually you design the makeup all over again—for every age, you redesign the makeup. But since I had so little time and the film was almost finished when they called me, I had to actually make appliances that fit on top of appliances. It worked to my benefit, because when the real Chaplin got in his eighties, he gained a lot of weight—he was like Santa Claus without his beard. So the appliances-on-top-of-appliances theory worked out, because I not only aged him, but I made him look heavier, too!"

Though he says he'll go wherever the wind blows him, it's obvious that die-hard New Yorker Caglione dislikes the artificiality of the Hollywood dream machine and the discouraging competitiveness of the makeup business out there. In 1994 he happily relocated to the Big Apple, where he is currently rediscovering his roots as key makeup artist on NBC's *Saturday Night Live*. For someone who has been nominated for an Emmy (for *SNL*), won an Oscar, and doctored more celebrity faces than a Beverly Hills plastic surgeon, Caglione's response to the question of what he enjoys most about his chosen profession approaches the sublime.

"This is my twentieth year in the makeup business, and the other day I went up to church here to make up this priest friend of ours," he says. "They were doing St. Nicholas with the kids, and I did a quick Santa Claus white beard and paint makeup on this priest. He went out, and these kids—the reactions from the kids! They had two- to five-year-olds come up and visit St. Nick, and the kids were crying, wouldn't go near him, and some kids would stand next to his chair, petrified, and just stare in awe at him. And others loved him and hugged him. It dawned on me that that's the reason why, it's the reaction that you get from people about your work.

"I just want to keep doing the work," he concludes, "and I hope that I can always work out of a makeup box."

Six

Steve Johnson

The Art of Design

Steve Johnson could spend hours describing the nuts and bolts of his envelope-pushing makeup creations. For example, it's not every day that you're asked to create diaphanous aliens that glow underwater (*The Abyss*), beautiful women who morph into translucent extraterrestrials (*Species*), vampires that deteriorate from *within* (*Innocent Blood*), or a family of battery-operated human robots (from a long-running series of Duracell commercials).

But what's most impressive about Johnson's work—from his Emmy-winning makeup on the epic ABC miniseries *The Stand* to low-budget rent-payers like *Night of the Demons*—is not the creation of the FX themselves, but the design, detail, and the amount of creativity Johnson and his XFX, Inc. crew put into each project before a foot of celluloid is even shot. The easy part is showing up on set with a rubber monster mask the day the gag is due; the tough part is coming up with stuff that hasn't been seen before. He is a true collaborator with his directors and producers in every sense of the word.

"Designing is the only pure art left in this business for me, and the most rewarding part is in the conceptualization," the bushy-haired, casually dressed Johnson begins, seated in the office of his Sun Valley, California–based XFX company. "It's something that can be done as 'art for art's sake'—I can sit back with a script and begin to think of ideas and twist concepts all around and crawl way back into the space inside my head and look at things sideways, upside down, backwards, and inside out, and think, 'What hasn't been done?' One idea will spur another. It's a wonderful creative process and it's pure art, because it's just me thinking of how I want to do something, and finally coming up with it. After that, it's work."

A room away, Johnson's crew is toiling on one of XFX's latest assignments. His seven-thousand-square-foot shop is an efficiently managed, two-tiered setup. In the loft above, employee Norman Cabrera is sculpting a corpse. Downstairs, chief designer Bill Corso reviews with Johnson his sketch for an old-age makeup. Cabrera later sculpts away at a clay bust of some demonic figure, based on Johnson's initial concepts and instructions.

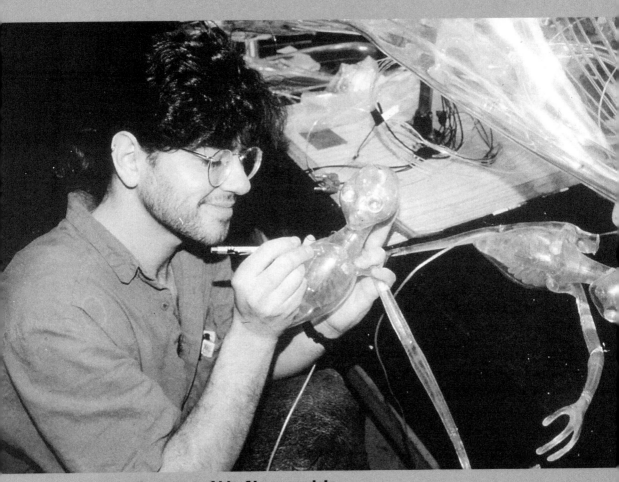

Johnson toils on one of his _Abyss_ models.
(ALL PHOTOS COURTESY STEVE JOHNSON/XFX)

"Our designs stand out," Johnson says, "because [the conceptualization] is really the only thing I do anymore. I liked to think of myself as the spearhead of quality control, coming up with the initial concepts, and then pushing other people in different directions, and also using what they come up with and brainstorming some more."

Just about every makeup person has the ability to put pencil to paper and draft an effect, but Johnson points out the difference in what makes a great designer. "Contrary to what most people may believe, I don't think that being a technical artist per se is the major criterion," he says. "You don't have to be a really good sketch artist, or a really good sculptor. You have to have a creative mind. You have to have the capability of turning intangible things into something tangible, so that you can see them mechanically and work with them in your mind and twist them over and over, almost like a computer 3-D grid readout, so that you can spot potential problems before they happen. That way, you're a step ahead of the game before you've expended any real energy.

"You just have to be able to think mechanically creatively, if that makes sense," he continues. "You have to know what looks good in your head and have a gut feeling for what will excite people. A good designer in this business is somebody who knows a lot about psychology as well; you have to know how you want to affect people with what you're trying to do—if you want them to be fascinated, horrified, or awe-inspired. Of all the different areas of this business, to me the most challenging is always creating a character that's beautiful or awe-inspiring or even humorous. Getting a reaction through gore, or even doing an old-age makeup—those things are much more mechanical to me. But when you have to create awe in someone, you really need to know how to push those buttons intellectually, through a physical piece."

With his own crew, Johnson freely delegates work in a manner that builds confidence and self-esteem in his employees, a system he learned from his former boss, Rick Baker. The Houston-born Johnson met Baker at a Texas fantasy convention in 1977. Then sixteen, Johnson impressed Baker with his portfolio of monster makeups (many of which he created for his own Super-8 movies) that he derived from a childhood fascination with creatures and learning exercises from *Dick Smith's Do-It-Yourself Monster Make-up Handbook*. "I always wanted to go further with the stuff," he says.

Baker recognized the spark within Johnson, who, despite the drawbacks of

limited materials and lack of access to the FX community, could still whip up a convincing makeup disguise. Most of all, Baker gave him the confidence to set his goal. After this turning-point encounter, Johnson abandoned his college aspirations that would have led him into—horrors!—advertising.

"Rick was incredibly encouraging," he recalls. "He gave me his number and address and I started corresponding with him, and that gave me something to shoot for: to do a makeup that would impress Rick Baker. So I really went all-out at that point. I designed them, spent all the time it took to even test them *before* I would photograph them and send 'em on to Rick. He was really good about writing back and criticizing, and he offered to help me out if I came out here. So the minute I turned eighteen, I jumped in my car and took off, and never stopped working since."

Before joining Baker's company, Johnson spent time at Greg Cannom and Rob Bottin's shops. While at Bottin's place, Johnson learned the ropes on a variety of projects, including *The Fog*, *Humanoids from the Deep* (for which he also played one of the creatures), and *The Howling*. Bottin, whom Johnson calls the "best designer in the business," instilled in the eager teenager a perfectionist's attitude about his craft. Johnson next landed on Baker's doorstep, where he continued to progress on several shows (*An American Werewolf in London*, *Greystoke*, and *Videodrome*) and gained the self-assurance to push his abilities to the limit.

"Rick has influenced my career more than anyone," Johnson says. "He really taught me to think for myself, and to learn how to solve problems myself, because that's what this business is really all about. You have to be a little bit of so many different things, but first and foremost you have to be a problem-solver, because there's no school you can go to that teaches you how to do…a deteriorating vampire, for example. You have to figure that out every time for the specific situation.

"Even as a kid, I never really learned how to do a lot of stuff for myself," he continues. "I never learned how to figure things out. If I didn't know how to do it as a kid, I just assumed I couldn't do it, and I would go to someone who could do it. But when I went to work for Rick, I found myself in a situation where it was myself and a few other young people who didn't have much experience at all, doing this major movie, *An American Werewolf in London*. I knew Rick had all these amazing ideas, and one day I asked him, 'So, Rick, we got Tom Hester,

Johnson's popular TV commercial work has been seen by more people than his movie gigs.

Shawn McEnroe, me, you…who else is gonna come work on this job?' He said, 'That's it.' I said, 'Who's gonna do all the mechanics? Who's gonna cast these things, who's gonna paint 'em—?' 'Oh, *you* guys are.'

"I said, 'What do you mean, we are? We don't know how to do this stuff!' But then this major light went on inside my head, and suddenly I realized that Rick trusted me. If he thought I could do it, I must have that in me somewhere, to be able to dig down in myself and figure out how to do this stuff, and be good enough to have Rick Baker's name on my work. It was an amazing feeling. Working for Rick gave me an incredible boost of self-confidence. It taught me to think for myself and to solve problems."

Seeking to cast his creative net further, Johnson graduated from Baker's troupe to a choice position at visual FX artist Richard Edlund's Boss Films. Edlund, wanting to expand his company's bag of tricks, hired Johnson (with Baker's recommendation) to head their new creature FX division, The Ghost Shop. At age twenty-three, Johnson's significant responsibilities included creating all the makeup FX, both physically and conceptually, on such big-budget flicks as

An alternative design for *Ghostbusters's* Slimer, the hit film's mascot.

Ghostbusters, *Big Trouble in Little China*, *Poltergeist II*, and *Fright Night*. Johnson says Edlund practically granted him a blank check in devising the makeup FX illusions featured in these creature-heavy extravaganzas. At one point, Johnson had eighty people working under him.

Besides the frightening library specter, Johnson's favorite creation from his *Ghostbusters* gig is Slimer, the frankfurter-eating green ghost that he designed, sculpted, and built. Initially called "Onionhead" in the script, Slimer boasted a complex series of internal mechanisms that gave the tubby spook a variety of slovenly expressions and characteristics.

"He's a fun character," Johnson says. "It was one of those rigs where the guy in the suit looked out through the mouth, and I would find myself talking to him but thinking of him as Slimer. I would make eye contact with the mechanical eyes, talk to them, and then start cracking up when I realized what I was doing! Mark Wilson was the guy in the suit; he did most of the actual building of it, so we had him build it to fit himself. It was originally going to be a puppet, but we went with an enormous, giant suit instead."

After playing an essential behind-the-scenes-role on one of the highest-grossing comedies of all time, Johnson says he felt slighted by *Ghostbusters*'s final credits, which downplayed his contributions with a simple "Onionhead/Librarian Sculptor" listing. Eventually, Johnson came to terms with his credit disputes (a common complaint among FX assistants), and Edlund granted his main makeup supervisor stronger attribution on follow-up projects. Still, as with his Baker tenure, Johnson yearned for greater creative control. He had progressed to the point where he began to question his mentor's artistic decisions. Though he admits to being "bull-headed" in his desire to do things his own way, Johnson felt stifled. Finally, in 1986, he decided to add his own studio to the burgeoning ranks of Hollywood makeup FX houses. "It was pretty scary, actually, when I first opened XFX, because I thought, 'What if something goes wrong? It's *my* fault, completely *my* fault if something goes wrong!' " He laughs.

Johnson's first XFX project, the predictable haunted-house romp *Night of the Demons*, called for standard possession makeups. Regardless of the low budget, the artist refused to limit his imagination to the constraints of the buck and delivered many offbeat and startling gags. In one surreal sequence, Johnson built a prosthetic breast for scream queen Linnea Quigley to push a tube of lipstick through. Johnson enjoys reminiscing about his first encounter with the lovely Linnea; the two dated, then married soon thereafter, only to divorce amicably in 1993.

For his demon makeup, Johnson studied the old techniques of silent star Lon Chaney. The general method of depicting emaciation or old age is adding to the subject's features, a building-up process that's a contradiction in a sense—instead of making the person thinner, the multiple prosthetics add an even heavier appearance. Putting silk organza lifts (a sheer, resilient sewing material) with Velcro backing under his appliances, Johnson created an effect that stretched the person's features—an instant facelift. "I glued these silk organza shapes under the enormous cheekbones, pulled 'em behind the ears, and Velcroed them to the back of the head," he notes. "This tightened up the face and stretched the mouth, and it really thinned

the face down a lot, completely counteracting the problem of adding appliances." For the devilish Trickster, a Keith Richards lookalike from 1994's *Brainscan*, Johnson again incorporated silk organza in his makeup design. The lifts widened actor T. Ryder Smith's mouth and helped enhance his performance.

During such modest late-'80s endeavors as *Howling IV* and *Night Angel*, Johnson's makeup style continued to develop. He signed his work with distinguishing trademarks: beasts and creatures that sported gaping mouths, leering snarls, flat, sloping foreheads and overstated eyebrows over deep, black eye sockets with beady orbs planted within. Most characteristic were the unique painting schemes that Johnson incorporated into his unusual creations.

"On *Night of the Demons*, I developed a style of painting that I use to this day, and it's pretty much a trademark for a lot of my stuff," he says. "As a matter of fact, I have to try *not* to use it sometimes, because it's so easy for me to fall back into it. It was almost an accident, the way I did it, it was just by virtue of the fact that I had to work so fast, and at that point I wanted everything to be mine on that film. It's almost an impressionistic style of painting, the way the *Innocent Blood* stuff ended up being, with hundreds of blotches of overlapping color, to give it a lot of translucency and break-up. I didn't want it to look like it was one color, just with highlights and shadows. I wanted to really, really break the faces up."

Johnson mixed his two favorite genres—comedy and horror—on his next project, the failed zombie spoof *Dead Heat*. The 1988 movie concerns a reanimation machine that revives deceased cop Treat Williams. On their most ambitious film up till that time, Johnson's XFX team was responsible for the movie's various walking stiffs, a wacky butcher store sequence in which pieces of meat wiggle with life (and, in the case of a huge, living side of beef, charge at the heroes) and the shocking, rapid deterioration of actress Lindsay Frost. Regarding his *Dead Heat* designs, Johnson faced the primary obstacle of coming up with a new look for zombies—the '80s' most overused fright figures—and making one of them (walking dead Williams) sympathetic.

"I had a field day designing some of the stuff on *Dead Heat*," he says. "I was young, it was like my first big show with my own shop, and I went nuts with it. I'm probably most pleased with the progression of Treat Williams's makeup on that— he dies twice. His character is always a real closed-minded, straight-and-narrow kind of guy until he dies. Then, as he approaches his second death, he gets looser and looser and begins to enjoy life more. We wanted to show this through the makeup as well as the wardrobe. So he makes a wardrobe change into a much hip-

For *The Abyss*, Steve Johnson met director James Cameron's daunting level of perfectionism with his unique aquatic alien design.

per, modern outfit. The point where I was really able to go nuts, though, was after he blows up in the ambulance wreck. I thought, 'This is the perfect chance to really do something neat. Let's blast his hair into a spiked-out punk style; let's have the soot from the explosion change his clothes to all black and ripped in a few places.' He had a handcuff bracelet because he was handcuffed to a zombie, so I said, 'Let's leave half of it on, he'll have a bracelet. And let's have shrapnel pierce his ear and hang there like earrings.' It ended up being a cool, hip statement."

For the other ghouls, Johnson wanted to avoid the standard *Night of the Living*

Dead homage in favor of more character-based makeups. Inspired by Charles Dickens of all people, Johnson gave his zombies big Fagin-type noses, beard stubble, and long straggly hair, with overlapping prosthetic pieces. To provide a soft, translucent appearance for these newfangled ambulatory stiffs, Johnson airbrushed the makeups, helping to popularize this inventive painting technique. Rather than hand-paint, Johnson "fogs" his creations with his airbrush, an indispensable tool he always carries with him in his makeup kit.

The inspiration for *Freaked's* Stuey Monster came from '60s comics.

Dead Heat's obese, multifaced monstrosity first started out as a "faceless thing" in Terry Black's script. Though XFX eventually created a basic, foam-rubber mask with an actor-activated jaw mechanism, Johnson went crazy trying to visualize the featureless giant. "I sat down trying to design something interesting that had no face, and they gave me this seven-hundred-pound guy, and I just couldn't come up with anything," he recalls. "Probably, if I had pushed it, I could have. Finally, I came up with an idea: 'How about a bunch of faces? It might not be quite the same, but it could work!' So I did up this thing with three faces, kind of mishmashed together. Funny, it started out with no face and ended up with three."

Johnson captured the greatest praise for *Dead Heat's* spontaneous disintegration scene, in which the pretty Frost literally falls to pieces. The degeneration begins when the character's hand withers, discolors, and decays. The corruption of the face follows, which Johnson accomplished via an overlapping appliance sculpted with a torn-open area. A system of chemical-pumping tubes ran under the appliance, which made the fake face bubble and discolor.

"We started it out with her face beginning to sag," Johnson explains. "I always like the idea of concentrating a deformity or whatever on one part, or one half, of the face, rather than doing it pretty evenly—I like asymmetry. We attached lifts

under her eye, above her eye, by her nose, on her lip—little tiny pieces of silk organza. I glued them on, blended them off, and then with a tiny amount of filament, for the initial deterioration effect, we just pulled the string. These almost-invisible fabric lifts were really strong when glued to her face. It just started pulling her face, and it was a really effective shot. It's the simplest thing in the world—if you were to try to do it any other way, you'd end up with an expensive dummy head that would never look right anyway."

Many were impressed by *Dead Heat*'s makeup FX, including *Aliens* and *Terminator* director James Cameron, a former special FX technician who admitted to Johnson that he could not figure out how the artist had pulled off the Frost gag. When Cameron prepared to mount his next production, the underwater alien-contact film *The Abyss*, he paged Johnson to create the film's NTIs (extraterrestrials to you and me). The artist relished the idea of tackling the expensive SF adventure, which would catapult his fledgling shop into the big leagues. At first, he did not have the foggiest notion on how to carry off the film's never-before-attempted FX. None of his previous work would prepare him for this gargantuan undertaking, and Johnson admits to frequent bouts of insomnia while fretting over *The Abyss*'s technical requirements.

"I spent many a sleepless night on that one!" he shudders. "For one, Cameron is incredibly demanding—which is what I like about him. He pushes you, further even than I would push myself, and that's a lot [*laughs*].

"There were three problems with *The Abyss*," Johnson continues. "First of all, the aliens had to work underwater; second, they had to be glass-clear; third, they had to glow in and of themselves, not optically. And change color. If you get something that can glow, then it's not clear. Or if you get something that's clear and glows, it won't work underwater. Every working piece in the thing had to be machined out of clear acrylic. We ended up doing fiber optics for the glowing, but it was a really, really tough job. Even logistically, shooting the NTI chamber sequence, we had thirteen guys operating in water—that was the only show where I ever had a guy in charge of the movement. Trey Stokes was in charge of designing the puppeteering rigs throughout the project; he was on the movie for ten months, just figuring out how we would move the damn things. We had to build an enormous steel catwalk over a sixty-thousand-gallon tank that was completely modular, so we were prepared for anything."

The look of the ethereal, aquatic aliens, sort of a cross between a grasshopper and a manta ray, came straight from the director himself. "They were very specifi-

cally designed by Cameron," Johnson reveals. "However, they were line drawings, basically. They were white line drawings on black paper. Because they were clear things, that's all Cameron felt we needed. We brought in a lot as far as the inner workings: We had layers inside layers, different internal shapes, patterns of fiber optics, different mechanisms and things inside so we could see all the way through. We were free to deal with all that stuff as we saw fit. And I always wondered, actually, how much I did bring to *The Abyss*, because it's interesting to sit back and mull over...If someone else had done the job, say Stan Winston, he would have gotten the exact same designs from Cameron, but his stuff would have looked very, very different from mine. So that goes to show you, even when something is that specifically designed, how much input you end up having."

In 1989, Johnson ventured from the awe-inspiring sea world of *The Abyss* into the terror-inducing dreamscape of *A Nightmare on Elm Street 4: The Dream Master*. While four other separate makeup FX teams (John Buechler, Screaming Mad George, Chris Biggs, and Kevin Yagher) contributed to the sequel's shock scenes, Johnson won the project's plum assignment—killing off razor-gloved maniac Freddy Krueger in the movie's wild finale. Directed by Renny (*Cliffhanger*) Harlin, the film closes with the souls of Freddy's young victims ripping out of his burned torso. The dream stalker has died in seven films to date, but none as spectacularly as when XFX vanquished him in 1988.

For the sixteen different *Nightmare 4* FX shots Johnson's shop was responsible for, the young wizards combined small mechanical puppets attached to actor Robert Englund, intercut with a twenty-foot-high groin-to-neck puppet of the character with fully articulated arms. Inside the torso's shell were four assistants/actors (including a cameoing Quigley) who thrust their real arms out and shredded the red and green sweater to reveal Freddy's horrifically scarred chest.

"My biggest fear always was, if we make this big giant Freddy, it's gonna look like a big giant Freddy, because big things always look like big things to me," Johnson says. "It's a lot easier to make a realistic miniature than it is an oversized prop, for whatever reason."

The torso was made out of enormous strips of specially ordered dental dam (the stretchy rubber that dentists use), with Freddy-textured foam latex set on top. For the life-size version in which multiple arms battle for control of Freddy's body, XFX hid the actor behind a slant board; in reality, only his head, upper shoulders and arms poked through. A false body from the chest down suffered

the various indignities as twelve FX assistants manipulated seven mechanical puppet arms with off-camera rods and cables.

Though not technically innovative, Johnson's *Highway to Hell* monster suits and makeups emerge as some of the best designed, sculpted, and realized creations of his career. The artist tried to stay as far away from Elm Street as possible in conceptualizing *Highway*'s lead villain, the demonic patrolman Hellcop (C. J. Graham), in order to avoid comparisons with the similarly disfigured Freddy. "In the script, Hellcop is described as a reptilian zombie, and I thought, 'Two of the most overused things ever!' That was really dumb," he explains. "I wanted to give him a very strange texture, a texture that you might not notice until the camera gets close enough to see that it's actually words—quotes from scripture—carved into his face, an idea I picked up from Clive Barker's *Books of Blood*."

Hellcop's full-head makeup featured seven separate prosthetic foam-rubber pieces, requiring as much as five hours daily for application. Most problematic were his bolted-to-the-skull sunglasses, which fogged up periodically due to air trapped within. Johnson's design for the Rachel demon, a female hellspawn with floppy breasts and a whipping tail, derives more from *National Geographic* than the *Necronomicon*.

"I put a lot of primitive African tribal influence in the Rachel demon, which helped a lot in the overall look of the thing," he notes. "The wardrobe that she's wearing, and actually the face, are very African. I always thought that the tribal warrior thing is a scary concept, and it just hit me one day to try to put those themes in. You can sculpt a demon, but if you're not thinking about something specifically, then it won't have a lot of punch to it. She also has plenty of ritual scarring, and then of course the jewelry and ornamentation."

Actor Michael MacKay played the Rachel Demon, costumed from head to toe in a skin-tight full-body foam latex suit supported by raised metal braces. To complement the suit's hooves, MacKay stood on the balls of his feet. The feet and three-fingered hands blended into bracelets so that they could be popped off easily. In the back, Johnson made a special appliance covered with hair that hid the costume's zipper. The breasts were weighted with lead-shot-filled balloons to jiggle realistically, while simple monofilament line lashed the demon's tail around. Authentic animal horns from a supply catalog topped off the creature.

Johnson stuck with character makeup methods for *Highway*'s debonair Prince of Darkness (Patrick Bergin). "Originally, what I wanted to do with the devil was

make him a very, very old demonic thing. For some reason, that was decided against, and so I thought, 'Well, we have to know this is the actor, I want to leave him as much facial mobility as possible.' So I just put a few evil wrinkles and the evil structure to his face with slanted brows, raised up his head, put about three sets of horns on him and a lot of hair. Patrick loved it, too; he actually ended up, in a strange way, being very suave and handsome in that makeup;

Though H. R. Giger received the lion's share of accolades for designing *Species*'s nightmarish creatures, Johnson came up with the hyperactive lab experiment monster himself.

the long hair and the high forehead made him look very regal."

XFX designed yet another full-body monster suit for the sci-fi comedy *Surburban Commando*, in which galactic hero Hulk Hogan wrestles an eight-foot-tall reptilian space monster. The shop's Bill Corso handled the majority of the creature's design and execution, derived from an amalgam of past Hollywood favorites, beginning with the cheesy *Slime People*.

"It was a kind of tongue-in-cheek approach," Johnson admits of the alien bounty hunter. "We got a budget to build a guy in a suit. We didn't have a budget to build a mechanical mask or arm extensions or leg extensions or a puppet, or anything that you would expect from an alien. My problem with aliens in movies is that they always have two arms, two legs, and a head. Only humans and primates on Earth, out of millions of lifeforms, have that, so *why* would these other ones? Because it's cheap, that, why! So because it was such a silly concept anyway, we felt, 'Let's put a little bit of every alien ever made in it.' There are influences from the Creature from the Black Lagoon to the Alien to the Predator and everything else in there."

The seamless *Surburban Commando* suit, like the Rachel demon, had an appliance going over the back zipper, and the hands blended on as appliances. The stuntman wore a close-fitting, one-piece, over-the-head mask, along with separate nose and lip pieces that were glued on. "It took six hours to get the guy in the damn thing," Johnson groans.

Since 1992, XFX has been relishing its busiest years since the company's inception. Producers commissioned the expanding shop to supply makeup tricks for a variety of projects, among them *Pet Sematary II* (lots of gore FX, mechani-

cal dogs and human zombie makeups); *Return of the Living Dead III* (the lead gal ghoul's full-body makeup); the TV miniseries *Oldest Living Confederate Widow Tells All* (very convincing old-age makeups); rampaging robot mechanical FX for *Evolver*; the malevolent Nix of Clive Barker's *Lord of Illusions*; and, demonstrating their versatility in the industry, Gus Van Sant's *Even Cowgirls Get the Blues*, for which XFX created enlarged prosthetic thumbs for actress Uma Thurman.

During this period, Johnson particularly enjoyed his Pittsburgh stay on *Innocent Blood*, probably due to the wonderful collaborative relationship he shared with director John Landis. For this opus, Landis and Johnson sought to infuse new blood in the overworked vampire formula. Foregoing traditional legends, Landis's vampires did not bear stiletto incisors or taloned claws; their most distinctive features were their *eyes*. Johnson and his team spent months and thousands of dollars researching and developing the bloodsuckers' luminescent orbs. An initial attempt at holographic contact lenses showed promise, but failed in the long run. Glowing contacts, mirrored lenses, and "a million other things" proved equally fruitless until Johnson's perseverance—and that of key assistant Lenny McDonald—ultimately paid off.

"Finally, we developed this Scotchlite technique which worked out just fantastically," Johnson reveals. "Scotchlite is glass beads, basically. The material that's on 'STOP' signs, its quality is that it will reflect the light that's bounced at it. It appears to glow, but the light source has to be dead on your line of vision before it can work. So we used a beam splitter. If you're off axis at all, it doesn't work. With one pair of lenses, we can make them glow any color we want because it's just a matter of the light source that you're aiming at it. You can also make the lenses change color during the shot, which we did; my favorite shot in the film is when Anne Parillaud is having sex and her eyes are changing color. It's kind of rare for me to still be impressed with some of my own work, but I really am impressed with that one."

XFX fitted extra-thin scleral shells over the actors' eyes, which covered the entire whites. The lenses then went back to the lab to be treated with Scotchlite artwork. An additional protective lens went onto the sclerals, thus sandwiching the doctored ones in between for the actors' ocular safety.

Once aware of Scotchlite's possibilities and success rate, the crew utilized the material for other *Innocent Blood* gags. For instance, when vampire Don Rickles deteriorates—the film's FX showstopper—the artists treated the progressive deterioration with the reflective Scotchlite. When hit with an orange beam splitter light, it appeared as if the character was burning from within. Besides the decom-

 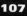

posing makeup on Rickles, XFX's Eric Fiedler created a fully animated puppet head to take the brunt of the damage. Shooting inside a containment room and taking extra precautions, the crew destroyed the head by pumping a mixture of sulfuric and nitric acids through a network of tubes that snaked inside the patterned understructure of foam skin. When the two acids reacted chemically within, the foam combusted without flame.

For the lead vampire villain's incendiary last stand, Landis requested that the FX be fascinating instead of disgusting. As bad guy Robert Loggia delivers his soliloquy, his face cracks like a dry river bed. Six Scotchlite-treated prosthetic pieces were glued to the actor, while a mouthpiece containing tiny but powerful LED lights (similar to those of digital alarm clocks, which emanate a strong glow) were inserted within his mouth. The Scotchlite tape and paint doubled as the makeup's "hot spots." Loggia, for one, would rather forget the experience.

"Loggia hated working with makeup *and* us," Johnson laughs. "His complaint was that we treated him like a puppet—'I'm not one of your damn puppet heads, Steve. I'm an actor and you're draining my energy, taking three hours to paint my face!' The last effect we did on him was this big makeup where we had all the cracks and glowing embers. We had twelve pieces of his face that were rigged to fall off as he talked, so we had him standing in front of a blue screen with a full prosthetic makeup on, with all these pieces put in just barely, so they would come off on cue when we pulled the monofilament wires they were attached to. So basically, his fear came completely true in the last shot—he was a puppet! He couldn't move this or that way because he'd pull the things off—we had all these puppeteering strings attached to him, just puppeting him!"

XFX adapted their *Innocent Blood* innovations for *The Stand*, the Stephen King TV miniseries directed by Mick Garris. Scotchlite-treated horns adorned the satanic Randall Flagg character, as well as glowing lenses and a LED mouth appliance for his scarecrow embodiment.

Johnson moved on to more benign fare with *Freaked*. Joining the comedy's all-star FX roster (Screaming Mad George and Tony Gardner's Alterian Studios also supplied the movie's human oddities), XFX delivered six stunning creations, most notably Alex Winter's mutant makeup and transformation, the cartoonish, giant Rick and Stuey monsters and the Siamese twins. "I can get excited about *Freaked* because some of the most exciting work we've done is in it," Johnson raves.

The film's two directors, Tom Stern and Winter, instructed XFX to base their designs on the comics of underground greats Basil Wolverton and Ed "Big Daddy"

Roth. The FX team labored to convey enough structure and anatomy to their bug-eyed, wide-mouthed, and jumbo-toothed oddballs so that they resembled some sort of actual living beings.

For his part, Winter wore a Bill Corso–sculpted creature makeup that twisted and expanded the left side of his face into a bizarre cartoon disfigurement. To achieve the effect, Corso placed a partial vacuformed skullcap on the left side of the actor's head, onto which he next applied the misshapen forms. A prosthetic hump on Winter's back hid two separate radio-control packs that wiggled the freak's mechanical wraparound ear and lip prosthetics. Winter's phony half lip was seamlessly blended with Pax paint to match his real one. Dentures, contact lenses, a wig, deformed left arm, and leg and foot prosthetics completed the job, which took up to four hours to apply. Since Winter was also co-directing the film, he frequently slept in the gross makeup, with three consecutive nights being the record. "I would find myself in dailies watching this thing, falling for the illusion and forgetting how we did it," Johnson exclaims.

The giant Rick and Stuey freaks were played by seven-foot-tall actors. To make them even taller, XFX built feet for the monster suits with six-inch lifts. The crazy heads were extended up and forward over the performers' own, adding even more height to the walking freaks. (The actors saw through the masks' mouths with limited vision.) These totally mechanical radio-controlled heads featured thirty-five separate motors in each, operating the lips, tongues, eyes, brows, ears, cheeks, noses, and throats. In addition to full-universal movement, the hi-tech masks boasted lip-sync capabilities!

Johnson becomes even more animated while discussing *Freaked*'s merged Julie/Ernie creation. "The Siamese twins were innovative because no one had gone to the trouble or the extent of pulling off a two-headed character like this before," he says. "We used computer digitizing to get two bodies together in several shots that are superb. Mostly we used very complicated state-of-the-art remote-control puppets, one for the girl and one for the guy. When the guy is the most important in the shot, we used the girl puppet, and vice versa. We also did a lot of half-body tricks, going through walls, beds, and tables, where we would actually put both actors up and blend 'em onto a false rod-puppeted body. Every trick we could possibly use, we did, and it worked out incredibly in the film."

Following the box-office disappointments *Highway to Hell*, *Innocent Blood*, and *Freaked*, Johnson finally had a winner with *Species*, the summer '95 hit about a sexy human/alien hybrid making short work of mankind in a bid to procreate. The

film reunited Johnson with former colleague Richard Edlund, who handled the film's computer-generated renderings. As in *Jurassic Park*, *Species* demanded a marriage of computer-generated (CG) and makeup FX to make lead lady alien Sil *real*.

"I had a really good working knowledge of what the parameters were with opticals and makeup effects being blended," says Johnson, "which is the best way to go, any time you do something like this; the more things you throw at the audience to fool them and keep them guessing, the better the effect's going to be. So Richard and I both thought, 'Great, we can do the CG now, so we can do even more.' So that's one of the most astounding things about *Species*, that we had this really nice blending of CG and makeup effects."

Supported on the prominent project by a comfortable budget, XFX set out to visualize Sil's various incarnations, transformations, and relations. Designing everything except for the adult, final-stage Sil, which was rendered by *Alien* Oscar winner H. R. Giger, Johnson sought to deliver the unexpected.

"I didn't want Sil to look like anything that had been done before," he says. "I knew we had the advantage of starting out with an H. R. Giger design, so I wanted to take it all the way through. For instance, when it came to design the head mechanism, we didn't do anything in a standard way. We put the makeup *under*. There are two layers to the head; there's a Giger-type skull with a beautiful face on the outside of that. We put rolling bands of texture in the cheeks so you see something under there, but you're not sure what it is—there's just these rolling bands of Giger texture, and it's a very interesting thing. It's under the skin."

Johnson, whose shop has also contributed animatronic space critters to Showtime's *Roswell* and NBC's *Visitors of the Night* movies, drew from past work experience in building Sil. "I never would have made Sil work as a translucent figure if I hadn't done the research I did on *The Abyss*," he says. "What was good about her was that for the first time we created something that was fully translucent; when you see Sil, you're seeing through her, into her, and it confuses the eye a bit, which is what Giger's work is about, too—it's very translucent."

Johnson strived to keep his own designs in line with Giger's unearthly visions. "It made it a little more fun for me to work with Giger on the lead creature, while designing the others myself," he admits. "But I tried to think like Giger. For instance, the triple-tailed worm thing—that was something Giger did like, and similar to something he might design. I didn't want to design it in any way that I normally design something. I decided to design something that was almost like a creature from the subconscious—squiggly, disgusting, and wormy."

Having collaborated with the perfectionist Swiss surrealist on the botched *Poltergeist II: The Other Side*, Johnson says that in adapting Giger's art with *Species* he wanted to make amends for past Hollywood injustices. "Giger is a very difficult man to please," he says. "One of my goals was making this the first movie that Giger was going to be happy with in terms of the presentation of his work. And you know what? We did it. I couldn't believe it. He was very, very happy with our work on *Species*."

The interview winds down when Johnson is called back into the lab. It's a bustling time for XFX, Inc., and Johnson feels that his company has finally come into its own. "Things have been going fantastically lately," he says proudly. "I've always felt that everyone gets their turn. If you're really good and if you're really serious, eventually you'll be recognized. I'm beginning to get better jobs and more offers. Sometimes it just takes a long time for people to notice. It's frustrating in the beginning: You think, 'I'm so much better than a lot of these people who are working so much, how come I'm not working?' Or, 'How come I'm getting offered only these low-budget things?' And I would get so frustrated. But it takes time, and I actually think it's better to progress slowly. It becomes easier to deal with everything and to learn how to work within the business if you progress slowly, and a very solid way to get into this very unsolid business is to take it one step at a time."

On the set of *The Fly*, Chris Walas shares the spotlight with a critter cut from the film.
(ALL PHOTOS COURTESY CHRIS WALAS)

Seven
Chris Walas
Transformations

Transformation scenes were really something to gawk at in the '80s. *The Howling, Cat People, An American Werewolf in London, The Beast Within,* and many other movies featured the latest special makeup FX technology to turn hapless humans into frightening beasts—right on camera, with few if any cuts or dissolves. Since then, the computer has risen as the primary tool in many transformation scenes, "morphing" actors into creatures seamlessly and almost effortlessly. But even if this burgeoning technology has superseded the lengthy, bladder-packed, latex-ripping FX spectacles of the past, 1986's *The Fly* still stands out as the ultimate metamorphosis movie.

Directed by David Cronenberg and a remake in name only of the 1958 movie of the same name, *The Fly* achieved new levels of man-into-monster FX, bracketed by an emotional story of one man's loss of humanity. The film won makeup FX creator Chris Walas an Academy Award in 1987.

"It became a cooperative effort," recalls Walas of the film's genesis. The forty-one-year-old designer's Marin County–based company, Chris Walas, Inc., has gained notoriety on such movies as *Gremlins, Enemy Mine,* Cronenberg's *Naked Lunch, Ghost, Arachnophobia,* and *Virtuosity.* "I broke the script down, saying, 'I think there's got to be five stages of makeup. And then we're gonna have to just get rid of the actor [Jeff Goldblum] and move on to a puppet for the last sequence.' It was everyone's intent to try and keep the actor in the role as long as possible, because you can get a lot more out of an actor than you can from a rubber puppet. So it was very tough finding an avenue, visually, that would allow that.

"Our initial designs were very biologically oriented, but they were sort of symmetrical, logical progressions," Walas continues. "It was David who came in and said, 'No, you gotta look at it as a disease, as a cancer that's in there that's really twisting and turning, and not balanced out.' That was a real good inspiration. We ran to a medical library and brought a few disease books back, and just kind of spent a half hour getting sick to our stomachs."

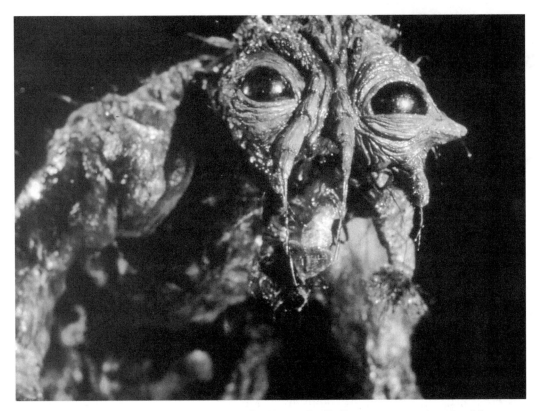

The fusion of man and insect, Walas's "Brundlefly" set a new standard in creature FX.
(ATTILA DORY)

Cronenberg, who first worked with Walas on 1981's *Scanners*, insisted that the transformation of his *Fly* hero, Seth Brundle, adhere to some kind of scientific realism and not be included for simple shock value. "The primary image and one of the things the producers and I spoke about, and wanted to *avoid*, was having Brundle turn into a hundred-and-eighty-five-pound fly," Cronenberg said on the set of *The Fly* in February 1986. "It would be silly if Brundle was just turning into this huge bug—and physiologically impossible, even given the fantasy elements of any SF-horror film. It would've been as silly as the head switch in the original and wouldn't even work as well as that did, since this isn't the '50s anymore. I wanted to make sure, as Brundle says, that he was evolving into something that had never existed before, a real fusion between an insect and a man that would embody elements of both. The evolution of the creature was very open, and Chris Walas was very happy about that."

Walas concurs on the metamorphosis's design evolution. "What I wanted to do

was make sure that it was stuff that wouldn't take away from the drama of the story," he says. "We had an hour for our transformation, and [in other films] most people have two and a half to four minutes of transformation maximum. They tend to have very violent, bone-cracking stuff. That's definitely what we didn't want. We wanted the feeling that, on a day-to-day basis, you might not even notice very much of a transformation if it was happening in real time. I wanted to draw analogies to the aging process, losing hair, losing teeth, things like that, as well as being similar to an insect shedding its skin."

What makes Walas's story special is that he has undergone a metamorphosis of his own. After contributing FX to a number of hit films throughout the '80s (among them many George Lucas and Steven Spielberg blockbusters), Walas segued into feature film directing beginning with the 1989 sequel *The Fly II*. He sees this as a natural progression in his professional life.

"The good thing about creature-making, basically, is that I got to do makeup; deal with actors; do puppets; deal with a lot of technical stuff; and I had a say in and was very involved in the way things were shot, in terms of the lighting conditions, the breakdown of actions," Walas says on how makeup prepared him for the director's seat. "I tend to do a fair amount of storyboarding on all the movies I work on, whether it's directing or special effects. So in that sense, on a 'floor functioning' level, there was a tremendous amount of very practical experience—not just *how* to do it, but how *not* to do it, too. It made me very aware of all the mistakes."

A Chicagoan by birth, Walas first began experimenting with movie- and monster-making while attending high school in Parsippany, New Jersey. The young horror fan experienced a "whole new awakening" when he got his mitts on a copy of *Dick Smith's Do-It-Yourself Monster Make-up Handbook* in the '60s, and his twin interests continued to mature. "When I was a little kid, all I ever wanted to do was make movies," Walas recalls. "I was Mr. Super-8 in high school, did all sorts of stop-motion films and really bad, incomplete horror movies. And I never actually made the separation when I was younger; it was just, 'I'm gonna make movies, and of course my movies are gonna have weird creatures and monsters and fun stuff in 'em.' And all through college, anytime there was the opportunity to get a group of people together, I always brought my camera—'Hey, let's make a movie!' "

In 1975, Walas packed his bags for L.A. to turn his hobby into an occupation. After a brief try at college, he took a job at Don Post Studios, a famous supplier of Halloween masks. His Post position led to his first film assignment, making killer fish puppets for director Joe Dante's humorous *Jaws* steal *Piranha*. Steady

employment from New World Pictures (*Up from the Depths*, *Screamers*) and other cheapie companies in the '70s allowed Walas to gain experience working fast with no money, but before he could get stuck on the low-budget treadmill, more prestigious productions began popping up. George Lucas's Industrial Light & Magic company brought Walas up to their Northern California headquarters to join the FX staffs on such extravaganzas as *Raiders of the Lost Ark*, *Return of the Jedi*, and *Dragonslayer*. In a bit of a switch, Walas didn't find a career during this time—a career found him!

"The funny thing was, it wasn't really that much of a decision on my part, to make it a career," he says of his employment path. "My original interest in trying to get into film was to—as everybody does—make movies. My interest and hobbies had always been very closely related to creature-making, makeup and all that stuff, so it was a natural inroad into the industry for me. I was just incredibly fortunate to fall into a vast opening in the industry at the right time."

It was also the right time for Walas to break out on his own. In 1981, he founded Chris Walas, Inc. in San Rafael, just north of San Francisco. Two years later, Dante paged Walas's services again for his creatures-amok film *Gremlins*. On his first major solo gig, Walas and company designed and fabricated hundreds of the mischievous critters, ranging in size from two inches to two feet. The tiny terrors were radio- and rod-controlled, hand-puppeteered and cable-operated throughout the film's delirious action.

Gremlins's box-office popularity and resultant buzz next landed Walas *The Fly*. Before joining the remake in Toronto, he and a crew of thirty dove into designing more than two dozen different special makeup FX, rigs, and puppets at his shop. Work began in September 1985—a scant three months prior to the start of principal photography. Walas usually hopes for six months of preproduction, but such luxuries rarely exist in the hectic FX business.

"We did an awful lot of work on *The Fly*," Walas recalls. "Though we started in September, we didn't have the lead actor or any designs locked in until the beginning of October, when we finally got Jeff. We had to basically do all our makeup pieces, suits, and everything in less than a month. We would be sizing up designs and tailoring on Jeff—who was needed for filming—while still trying to incorporate all the design aspects needed for the final stage—not much time to pull a lot of stuff together."

With deadlines looming, the situation became something of a free-for-all when it came to the film's designs. The FX team went "crazy" trying to envision the seven-

left: Makeup legend Dick Smith makes up actor F. Murray Abraham for *Amadeus*. Both won Academy Awards for their work.
(PHOTO COURTESY DICK SMITH)

below, right: *The Exorcist*'s Max von Sydow was only forty-four years old when Smith applied his artistry.
(PHOTO COURTESY DICK SMITH)

below, left: *Gorillas in the Mist* ape creator Rick Baker credits John Alexander's performance as Digit as an integral component of the animal character's believability.
(PHOTO COURTESY RICK BAKER)

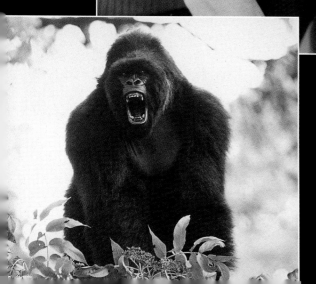

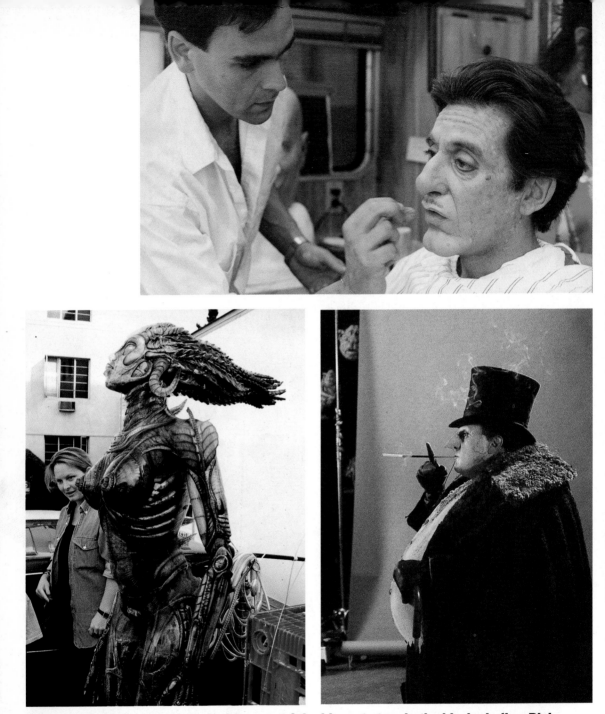

top: John Caglione has worked with some of the biggest stars in the biz, including *Dick Tracy's* Al Pacino.
(PHOTO COURTESY JOHN CAGLIONE)

above, left: Steve Johnson's transparent Sil suit from *Species* allowed us to see what made this baby tick.
(PHOTO COURTESY STEVE JOHNSON)

above, right: The Penguin (Danny DeVito) of *Batman Returns* was a successful combination of makeup, costuming, and performance.
(PHOTO COURTESY STAN WINSTON)

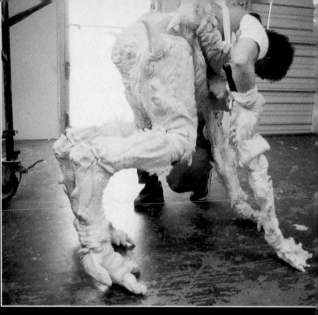

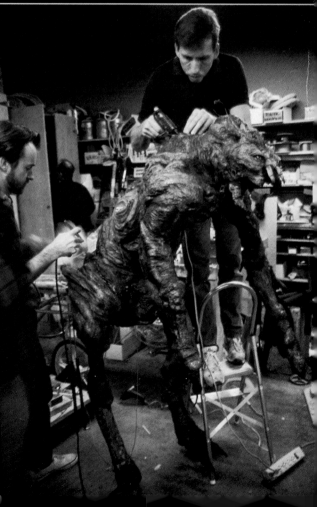

above: Some of the best FX are never seen in the finished film, like this demonic figure created by unsung makeup artist Gordon J. Smith for *Jacob's Ladder*.
(PHOTO COURTESY GORDON J. SMITH)

above, right: CWI's David Myhea is fit for *Fly II*'s walker rig.
(PHOTO COURTESY CWI)

right: Jerrold Neidig and Gregg Olson of Chris Walas Inc. paint the sixth-stage puppet of the Fly's metamorphosis.
(PHOTO COURTESY CWI)

below: Johnson's Slimer from *Ghostbusters* was the only spook character who really took off from the film.
(PHOTO COURTESY STEVE JOHNSON)

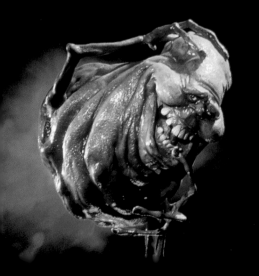

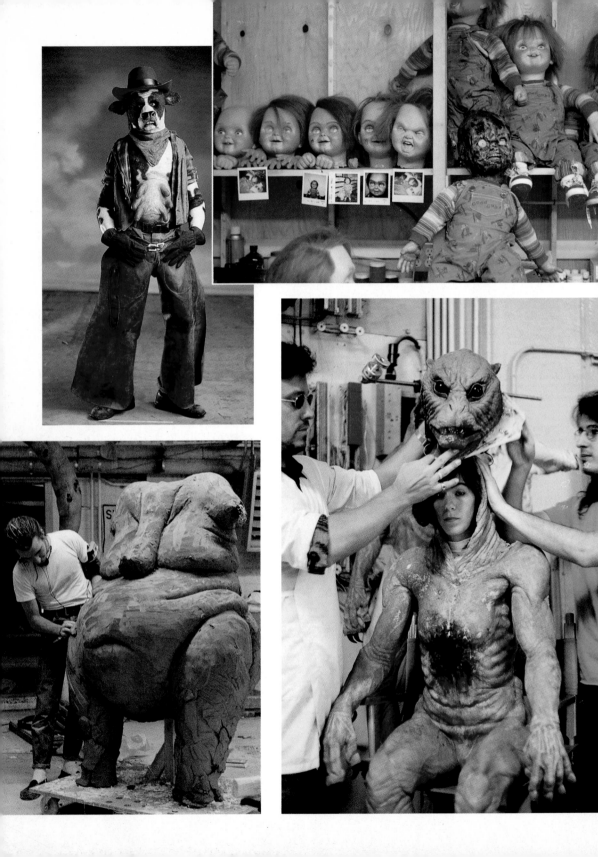

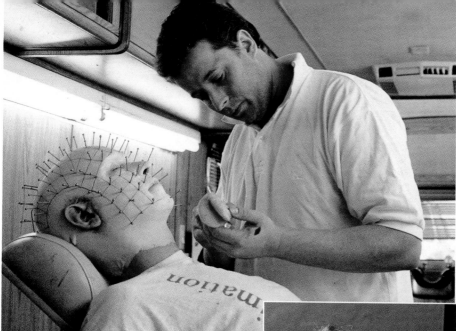

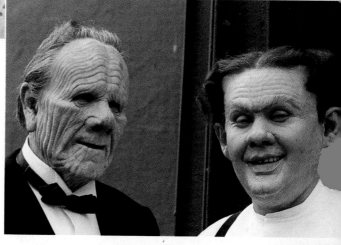

far left, above: Alterian's repertoire, like *Freaked*'s Cowboy, ranges from the sublime to the udderly ridiculous.
(PHOTO NELS ISRAELSON)

above, left: The many stages and faces of Chucky, from the first *Child's Play*.
(PHOTO COURTESY YAGHER PRODS.)

far left: Behind the scenes of *Nightbreed*, Little John sculpts the obese Vasty Moses.
(PHOTO COURTESY GEOFF PORTASS)

left: Brian Penikas (left) and Tony Gardner suit up *Sleepwalkers* stunt performer Karyn Malchus for the film's finale.
(PHOTO COURTESY ALTERIAN STUDIOS)

above: Yes, those pins have to be applied one at a time! Gary Tunnicliffe readies Doug Bradley on *Hellraiser: Bloodline.*
(PHOTO COURTESY GARY TUNNICLIFFE)

above, right: John Caglione described his work on *Dick Tracy* as a "rubber festival." Pictured: Pruneface (R. G. Armstrong) and Flattop (William Forsythe).
(PHOTO COURTESY JOHN CAGLIONE)

right: Caglione aged actress Bette Midler to eighty-five in *For the Boys.*
(PHOTO: FRANCOIS DUHAMEL)

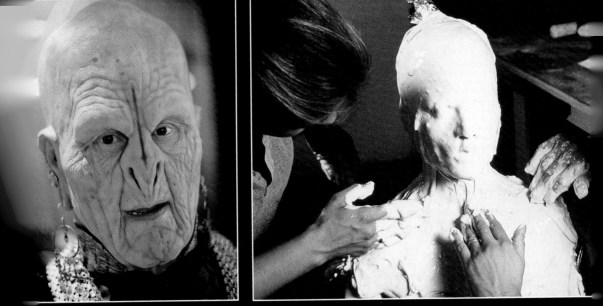

top: For *A Nightmare on Elm Street 3,* Yagher built a gigantic animatronic Freddy snake puppet that could swallow Patricia Arquette.
(PHOTO COURTESY YAGHER PRODS.)

above, left: TV's science fiction boom keeps a large number of FX artists busy today, such as Optic Nerve on *Babylon 5.*
(PHOTO COURTESY OPTIC NERVE)

above right: The art of prosthetic makeup begins with the life cast.
(PHOTO: BEN MARK HOLZBERG)

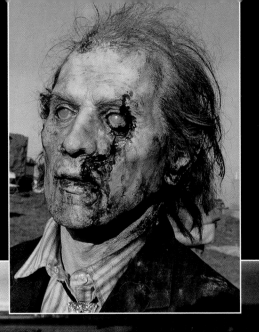

f the Living Dead's cemetry
...rve provided the ghoul player
...milky contact lenses and a

...*OPTIC NERVE*)

...Tony Gardner (left) and Brian
...ngs to Erika Eleniak's character.
...*T TRISTAR*)

...atronic Crypt Keeper is a team
...k Winkless puppeteers the
...character's mouth.
...*YAGHER PRODS.*)

left: Howard Berger walks down the aisle with his Bride of Re-Animator. (PHOTO COURTESY KNB)

below: Star-to-be Kevin Bacon gets all choked up in *Friday the 13th.* (PHOTO COURTESY TOM SAVINI)

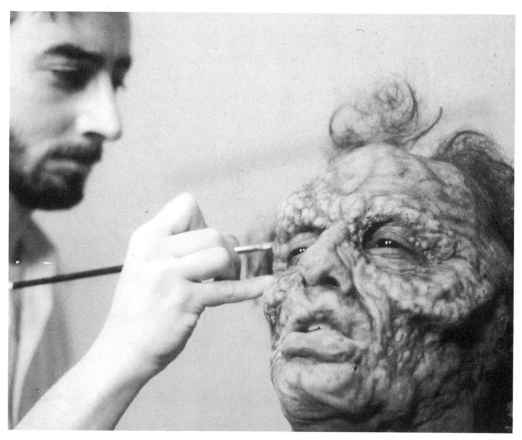

Stephan Dupuis gives Jeff Goldblum the proper diseased look.

stage "Brundlefly" transformation. Most of the final makeup concepts came from the hand of supervisor Stephan Dupuis, with input from others. Jon (*Star Wars*) Berg did much of the full-figure Space Bug design (first sketched by Jonathan Horton, then reworked by Walas for more of an insectlike look) and eventual mechanical FX.

Walas also credits Goldblum's acting and makeup-chair endurance as reasons for the movie's success. For Stages I to III in his metamorphosis—which ranged from makeup color changes to partial foam latex appliances—Goldblum went through the basics. But for steps IV and V, the long-limbed thespian underwent a complete makeup job that covered virtually his entire body. In all, Goldblum spent at least ten hours a day in the heavy makeup, over a twenty-day haul. The final stages consisted of several mechanical puppet rigs and did not involve the actor.

In greater detail, CWI accomplished Goldblum's metamorphosis into *The Fly* as follows:

Stage I

The transformation begins subtly, mirrored in the character's face, which breaks out into a "bad allergic rash," the start of his red and blotchy skin discoloration. FX pro Dupuis painted Goldblum's face with simple cosmetic colorings, dabs of red, yellow, burgundy, and blue.

Stage II

This is a more accentuated version of Stage I. Plastic was used to make facial warts and pimples. Brundle's fingers become discolored. The scabby FX on Brundle's scratched back were made of plastic, while the Fly hairs growing from the scratches were nylon monofilament, trimmed and tapered at the end and slightly tinted with black ink to give a translucent look.

For Brundle's pus-oozing, nail-losing fingers, channel tubing in the palm of his hand ran along the actor's fingers, concealed by a rubber outer piece. The small fingertip prosthetic appliance was glued on and blended with makeup to match his own fingertips and disguise the tubing system. The crew inserted a dental-acrylic "fingernail" in the foam rubber. Two syringes connected to the tubing system pumped up "Fly juice" causing the liquid to "pop" the fingernails. The Fly juice was comprised of glycerin, zinc oxide, Methocel thickener, and yellow food coloring.

Stage III

Brundle's "disease" is more advanced. His face looks bloated and lumpy and his head a bit wider. He's losing his hair and his skin is heavily discolored. To accomplish this, Goldblum wore a prosthetic foam-rubber appliance covering his ears and most of his face, leaving open only the middle part of the nose and space around the eyes and lips. Blotchy reds and bruised purple colors were added, along with a bald-spotted wig.

For the scene where Brundle loses his ears, the face appliance had a fake pair. A line attached behind one ear went through a tube underneath the wig. When the line was pulled, the ear loosened. Another tube in the ear cavity was attached to a syringe that pumped out more Fly juice.

Stage IV

The distorted Brundle is barely recognizable. His head is more misshapen. Goldblum wore a facial appliance covering his whole face and neck. In addition, a hernia bulges on his left side, the beginnings of an extra Fly leg which develops later. Partial wig pieces on his head have patchy hair. Later in Stage IV, a full-body foam suit was donned by the actor, who only wore makeup and appliances in the previous stages.

For Brundle's receding gums and split lower gum, specially made dentures were fitted over the actor's teeth. Body makeup (resembling a pattern of bruised flesh) consisted of blue, red, and purple.

Stage V

For this more wildly distorted version of Stage IV, Brundle's head and body are lopsided. Goldblum wore a full-body foam suit—a mass of swirling and lumpy flesh with green and red blotchy skin tones. Five fingers existed on one hand, four on the other. He also sported a widened, black marble-colored contact lens making one eye look bigger than the other.

A second set of dentures showed that Brundle has lost most of his teeth. A mechanical puppet replica of Goldblum's head featured an extended lower jaw which split in two to eject the Fly tongue. A self-contained mechanical system inside the head unfolded the eight-inch appendage. Also, cushion pads in the palms of the actor's hands produced another helping of Fly goo. The minimum amount of time required to apply Stage V, the most complete makeup, was four hours.

"The greatest challenge of *The Fly* was keeping somebody in a full monster suit for the greatest part of the production, and have it still be believable and maintain itself," Walas says. "It's easy to do a transformation that lasts a minute or two minutes, because the audience just doesn't have the time to focus on it. The challenge that we had to overcome was the fact that the audience was gonna sit there and see every little nuance, every hair on this guy's face. The tone of the film was that it was a very real, human story, and we did not want the effects in the transformation to detract from that, or to draw it into a different tone."

Stage VI: The Brundle Puppets

This stage is that moment in *The Fly* when the culmination of the fusion

between man and fly is revealed. This served as the most entailed and important animatronic manifestation.

The Stage VI Brundle (or Space Bug) was made up of several different mechanical puppets. The transformation from Stage V to Stage VI was achieved through the use of several mechanized Brundle heads, the first of which was enlisted in the struggle with antagonist Stathis Borans (played by John Getz). The FX crew rigged the head so that the jaw split and extended, allowing the character to discharge caustic digestive juices which dissolve Stathis's hand and foot.

As Veronica (Geena Davis) then struggles with Brundle, she rips off his jaw. This action triggers the key transformation where the Fly finally bursts out from Brundle's body. "We used real-life biology for our avenue," Walas says, "in that we used the concept of a butterfly being born, in that it makes its chrysalis—which in our case was the skin of the human being—and it changes internally, and then escapes from that chrysalis. That's where we got our skin-shedding sequence."

Brundle Puppets in Chronological Order/Stage V Continued

1. Flexo Jaw Head. Four to five operators were appointed to manipulate this full-bust puppet, which was mechanized to display a jaw that flexes and spreads in a very non-human way, as well as the emerging eight-inch fly tongue. (Barely seen in the completed film.)

2. Removable Jaw Head. Four operators worked this one, for the scene in which Veronica tears off Brundle's jaw.

3. Transformation Head. This included the head distending and stretching (four to five operators), the eyes (condoms filled with thinned K-Y Jelly, bits of latex, food coloring and threads for veins) popping and goop dripping out of the sockets while his new insect peepers emerge—beginning Stage VI. "Popping the eyeballs was just a fun thing to do," Walas says. "It gave us the option of being gooey and yucky without being bloody."

Stage V to VI: Transformation

4. The transformation leg rig. A waist-down puppet operated by five technicians covered the action of the right leg reversing its hinge, the waist pushing out and the fourth joint forming in the left leg.

5. As Brundle's fifth-stage hand holds Veronica's, the skin splits and three-inch-long insect claws sprout. The whole hand elongates, too.

6. The transformation torso figures in with the final leg emerging from the side of the torso and the skin splitting and dropping away.

Stage VI: The Space Bug

7. The walking rig. Jon Berg's waist-down puppet (with two operators) covered the actual striding and walking of the Space Bug.

8. The hero puppet. Used for all specific Space Bug action and close-ups, this waist-up puppet possessed full-head facial movement, two arms, a sixth leg that breaks out and moves, and shoulder movement. Five operators.

9. A full-figure Fly. This one utilized a lumberjack rig mounted on an eight-foot tubular steel support. Using six operators, this stage was the most specialized puppet as far as engineering goes. The principal puppet movements were controlled by one operator using a cable-controlled slave system. The final Space Bug was built out of fiberglass sections, latex skins, foam latex pieces, and partial urethane coatings.

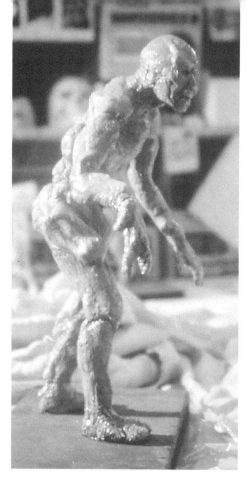

An early CWI design maquette for *The Fly's* tragic hero.

"We had a basic problem in that the head of the Space Bug was about four or five inches larger than the human head that it was supposed to be *inside* of," Walas says. "So like most insects, we took the approach that, yeah, well, most insects, when they come out of their pupa, they have to inflate their bodies with oxygen and all that stuff anyway. So there was a logical biological functioning to it."

Stage VII

10. The Brundlething (aka. Brundlebooth). Nine operators huddled beneath the stage on the last rod puppet, which was controlled by hydraulics, cable systems, and an electric motor drive. The FX team put in translucent membranes for this

CWI's Buzz Neidig develops paint schemes for the sequel's fly creature.

final fleshy metamorphosis, and a new back section was made from a thrown-together mix of latex, rubber tubing, garbage bags, and whatever else was handy. It still has the same face and hands of the sixth stage. Although it might not be apparent in the film, the final Fly appearance represents the molecular combination of Brundle and the telepod which occurs when Borans shotguns the in-progress transmission. Walas wanted to avoid a biomechanical look for Brundlething.

"It's an organic mess," says Walas of the Stage VII puppet. "We made it as pathetic as possible. If it resembled something mechanical, it would've appeared too functional and not hopeless enough. It had to look like it was in pain just existing."

Regarding the film as a whole, Walas sums up, "Overall, the stuff we did on *The Fly* was very simple except for the head rig, which we decided to make the one focus. We went through a lot of designs and choices were made. There was a great deal of pressure to fall back on the tried-and-true methods, due to lack of time or money. But it all worked out, and we were really thrilled with it."

A bigger thrill awaited Walas after *The Fly*'s release. Following a strong critical reception and a popular run in theaters, CWI's work on the film garnered the shop an Academy Award nomination for Best Makeup. Never expecting to take home the prize (the competition included Rob Bottin's striking work on *Legend*),

an "astonished" Walas and co-nominee Stephan Dupuis won the Oscar—and a new legitimacy in Hollywood—that night. When *The Fly II* started getting swatted around in development meetings, original producer Stuart Cornfeld pushed for Walas to direct. The artist was now ready for his own professional transformation.

"When *Fly II* came up, it was very natural that I direct," he says. "The planets were in alignment, so to speak: *The Fly* had been very successful, the Academy Award occurred, *Fly II* was directly in line in terms of the effects and stuff. It was a very natural progression, not a real stretch of the imagination."

Fly II continues the Brundle family saga with the original character's orphaned son, Martin (Eric Stoltz), infected with the same genetic curse as his late father and beginning to mutate at an accelerated rate. The sequel demanded a variety of FX that surpassed that of the first film, including four stages of makeup and prosthetics for the metamorphosing Stoltz and four multifunction mechanical creature rigs (their use signaled after Martin emerges from his giant pupa in the film) that carried the action for the follow-up's last third. Director Walas and CWI eschewed the romantic tragedy of the first *Fly* and its messy transmogrification for a new approach.

"The one thing I wanted to try and avoid [on *Fly II*] was doing the same thing with a different story—the same look, the same visual sense," the director says. "Because, no matter what, people are gonna draw that comparison. I wanted to find a different style, to define his transformation more logically, more purposeful than the first one. The first transformation was a genetic nightmare, a genetic imbalance gone wild. What I wanted in *Fly II* was a genetic balance—the same thing occurs between an insect and a human, but *how* would it actually function, *how* would it work if that happened? In terms of the transformation stages, I wanted them to be a little bit more subtle, and I drew the analogy of going into the cocoon to really make it a much more directly biological progression. I wasn't out to repulse people the same way—it wasn't a disease, it was a real transformation."

Pressured for time because of the late casting of Stoltz, CWI supervisor Dupuis and assistant Dennis Pawlik drafted the use of gelatin makeup appliances to hasten the application process. Not unlike the dessert Jell-O, but industrial-grade, gelatin material is melted, fillered (for toughening), colored, and then poured into a regular negative mold. The positive is then placed on top and clamped to hold the two together. When the material cools, the molds are pulled apart and the appliance powdered and removed. Whereas a foam rubber appliance may need six hours to bake and cool, a gelatin piece can be ready in ten minutes!

"The makeup pieces were all gelatin, which was a real challenge in and of itself,

A rear view of *Fly II*'s window leaper, with open back panel.

because coloring them is very different from coloring regular foam appliances," Walas explains. "To try and get that translucent quality to them, the color has to be translucent, but there has to be a certain level of tint to the gelatin or else it absorbs light so completely that the gelatin next to skin will look very dark gray. It's just the nature of the material and not its color. We had to do a lot of lighting and tests."

The first stage of the "Martinfly" makeup needed simple skin coloration makeup. Later in the same phase, small bag appliances were placed under Stoltz's eyes. Stage II begins with cheekbone distortions, signifying a change in the character's bone structure as opposed to Goldblum's skin deterioration. Martin's condition worsens in Stage III, by which time the actor settled in for two and a half hours in the makeup chair for the application of seven individual gelatin pieces to cover his entire head. By Stage IV, at which point an insect eye has already asserted itself, Martinfly begins sprouting white cocoon webbing, bristly white filaments that CWI fashioned from Halloween decoration "spiderwebs." At the end of this fourth stage, the makeup team also covered Stoltz with a mass of tiny gelatin body lumps and attached webbing to his fingers and claws to his knuckles. After five hours of application at this juncture, the actor spent *another* five being encased in a giant latex cocoon! Walas only took a day to shoot this complicated scene, no doubt due to his past FX background.

Walas's brother Mark and Jon Berg supervised the final stages of Martinfly,

where Stoltz was replaced by a series of latex foam and mechanical puppets. Martinfly was performed on screen by at least ten creatures or half-creatures for specific actions, as well as fourteen sets of insect limbs for miscellaneous setups. Four head-to-toe full-body critters were built, the most complex being the "leaper," which launched itself through a window and swooped down. The mechanical quartet was a combination of marionettes with radio-controlled heads and cable functions, foam coverings, lightweight hang-glider tubing, aluminum rods, aircraft components, and harness gears and walking rigs supported by stuntmen. Structural details common to these puppets were vacuformed, clear-plastic underskulls which covered much of the body's inner armatures. The underskull shell was encased with an outer urethane and foam latex skin and helped give the monster marionettes definite form. "I wanted the full-size creatures to have six limbs too, just like insects do," Walas adds.

For its first-time director, the hardest part about shooting *Fly II* was stepping back from the FX. "It was very, *very* difficult," he admits. "Probably the toughest thing about making that movie was not doing a lot of hands-on stuff. I wound up doing a little bit, but not much. And I certainly felt most comfortable handling the effects sequences. It was the relaxing part of being a first-time director, doing something I was a little familiar with."

Walas has continued to pursue other directorial projects for himself, as well as FX assignments for his shop. He sees no conflict in juggling both. "I looked at makeup as a tremendous opportunity, a lot of fun, a great learning experience, but I *never* viewed it as the end-all," he says. "I never viewed it as anything I would abandon either."

Besides helming a second film, the blackly comic thriller *The Vagrant* (1992), which he'd rather forget, Walas directed an entertaining episode of *Tales from the Crypt* ("Till Death"). In the future, he would prefer to direct a kids-style fantasy film that would appeal to his young daughter, as opposed to molting-monster movies. And despite the Oscar sitting in his office from *The Fly*, he feels that the ultimate transformation has yet to be captured on celluloid.

"Oh, there is no such thing!" Walas insists. "As technology and storytelling improve, there are always going to be changes and improvements. I think I've done a *notable* transformation on film, and I'm very happy with that. Unless I get on a project that demands another transformation, I don't know that I'm going to be looking for transformations in the future. Transforming a man into a fly—and a special effects man into a director—are enough transformations for one life!"

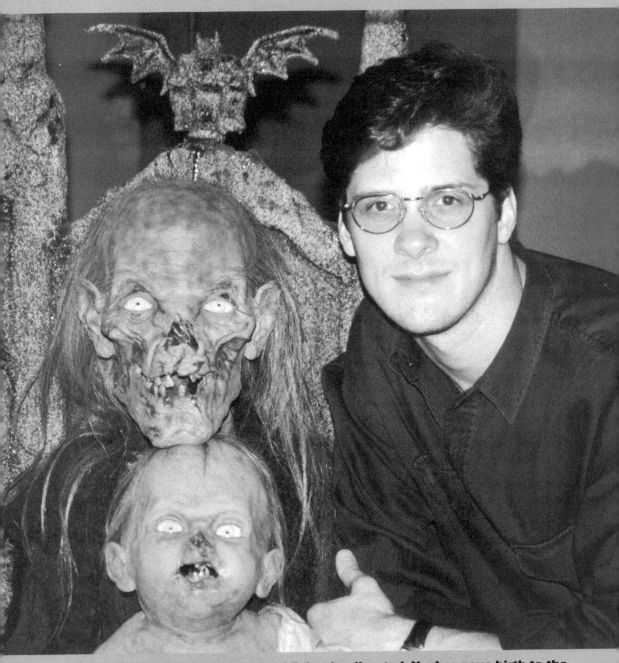

For the *Crypt* episode "Lower Berth" that he directed, Yagher gave birth to the baby Crypt Keeper.
(ALL PHOTOS COURTESY YAGHER PRODS.)

Eight

Kevin Yagher

Puppetmaster

As a youngster, Kevin Yagher was a follower. His older brother Jeff loved monsters; so did he. Jeff built models; so did Kevin. When Jeff made monster masks, his little bro picked up that hobby, too. Today, inspired by the younger Yagher's success on a wide variety of projects—*A Nightmare on Elm Street 2* through *4*, *The Hidden*, the *Bill & Ted* films, *Child's Play*, *Honey, I Blew Up the Kid*, *Radio Flyer*, *Man's Best Friend*, and the 1989 *Phantom of the Opera*—kids are following *him*.

"Just growing up with an older brother who was into the classic monster stuff, and *still* loves it more than anybody, inspired me," Yagher says with fondness. "I probably would have dropped it if it wasn't for him. He had a lust for it. So he really was a great inspiration for me."

By all accounts, the thirty-three-year-old Yagher's been doing pretty well for himself as a practitioner of monsters and makeup. Though he cut his teeth supplying Freddy Krueger's burned visage, Yagher's forte has been in the creation of puppeteered and animatronic figures. Mastering an array of electronic, mechanical, and computer techniques, he has turned a huggable kid's toy named Chucky into a walking, talking, stalking, tiny Terminator. For HBO's long-running *Tales from the Crypt*, Yagher has created the cackling Crypt Keeper, the tube's most entertaining and ghoulishly macabre anthology host since Rod Serling and Alfred Hitchcock kept audiences spellbound.

"When you take the camera in on the Crypt Keeper or Chucky, the face really holds up in the close-up," Yagher says. "And you get so much emotion out of the face. Three guys are working: one guy's working eyes, which includes eyelids; another's working all facial expressions—brows, cheeks, nose, so on and so forth; and the third guy's doing the mouth. When you get all those elements together and there's been enough rehearsal, it's amazing when a face comes to life."

The collegiate-looking makeup artist runs Kevin Yagher Productions, a fourteen-thousand-square-foot FX facility situated just a few blocks down the road from former employer Stan Winston. Located in Van Nuys, California, the cavernous two-level shop is quite impressive. Beneath a cathedral ceiling, Yagher's

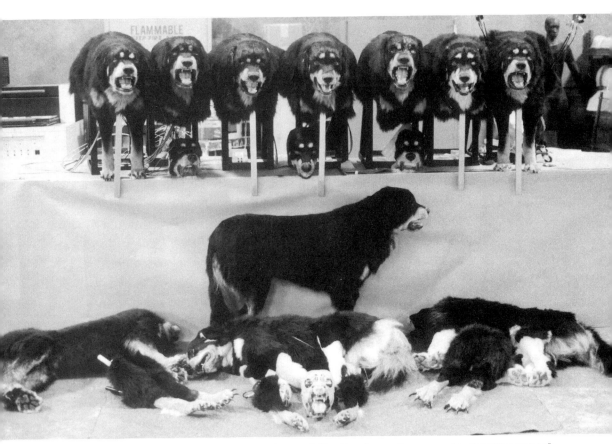

All dogs go to Heaven—except this one! Yagher's various animatronic stand-ins from *Man's Best Friend* await their cue.
(ALL PHOTOS COURTESY YAGHER PRODS.)

employees busy themselves in the main workplace. Yagher watches the progress below from the glass-enclosed balcony of the second level.

The place has something of a family feel. Perhaps that's because Yagher's younger brother, Chris, has an office on the premises where he handles the shop's accounting, and Yagher's baby daughter Catie is gurgling away to the delight of her babysitter/company receptionist in the main lobby. Yagher moves into his office and sits behind a large, wooden desk. His other children—full-size replicas of Chucky and the Crypt Keeper—decorate the interior, while the walls boast several Ace nomination plaques honoring his *Tales from the Crypt* accomplishments.

Born in Illinois, Yagher spent his formative years in Dayton, Ohio, where the family had moved when he was eight. Kevin and Jeff carried on with their monster passion in the form of producing their own Super-8 stop-motion shorts. Later,

Kevin started his own Halloween mask company, selling over seventy-five masks the first season. Jeff switched career goals shortly thereafter and enrolled in the Yale Drama School to pursue acting. Kevin, meanwhile, stuck with makeup.

"I didn't really know I wanted to be a makeup artist or a creature builder, whatever you want to say—monster maker!—until after I graduated high school," Yagher says. "I went to visit my acting teacher, and I dressed up in a complete old-age makeup—the whole Dick Smith thing. He thought the makeup was great. So he introduced me as his grandfather to this girl in a dimly lit hallway, and I did the whole acting job. She bought into it hook, line, and sinker. That gave me such a big thrill. That pushed me—'I'm gonna do this for a living.' "

After a one-year try at Ohio State University, the artist dropped out and headed to Los Angeles on the recommendation of Smith, whom Yagher had impressed with photos of his old-age makeups. He soon found spots on the FX crews of Greg Cannom (*Cocoon, Dreamscape,* and *The Last Starfighter*), Tom Savini (*Friday the 13th—The Final Chapter*), and Stan Winston (*Invaders from Mars*). While working for Winston, Yagher learned that the producers of *A Nightmare on Elm Street 2* were actively seeking a new makeup FX chief to replace the departing David Miller, who created Freddy Krueger's makeup on the first *Nightmare*. Producers Joel Soisson and Michael Murphey soon asked Yagher to redesign Krueger's ugly mug. Biting the bullet, the nervous rookie took the plunge on his first solo assignment.

Yagher's new take on Freddy's makeup accentuated the character's horrifying past—in which the child murderer was set aflame by vengeful parents—in his design. Consulting photos of actual burn victims, Yagher crafted a nine-piece makeup that featured more exposed bone, gaunter cheeks, and extended cheekbones. "I wanted to give him more bone structure, because he was lacking in a few elements—more of a witchy, warlock-looking thing," he says. "I think Freddy's like a big witch—he's got a hat and long nails, and he's got the same kind of elements as the bogeyman. I thought I'd streamline him a little bit more." The tailored makeup was extraordinarily detailed for such a low-budget movie.

Yagher first began experimenting with articulated, puppeteered creatures on 1986's *Trick or Treat*, which called for a demonic mascot named Skeezix. The cable-controlled, gargoylelike creation was composed of eight separate components. The head, neck, arms, and hands were made from foam latex, while its long, slithering tongue was derived from hot-poured vinyl and slipped over cable mechanics to make it move. The teeth and reptilian eyes were painted dental

acrylic, and the eyelids and ears were made separately from foam. The pieces fit onto a polyfoam and latex trunk. An assistant operated Skeezix from inside, entering through the back. Breathing, cheek movement, the snarling mouth, and the tongue were all mechanically cable-controlled. The creature's arms were manipulated by means of two rods that extended back from the elbows. Despite the labors of Yagher and his crew, Skeezix barely made it into the completed film, thanks to the directives of the film's FX-shy helmer, Charles Martin Smith.

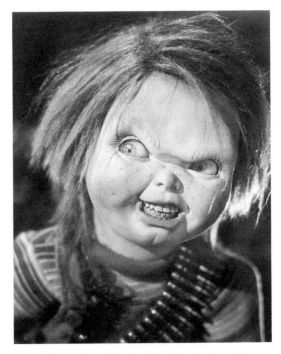

With Chucky, Kevin Yagher helped turn an innocuous kids' doll into a toy of terror.
(PETER IOVINO)

Yagher built his first large-scale animatronic puppet for 1987's *A Nightmare on Elm Street 3: Dream Warriors*. For a wild sequence in which Freddy appears as a giant snake, Yagher and his crew (Jim Kagel, Mitch DeVane, David Kindlon, Gino Crognale, Steve James, Brian Penikas, and Willie Whitten) fabricated five versions of the twelve-foot-long mechanical serpent, which gobbled up actress Patricia Arquette through a combination of radio-controlled and cable-activated methods. Another FX outfit, Image Engineering, provided the creature's elevation capabilities.

"We had different versions of the Freddy snake," Yagher reveals. "One was a swallowing one. There was a stunt one that could swallow and had a full body that went down to the ground. A stuntwoman just got into it and jumped up and down, flopping the thing back and forth. Then there was the animatronic head. I also wanted to do this reverse idea where we put the Freddy mouth on over the victim and then pulled it off. When we reversed the footage, it looked like it was swallowing and biting her. We did an eye-stabbing one, and one that spits her out. And then the final, full-talking version."

Yagher's much-praised *Nightmare 3* gig led to a call from producer David Kirschner, who had a script about a killer doll making the rounds. Though

impressed with Yagher's talking Freddy snake, the producer hired Oscar-winner Chris Walas for some preliminary design input on the film. But when *Child's Play* switched directors (from *Stepfather* helmer Joseph Ruben to *Fright Night*'s Tom Holland), Yagher was back on board. This indecisiveness plagued *Child's Play* throughout preproduction, as the nervous filmmakers and studio, United Artists, bickered over how to turn a lovable Play Pal into a believable instrument of terror.

"All of a sudden, we had sixteen people around this big table—all of 'em were chiefs, none of 'em were Indians," Yagher recalls of the preliminary meetings. "I had to listen to all these people, and it was hell trying to get answers from them because everybody was afraid to say anything. Plus, we were dealing with the dolls. We kind of took from an existing animatronic doll that was on the market called Corky, which had curly red hair. And we studied that doll. It was like working at Mattel; designing a toy first, it had to be *so* sweet, and then it had to be *sinister*."

Next, Yagher sculpted Chucky's cherubic face for his prepossession stage in the film. "I kept bringing in the cute clay head, showing 'em the cute mouth and everything, to get an approval on this little smile," he recalls. "They kept saying, 'It's not as cute as the Corky doll.' So I went back and I was really mad, because I knew that they were being fooled by the green color of the clay. So I took the Corky doll and pulled out all his hair, and I put in the same colored eyes and painted him green. And I brought him in, and our doll was actually much cuter than the Corky doll when you turned him green. That proved to them that they were being fooled by the color. So they said, 'OK, fine, go ahead, mold it.' "

Yagher then had to construct five different stages of heads, taking him from innocent Chucky all the way to "Jack Nicholson killer Chucky," with receding hairline and hairy brow. Approvals were required at every step. "It was really hell—a lot of people had opinions, and sometimes that can be insane, listening to too many chiefs," he says critically.

Yagher credits Chucky's final design as a group effort, with the most contributions, besides his own, coming from Kirschner and Yagher sculptor Jim Kagel. "He was a mishmash of [ideas from] a lot of different people," he notes.

When Yagher first turned up on the original film's set with the completed Chucky, his major hurdle was meeting the high expectations of his director and producer. "They were all waiting in anticipation," he recalls. "There was a lot of, 'Kevin Yagher's gonna be bringing in a working animatronic doll, it's supposed to be really good....' So there was all that tension there. And then we get on set, and Chucky had seven guys attached to his butt. People expected it to walk on and do

its thing! The first shot that we did was Chucky peeking through the window. We had a couple of weeks to rehearse, but I don't think Chucky actually got really, really good until two weeks into shooting. It took that long to get everyone working like a well-oiled machine. The first day was just really hectic, all that tension.

"Tom Holland was afraid, and David Kirschner was a little worried, too," continues Yagher, who married the film's star, Catherine Hicks, shortly after the production wrapped. "Dave would call me, sometimes at twelve at night: 'Are you certain this is gonna work? I'm really nervous, aren't you nervous about this?' I said, 'The only thing I'm nervous about is you callin' me like this all the time. You're *making* me nervous.'"

Kirschner need not have worried. Much of *Child's Play*'s popularity derived from Yagher's dynamic creation. Backed by a strong marketing campaign, *Child's Play* opened to brisk business in November 1988. Lensing on two sequels (released within one year of each other) commenced shortly thereafter for Universal Pictures, which had picked up the franchise from UA. Instead of simply recycling his previous puppets, Yagher strove to perfect Chucky, going so far as to build a new doll that could *walk* full-figure directly at the camera!

On the *Child's Play* films, Yagher and his crew picked the scripts apart, breaking Chucky's various appearances down into detailed storyboards to determine what FX and type of doll would be prescribed for each specific action. Nine different Chuckys were built for the first installment: the simple "Good Guy" doll that appears at the beginning of the film, before the spirit of a voodoo-practicing serial killer (Brad Dourif) inhabits the nice toy; a full-standing, cable-controlled Chucky; a barely used radio-controlled walking version; a couple of half-body/waist-up puppets which could sit, flail, and chomp in close-up; and five stunt Chuckys that took the brunt of his battle wounds and ultimate destruction. "You never know what you're going to need, so you build a lot!" Yagher says.

Yagher Productions perfected Chucky over the course of the two follow-up films, and the following technical breakdown is mostly derived from the puppet creation featured in *Child's Play 3*. The two-and-a-half-foot-tall, forty-pound mini-monster is a true technological wonder that forces the viewers repeatedly to suspend disbelief throughout the horrific movie series. In its full walking, talking version, Chucky was operated by seven to nine professional puppeteers or

Chucky's clear plastic shell enabled Yagher and his crew to examine the puppet's internal mechanisms at any time.

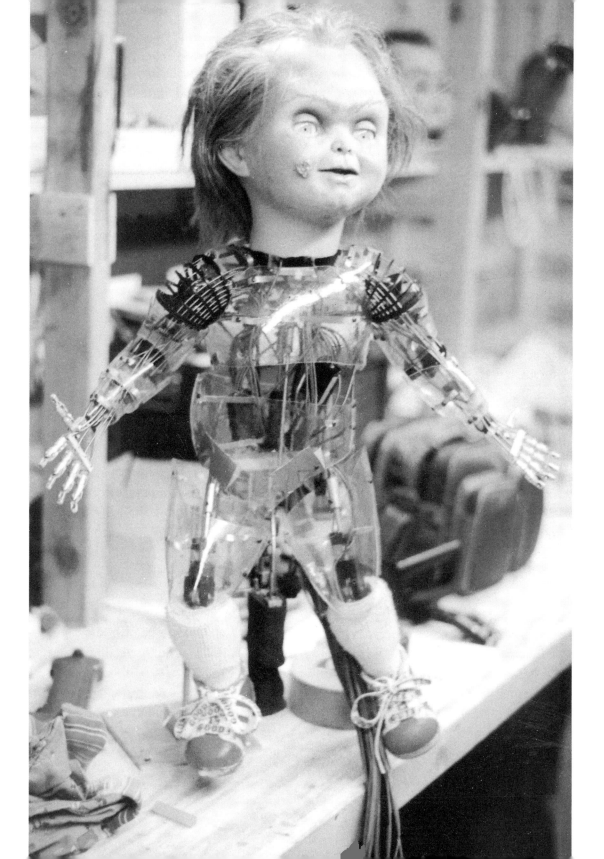

"Chuckettes." Each controlled a separate function via cables: the eyes, which were made of acrylic; the mouth and facial movements; head and torso turns; the right arm; the left arm; the hands; and the "walking" legs.

(Besides Chucky, countless other creatures have been brought to life with cable-control devices, including E.T., Yoda, the Gremlins, and many of Rick Baker's apes. These realistic critters are controlled by fairly simple push-pull assemblies made of thin-steel lines [housed within plastic tubes or metal cylinders] that pull on the rubber faces and push against the inner workings, giving the illusion of life and movement. In most cases, the cable is controlled by human operators who pull on the cables. The cables return to the original position because of the operator's push, the action of a spring, or the natural elastic pull of the latex or foam rubber to which the cable is attached.)

Chucky's humanlike face is composed of flexible, flesh-colored latex molded to a hard plastic head casting. Eighteen individual tiny servo motors are implanted inside his noggin to help the puppeteers produce Chucky's realistic facial expressions: six to operate his mouth; one for his nose; one for his cheeks; four for full-rotation eye movement; one for his tongue; and two for his smile. Chucky is capable of at least a dozen human expressions, including both cute and evil smiles, as well as distinctive mean, angry, and enraged looks, to name a few. Used in radio-controlled cars and toys and sold in many hobby shops, servo motors (or servos) are automatic motors whose speed is regulated by radio- or audio-frequency input devices, such as a joystick. "The head had plenty of strategically placed microservos jam-packed inside," Yagher explains. "I always like to put as much as I can into it, whether I use it or not; it's just fun to play with.

"When you first glue the skin down on a mechanical face, it's the biggest thrill to move it around," he continues. "Even though it's not painted and there's no hair on it yet, it's looking around and shifting its eyes. You just start laughing—there's this overwhelming joy."

Chucky's amazing repertoire was augmented with a variety of bodies and heads/faces, each with distinct functions and abilities. By the third film, seven switchable servo-implanted heads and twelve different torsos (three of which were operated by the puppeteers) were pressed into service. The interchangeable heads included two mean/smiling faces; three with mostly neutral expressions; one screaming; and one biting. "The thing that's great about Chucky is that he *is* a doll, and I can get away with a fairly mechanical look to him," Yagher notes. "That spoiled me, because when I got off of *Child's Play* and got onto other things, I found

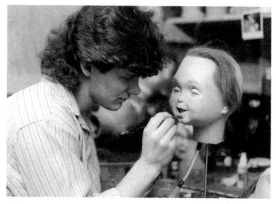

Yagher gives lip service to his expensive creation.

out that I had to make things look a little more realistic."

Chucky's all-cable (for strength) bodies included the principal "hero" puppet (the one capable of the most movement in the torso); one additional servo-operated body; another cable-operated body; and several others, most of which were simply doll-like and used in scenes where Chucky played possum.

The puppets' undershells were comprised of clear vacuform plastic. These transparent cores, which supported the skin, enabled the operators to open up the puppet in a pinch and replace any broken servos. Though some parts consisted of polyfoam, the doll's skin was mostly made of standard foam latex.

All of Chucky's below-the-head movements were cable-operated by the puppeteers, who sat atop portable seats watching monitors that showed them the puppet's actions as they happened. Four of these seats were hooked up by way of joystick devices to twelve feet of cable. The cables controlled Chucky's head, torso, arms, and hands. Some fifty-five individual cables were needed to operate all of the functions. On the first film alone, five hundred feet of cable were used for Chucky's manual controls. Since it took the puppeteering team working in perfect synchronicity to operate the doll, each move had to be ironed out well in advance so that they could coordinate their efforts and hit their marks. Usually hidden under the stage or offscreen, the operators huddled together for hours at a time, joysticks in hand.

For full-figure shots of the killer doll, Yagher and his team created a standing Chucky. Controlled by cables leading up through the stage and into one of the feet, this version could be filmed from all angles, and could turn or step forward without any camera-angle cheating or cropping. His other foot remained immobile, so the doll could take one step in any direction with his free foot. The cable-controlled hero doll, used for sitting or waist shots, was capable of the most torso movement and endured the majority of the film's "abuse." Combining the standing doll's cable-controlled legs with the half-body model of the hero doll allowed Chucky to take his menacing strolls on camera. For the walking scenes, the entire

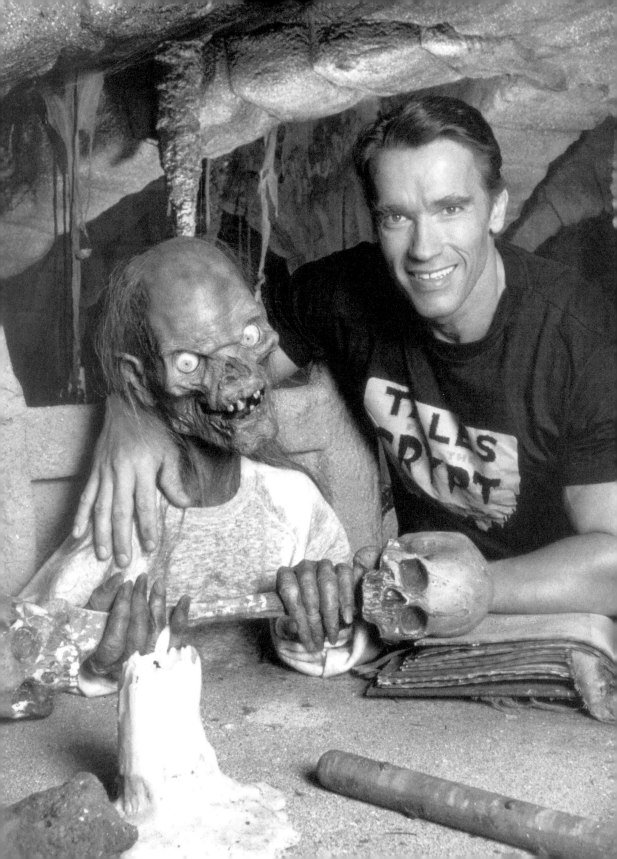

Chuckette gang operated their functions in tandem with the moving rig or dolly.

"On the first *Child's Play*, we had a radio-controlled walker, and it never quite did what it was supposed to do," says Yagher, who added second-unit directing duties to his job description on *Child's Play 2*. "So on the second one we did get a full body shot, all cable-controlled, walking right toward the camera. And that was exciting."

Chucky's walking scenes called upon the services of all seven puppeteers and necessitated the use of a walking rig (constructed of aluminum and weighing forty-five pounds) or a camera dolly, depending upon the director's camera-angle needs. For the walking shots, both of the doll's arms were operated by one puppeteer, who employed a slave system or waldo as means of operation to duplicate his motions on the doll. A slave system consists of a backpack equipped with pulleys and cables that are connected to elbow and wrist joints, etc.

"It's like a suit," Yagher explains of the system, "an upper body harness that you strap into, and all the cables go from Chucky right into your body suit, so that when you move, he moves. It's a similar idea to the Japanese Bunraku puppet, which is off a rod; the rods are attached to points in your body, and when you move, the puppet moves with you. That's kind of what the slave system is, except it's all with cable. Mecki Heussen designed one for us that straps onto you. We used it a lot, especially for Chucky walking, clapping, or reaching out and grabbing something."

Chucky's voice was performed by actor Brad Dourif in all three films with considerable gusto; the filmmakers prerecorded Dourif's voice prior to filming. This enabled Yagher's puppeteers to rehearse Chucky's lip-synching to Dourif's performance and ensured realistic lip movements. Each line of Chucky's dialogue was then played back over speakers while the puppet actually delivered his demented lines to the camera.

On *Child's Play 3*, the Chuckettes were aided in their lip-synching by a computer. On the previous movies, Chucky's mouth had been operated exclusively by a puppeteer wearing a head-brace transmitter. When the puppeteer moved his mouth, it activated servos that moved Chucky's jaw, and the doll's lips were manipulated by that same person using a joystick. Though this was still primarily the way Chucky was made to speak, a computer was utilized to play back the puppeteer's lip-synch recording exactly the same way for each and every take on

Yagher's Crypt Keeper meets the biggest stars, including Arnold Schwarzenegger, who directed an episode of *Tales from the Crypt*.
(MICHAEL PARIS)

part three, thus speeding up the filming process. This system worked best with close-up scenes of Chucky delivering dialogue.

"Usually it's done live, right to Brad's voice, with the puppeteer there, but we preprogrammed the doll on *Child's Play 3* with this wonderful computer animation system," Yagher says. "Then when it came time to play, we pushed one button and it would be in sync with the voice. That was neat." In order to make Chucky's speech more realistic, these scenes were shot at eighteen frames per second instead of twenty-four. This enabled Yagher's crew more time to synch up Chucky's facial movements to the words. The film was later sped up to match everything else.

Yagher credits his talented support group for Chucky's ultimate success. "By the time the third film came along, I didn't go on the set very much at that point because I had the same crew, and I just sent them off. We built and rehearsed it, and then I'd go to the set maybe once a week."

As a further display of what a team effort such projects are, the duties of Yagher's Chuckettes were broken down as follows: head and torso movements, lead puppeteer Van Snowden; eyes, Mecki Heussen; mouth, Brock Winkless, who wore the headgear unit to operate Chucky's speaking; facial movements, Thom Fountain; right arm, Fred Spenser; left arm, Greg Williams; hand manipulation, Greg Manion; walking rig, Yancy Calzada; Chucky costumer, Marilyn Dozer-Chaney.

"On the first film, Chucky's personality didn't really develop until the second week, because everyone was still 'finding' it," Yagher says. "At first the crew was just working things, and all of a sudden they began to work in the style and began to learn the other puppeteers' movements and functions, and they began to complement each other and move off of each other. It was really interesting to watch a character evolve from seven to nine different guys, and all of a sudden, *this* is the character."

With a recommendation from Stan Winston, and his Chucky accomplishments behind him, Yagher was tapped by the hotshot executive producers of HBO's *Tales from the Crypt* (Joel Silver, Robert Zemeckis, David Giler, Walter Hill, and Richard Donner) to adapt for the small screen the old E.C. Comics horror host, the Crypt Keeper. The artist was allowed a great deal of latitude in coming up with his own interpretation of the cackling ghoul and spent three weeks drawing

To complete the illusion, standup comic John Kassir provides the voice of the cackling Crypt Keeper.
(DOUG HYUN)

a Crypt Keeper for a new generation of fans. Following its approval, Yagher and a staff of eight (four assisting on its mechanics and the others doing painting, sculpting, and hairwork) delivered the actual puppet in about seven weeks, with Yagher sculpting the head himself. Pressed for money, he recycled Chucky's acrylic, heat-cured eyes for the Crypt Keeper's baby blues. He tailored other *Child's Play* construction methods into the new fiend as well. "The facial stuff is pretty much the same as Chucky," Yagher reveals, "but it's more extreme with the Crypt Keeper. He's got bigger pieces to move, and he's more cartoony. It's a bigger head, so we packed more servos and stuff into it."

Going for a rotted zombie motif, Yagher sculpted the Crypt Keeper without lips. Unfortunately, this left the host with nothing to speak with, so the designer redesigned lips that were fuller and closer together to make it easier to match Crypt Keeper performer John Kassir's humorous prerecorded dialogue. Yagher proudly adds that he cast Kassir in the role. A stand-up comedian, Kassir has given the long-running cable series much of its witty appeal.

The combined efforts of six puppeteers (Van Snowden, Charles Lutkus, Rico Topazio, Brock Winkless, Dave Stinnett, and Eric Schaper) allow the three-foot-tall Crypt Keeper to do his shtick. One puppeteer places his hand inside the head and arm and works the body; another wearing prosthetic gloves is the hands; and three other assistants control the facial expressions (lips, eyes, etc.).

"Patty Maloney, who's a little person, works the smile [using two cables] and the laughs," reveals Yagher, who directs and helps script many of the show's wraparound segments. "Patty also doubles for the Crypt Keeper. When I need full-body shots, I put a mask on her and let the Crypt Keeper walk. We've done things with full body, but sitting down; we have cable legs that can kick or cross, but we can't do any full-body shots with the puppet, so we use Patty for stuff like that."

Though the Crypt Keeper is a less-complicated creation than the mechanics- and cable-heavy Chucky, Yagher feels that the former's reliance on old-fashioned puppeteering techniques works in the character's favor. "You have more choices with puppeteering," Yagher says. "With the cable stuff, you're locked into what the puppet can do; he's always gonna have a certain look because he's basically a machine. But the puppet can do subtle things, not so mechanical. I don't try to pull him off as a human," he avers. "He's human enough. But there's something odd about the way that he moves, being a skeleton and all that, and I like the fact that he's sort of a puppet. There's a novelty to that. He's not supposed to look absolutely real, because he's also a cartoon character."

Originally, head honchos Zemeckis and then Donner were slated to direct the early shows' Crypt Keeper spots, but when Yagher showed Donner his detailed storyboards, the veteran helmer drafted Yagher for the job, a position he accepted with confidence. "There's only one guy in the Crypt and I built him," he says. "I know how he works, I know how he looks best, I know all the guys who are puppeteering him, so I've already got a personality thing going on. If they hired somebody else to do it, I just know they'd have major problems." Counting the prologues and epilogues as separate segments (they usually take place in separate Crypt locations), Yagher estimates that he has helmed well over a hundred shorts.

Noticing Yagher's proficiency in putting together *Tales from the Crypt*'s wraparounds, the anthology's producers offered the artist a shot at directing a couple of episodes, including "Lower Berth." This excellent installment, which explains the Crypt Keeper's perverse origins, netted Yagher a Best Director nomination from cable's ACE awards. Since then, he has graduated to his first feature film, *Hellraiser: Bloodline*, following in the footsteps of makeup artists-turned-directors Chris Walas, Stan Winston, and others. However, due to squabbles with his producers, Yagher took his name off the trouble-plagued sequel. "Directing actors is easier than directing puppets, let me tell you!" Yagher laughs.

The Crypt Keeper later made the jump to the silver screen, with Universal Pictures' *Tales from the Crypt: Demon Knight* and *Tales from the Crypt: Bordello of Blood*, the first two single-story *Crypt* horror films. As with the HBO predecessor, the twisted host bookends the movies. Yagher, who hopes to create a fully mechanical, walking Crypt Keeper someday *à la* Chucky, sees unlimited potential for the creepy commentator.

"As far as the character goes, he's definitely evolving," the artist says. "I want to do a shot where you can see him in a bathtub, scrubbing his back, all naked [*laughs*]. From a technical standpoint, it's something where you will see him and say, 'Wow, how did they do that?' "

While the jury is out on Yagher's future as a feature director, for now he can rest on his laurels as being the talented genius behind Chucky, the Crypt Keeper, and other animatronic and puppeteered marvels. However, he may not be completely comfortable with this notoriety. "I don't want to be 'Puppetmaster of the '90s' for effects," Yagher smiles. "Everybody has their niche, I just don't want to go down as the Doll Boy. No, I'm kidding. I'm happy with what's happened, with where I'm at, because a lot of the stuff that we've done has been extremely innovative, and it has also affected other shops."

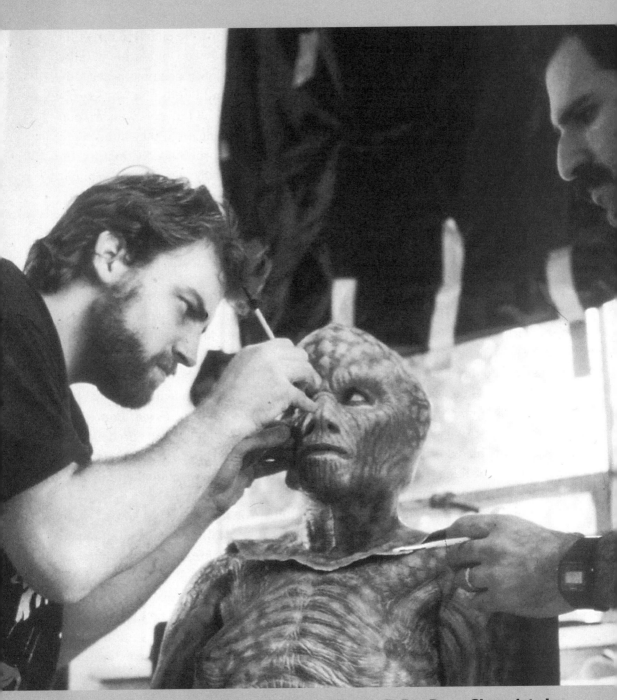

KNB'S Robert Kurtzman (left) and Howard Berger fit Rae Dawn Chong into her custom-made body suit for *Tales from the Darkside: The Movie.*
(DEMMIE TODD) (ALL PHOTOS COURTESY OF KNB EFX)

Nine

KNB EFX Group

The Monster Makers Club

Like most young FX artists, Robert Kurtzman, Greg Nicotero, and Howard Berger started out in the makeup business at the bottom—running foam, making molds, cleaning up the lab, and suffering through other unglamorous tasks. Moving from shop to shop in the early to mid-'80s during Hollywood's major horror/SF boom, the ambitious trio toiled together and separately for hotshot designers Stan Winston, Rick Baker, Kevin Yagher, and Tom Savini. Finally, in February 1988, they decided to throw their hats into an already overcrowded ring and open their own business.

"I supervised *Child's Play* for Kevin Yagher, and Bob and Greg supervised *DeepStar Six* for Mark Shostrom. And we were thinking, 'Know what? We're supervising for people on big shows; we're not making any money; we're not getting the credit that we feel we'd like to get. Let's put together our own company,' " recalls Howard Berger of the auspicious formation of KNB EFX Group, the studio that he, Nicotero, and Kurtzman have given their names to and which has since contributed makeup FX to a staggering number of films—over a hundred in seven years!

"Scott Spiegel was doing *Intruder*," Berger continues, "and he called Greg and said, 'I'm doing this movie, and there's no money; can you recommend some kids who might want to do the effects?' And Greg said, 'Jeez, we'll do it!' Scott said, 'Well, there's no money....' and Greg said, 'Fine!' Maybe we made like seven hundred bucks each on that show. And that was it. We did a bunch of low-budget stuff, and people thought, 'Yeah, they do good stuff for low money, and they're quick'—people still think that [*laughs*]! But that's what started the whole ball rolling. We kept growing; we moved up from a teeny 800-square-foot shop to this, our fourth shop, which is 12,000. And we could move any time again!"

KNB EFX is located about forty-five minutes from Hollywood, a bit removed from the hustle and bustle of the film world. The studio is nestled near the scenic Topanga Canyon mountains, in an area where suburbia competes with industry. The boys, as they are collectively known, formed KNB at the tender ages of twenty-one (Berger and Kurtzman) and twenty-three (Nicotero), a brave move for

guys accustomed to the steady pay-checks on someone else's crew. But in no time at all, KNB has graduated from the low-budget quickies that once were their bread and butter to prestige films such as Martin Scorsese's *Casino*. Their makeup skills have graced a wide variety of films: big studio horror efforts (*People Under the Stairs, Village of the Damned, Lord of Illusions, Vampire in Brooklyn*); franchise slashers (*A Nightmare on Elm Street 5: The Dream Master, Wes Craven's New Nightmare, Halloween 5, Leatherface: Texas Chainsaw Massacre III*, and *Jason Goes to Hell: The Final Friday*); and their emerging specialty, monster-heavy fright shows (*Tales from the Darkside: The Movie, Bride of Re-Animator, Army of Darkness, In the Mouth of Madness*, and *From Dusk Till Dawn*).

KNB built the animatronic buffaloes for *Dances With Wolves* in their Chatsworth shop and sent them off to the film's South Dakota location.

Besides the monster and slasher stuff, KNB has broken into mainstream motion pictures with totally convincing FX for such Hollywood smashes as *Dances With Wolves* (numerous prop and mechanical buffaloes); *City Slickers* (the calf birthing scene); *Misery* (Ouch! James Caan's crushed legs and Kathy Bates's cranial collision with a manual typewriter); *Pulp Fiction* (assorted violence à la Quentin Tarantino); *Sibling Rivalry* (a realistic Sam Elliott corpse); and *Pure Luck* (a clever gag in which the allergic Martin Short blows up after a bee sting).

When they're not cooking up some wonder on a film set, the KNB boys can be found introducing students to the magic of filmmaking on their national college lecture tour. With what little time they have left, Kurtzman, Nicotero, and Berger have been actively developing their own movie projects, making another successful transition to directing and producing.

The KNB shop is a modern but low-tech place. Tidy piles of discarded molds are stacked in various corners, and work tables reveal in-progress sculptures from the latest *Friday the 13th* film. A serpentine demon from *Doppelganger* greets visitors at the front of the lab, while an excised hellhound from *Amityville 1992: It's About Time* silently growls from a storage bin on the left.

Kurtzman, Nicotero, and Berger, who first worked together on Sam Raimi's *Evil Dead II* in 1986 while serving on the crew of makeup FX head Mark

Shostrom, are equally personable and cheerful. Nicotero is the most outgoing and talkative; Berger is the tallest and jolliest; and Kurtzman the most quiet and introspective of the three. Each fellow frequently punctuates his conversations with adjectives and exclamations on the order of "cool," "really fun," "funnest," and "wow." The guys also share a passion for Ray Harryhausen Sinbad movies, John Woo action flicks, and Warner Bros. cartoons. And, of course, monster movies. They *love* monster movies.

"Monsters definitely got me going," Berger, a big bear of a guy, says. "My main idols were Rick Baker, Stan Winston, and Dick Smith. I've always been fascinated with gorillas, so I was really drawn to Baker—each one was incredible." Kurtzman and Nicotero share similar stories. "I can't believe that my parents didn't think I was deranged when I was a kid," Kurtzman says. "Every day I'd come home with tapes of four or five horror films, movies that I'd always wanted to see and couldn't. My parents couldn't believe what I was watching." "For me, it was [Pittsburgh's] *Chiller Theater* movies with Chilly Billy," Nicotero adds of his early addiction.

Of the three, Nicotero was the least likely to go into the monster-making business, although his Pittsburgh family knew ghoulmeister George Romero. "I had just entered college studying premed when I got a call to work on *Creepshow*," says Nicotero, the businessman of the shop. "I turned them down, but I still visited the set. I wound up helping Tom Savini on his *Tales from the Darkside* ["In the Closet"], and I finally dove in with everybody on *Day of the Dead*. Next thing I knew, I wasn't in college anymore."

The son of a motion-picture sound engineer, California-born Berger grew up an avid movie nut; his father even drafted the adolescent Howard into doing cartoon voices. Through his dad's Hollywood connections, the fourteen-year-old youth contrived a visit to makeup ace Stan Winston. "I bugged the shit out of him," he laughs. At the same time, the meeting helped Berger decide on a career path, and he soon set his sights on makeup. Dropping out of art school, he began knocking on doors and eventually found employment at Makeup & Effects Laboratories, as well as John Buechler's low-budget FX factory, MMI. "I was paid a ridiculous rate a week, but I was there to make monsters and have fun. I met tons of people," Berger says of his tenure at the latter shop.

Kurtzman, another art-school dropout, grew up in Ohio. "I thought I wanted to be an artist, but I just wasn't into going to school for four more years," he recalls. "Plus, my way of thinking is that you learn from doing, from making mistakes. So I sat down and asked myself, 'Well, what do I really like in life, what do I really

enjoy?" I enjoy movies. Saturday mornings I never went out and played sports; I spent 'em in the basement with the TV on and a bowl of chips and a big container of Coke, and I sat there and watched bad monster movies! And I read *Fangoria* and *Starlog* and all those magazines. So I decided, OK, monsters!" Kurtzman packed up his belongings and headed west. After an unproductive semester at a local makeup school, he began pounding the pavement and crossed paths with Berger.

"I was working at John Buechler's and I got hired for *Day of the Dead*," Berger interjects. "John said, 'Well, you need to find somebody to replace you while you're away.' The day before, Bob had been in for an interview, so I gave him a call to see if he wanted to take my job. He said yes, and that's how we became friends. Then I went to Pittsburgh, and the first person I met off the plane was Greg, who was coordinating *Day* for Tom. Then Greg and I became friends. When I came back here, I hung out with Bob, and I kept saying, 'Oh, you gotta meet Greg, he's gotta move out here.' So Greg finally moved out, and the three of us got a house that we lived in for two years together. It was the House of Wayward Makeup Artists."

The boys bounced around from shop to shop, picking up valuable lessons from each that they would one day apply to their own company. In the span of three years, they contributed to a large number of films (though not always together), from big-budget shows like *Predator* to lower-rent cheapies such as *Troll*.

From Buechler, Kurtzman learned "doing stuff really quick and cheap." Yagher, on the other hand, taught Berger "discipline and organization," while at Winston's he gained knowledge from "the best" regarding such skills as moldmaking. According to Berger, the trio mastered "how to have a great time!" with Savini. All three chuckle in unison over their shared adventures.

In February 1988, the ambitious triumvirate decided to market their talents under one roof and compete with their former bosses and dozens of other smaller shops that had sprung up. Their most dreaded chore was mastering the tedious business details of owning one's own shop—paying sales tax, workers compensation, insurance, and overhead. Once settled, they began to offer producers a powerhouse combination of makeup professionals, each individual's talents complementing the others'.

"The big thing is that we are three partners," says Berger of KNB's uniqueness and competitive edge in the makeup trade. "We're the only company that has

KNB's Gino Crognale plays dentist to a hellspawn for *Pumpkinhead II: Blood Wings.*

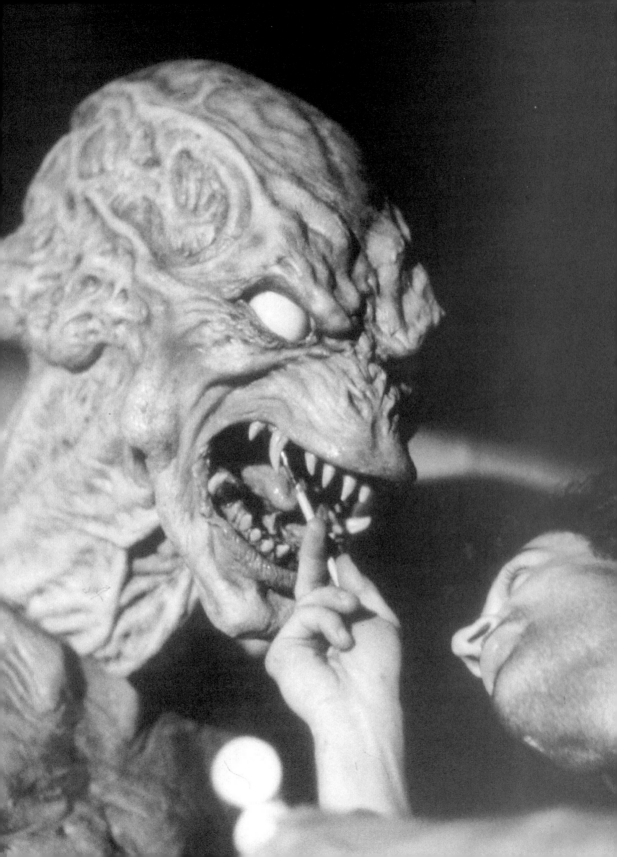

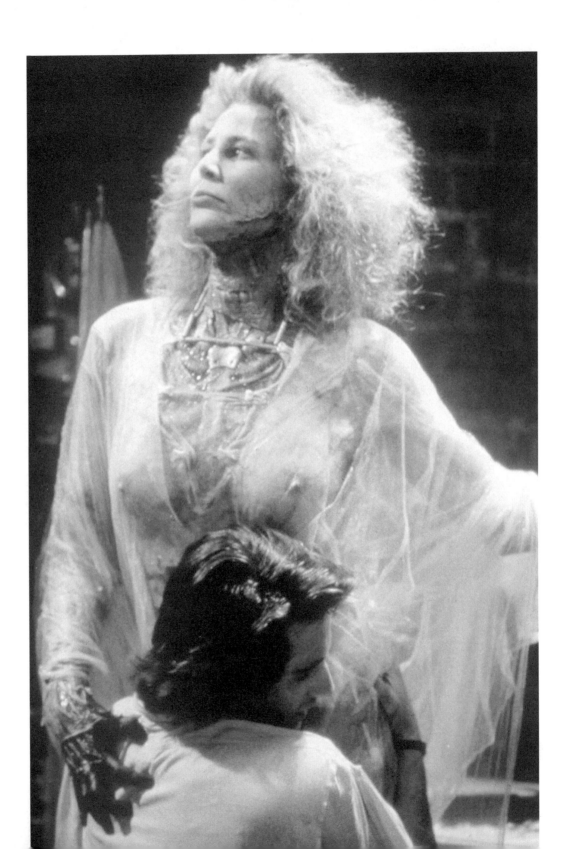

three partners. We work like a *fairly* well-oiled machine. Each of us has a specialty. We're all well-rounded, but Greg really handles the business aspect of the company, hustling. He's great on the phone—he's really good at wining and dining people and treating them well. That's Greg's big, big thing and that really helps us out, that's how we get jobs.

"Bob and I do a lot of the artwork," he continues. "Bob does a tremendous amount of it, and he's pretty much in charge of making sure everything's being done correctly, and coming up with ways to get things done within the budgets. Bob sits down with the storyboards and figures out what exactly we have to build, and making sure [our crew's] doing that job. And coordinating all the effects, and coordinating the execution of 'em on set. I make sure the shop's running fine in that there's a line of communication. Just overall making sure that we have the materials we need and everybody has something to do and so on. But we're all in there doing a lot of the work."

In the growing stages of the shop, Kurtzman, Nicotero, and Berger generally handled much of the creative aspects themselves, with the goal of keeping expenses low to underbid their substantial competition. Their strategy succeeded, and KNB attracted numerous cash-tight productions—forgettable direct-to-video fodder like *Dr. Hackenstein* and *Nightwish*. As KNB's reputation continued to grow, bigger and bigger films soon came to rely on the boys' services, necessitating the hiring of additional crewpeople and designers. This nomadic group of temporary and permanent artists included Mark Maitre, Bruce Spaulding Fuller, John Bisson, Wayne Toth, Mike Spatola, Mark Tavares, Gino Crognale, Dave Smith, and other gifted monster fanatics.

"Early on, when we were first starting out, we thought, 'We have to do everything ourselves or we can't put our names on it,' " Kurtzman explains. "But you start to learn that it's a business and you just have to make sure that you get the best out in the time frame and for the money, and you have to let your guys do the work. But we always have hands-on; if we don't sculpt something, we're either painting it or seaming it or whatever."

One of their résumé fillers, 1989's *Night Angel*, required the fabrication of their first memorable monster suit: a massive, toothsome, winged demon seen briefly at the movie's end. After director Dominique Othenin-Girard approved his initial creature design, Kurtzman sculpted the head and Berger finished the body.

Bride of *Re-Animator*'s Kathleen Kinmont somehow keeps her composure after eight hours in the makeup chair.
(BYRON J. COHEN)

The teammates completed the demon in two short weeks. The "pieced-together" hellspawn featured a foam-latex head, a polyfoam body with zipper in the back, and a stovepipe neck. When the original actress hired to play the beast quit, Kurtzman donned the cumbersome costume himself.

"It was very hot in that suit, and I couldn't see anything!" Kurtzman recalls. "The jaw was mechanized—it was cable-operated. There were no lips, it was just teeth and jaw movements. The arms were my arms inside. My arms also operated the wings with an extension that came off my wrist."

"We only had time to build one suit," Berger adds. "We just finished it the night before we shot it. We did it over the top; it was wild, wacky monster stuff. We look at it now and say, 'Oh, God, it's so crude!'"

That same year, the producers of *A Nightmare on Elm Street 5: The Dream Child* employed KNB for a rousing metamorphosis sequence, the trio's first Freddy Krueger film as a unit (Kurtzman contributed to *Nightmare 3*'s mechanical FX, while Berger previously helped apply Freddy's Kevin Yagher–designed makeup on *Nightmare 4*). The scene details Dream Master Alice (Lisa Wilcox) battling Freddy (Robert Englund) head-to-head, as their faces combine, stretch and warp into one twisted, scarred shape.

"Alice gets possessed by Freddy, and Freddy stretches out of her," Berger says of the FX highlight. "For the first stage, we did a makeup on Lisa. We got a Freddy makeup that Greg had sculpted, and we applied that on her. And then we had a series of three different heads: One head that was Lisa's face, with an air piston in it that stretched out the whole face. The first head was made of Skin-Flex, which is a urethane. You can plasticize it, making it softer or gooier. The second head was a very twisty combination of Lisa and Freddy, pulling apart. They were just hand puppets—all foam latex, with fiberglass underskulls. Then there was a third head which is more recognizable as Freddy than Lisa, that pulls apart from the two fighting. We didn't have Robert's lifecast, so we did a life cast of Bob with a screaming expression. It was pretty simple and took one day to shoot." For 1994's *Wes Craven's New Nightmare*, KNB constructed a series of prosthetic Freddy heads with widely stretching mouths, in addition to a six-foot tongue and a sleek, revamped glove for the popular maniac.

Freddy's 1989 rebirth heralded the return of several slasher stalwarts to the scream scene, each displaying KNB's bloody ingenuity. *Halloween 5* catalogued the gruesome exploits of undying killer Michael Myers, while *Leatherface: Texas Chain-*

saw Massacre III (released in 1990, due to ratings squabbles) continued the terrifying exploits of the cannibalistic 'saw clan. On both indie productions, Nicotero supervised the majority of the mutilation mayhem: burns, scars, bullet hits, and a few murders in *Halloween 5*; a new mask for Leatherface, the ancient, withered Grandpa, and many excised or censored splatter bits (sawed bodies and heads) for *Chainsaw III*. Nicotero's prior connection with gore auteur Tom Savini sufficiently prepared him for these corpse pileups.

"I'm good with gags," Nicotero admits. "Howard and Bob always leave the blood gag-type things up to me, because I'm really good at rigging that kind of stuff. And I got a lot of that from Tom. I helped him rig many of those gags on set. The opening sequence of *Bride of Re-Animator* is a perfect example, with Herbert West experimenting on the dead and wounded soldiers in the tent. That was my first day on set. I had flown in the night before from *Halloween 5* and [director] Brian Yuzna said, 'I'm not sure what I want here. What do you think you can rig up?' So I walked in, grabbed a machete, hooked up blood tubes, did this, did that, got a dummy, rigged that up—I rigged up about six different effects, and then he came in and I showed him each one. He was floored that within a fifteen-minute time period, I could have gone and worked out six different gags."

"Greg's excellent with gags," Berger concurs. "I'm terrible with gags, I get panicked and I have a heart attack, and usually I fudge it up somehow. Greg pulls 'em off, 'cause he has Tom's confidence and knowledge on how to do all that blood stuff. And it's tough, there's technique to it, appliance work and blood bladder stuff, *timing*....If I'm off a hair, it blows the whole gag. But Greg's dead on."

With a dedicated crew supporting them, KNB launched into the simultaneous shoots of *Gross Anatomy* (a medical-school comedy for which the boys created anatomical body replicas), *Halloween 5*, and *Nightmare 5* in spring 1989. During that same hectic period, they took on the overly ambitious *Bride of Re-Animator*, which united the services of several independent FX houses (surrealist Screaming Mad George, John Buechler, Tony Doublin, and others). The sequel's low budget was saddled with an impossible shooting schedule and failed to allow for adequate preproduction time. Nevertheless, KNB persevered, delivering one of their most impressive creations ever, the Frankensteinesque beauty of the title (Kathleen Kinmont). In addition, their lab produced a few relatively simple zombie makeups.

Due to a delay in the Bride actress's casting, Kurtzman and Berger only had one weekend to sculpt the makeup and just two weeks to build the suit. Without ample

A variety of convincing FX techniques gave life to the undead soldiers of Sam Raimi's *Army of Darkness*.

time to sculpt a design maquette, they instead modified a hobby store Invisible Woman model, embellishing how the replica would look "opened up." Yuzna suggested the addition of metal bones and joints to hold the Bride's motley body parts together instead of stitches, which KNB promptly incorporated. Hot off *Gross Anatomy*, the duo decided to accentuate anatomical realism for the reanimated character, emphasizing open muscles, exposed ribs, and splayed flesh. Actress Kinmont endured fifteen separate body casts, including one full-body cast which she fainted inside of. In one of two head casts, the FX artists asked Kinmont to hold a screaming expression (open mouth, squinting eyes) for the scene in which the Bride's head pulls itself free from its torso. For her debut, Kinmont lay across a slanted table as Kurtzman and Nicotero applied the thirteen-piece prosthetic makeup in a grueling eight-hour session (they later cut the time by two hours).

"There was the body suit; appliances on her feet, hands, and her neck," Berger

notes. "That was the toughest makeup Bob and I ever did. We started in the morning, and then Mike Spatola would come in and apply the feet and hands. We were spent. And Kathleen was spent. It was a hellacious show."

"It was a full-body makeup," Kurtzman adds. "The most we'd ever done [previously] was maybe a facial appliance and a chest appliance. Also, it had to go on in a certain amount of time. So we had to design half of it as a suit, but we didn't want to put it over her whole body. So one leg is her real leg and the other one a full prosthetic, all the way down to the ankle. Then we had to glue the whole thing down, which was another nightmare."

"We had to come up with this spray makeup," Berger interjects. "And we only had time to do three suits—but she shot six days, so we had to stretch each suit to two days of shooting. And that was very hard. We'd do it one day with a fresh suit, and then we cleaned her off really carefully. And that took two hours to take her out. We'd save the suit, clean it out. And then she'd come back the next day, and we'd put it on again. It was a hard show with difficult bosses, long hours, and no air conditioning—we were fried. It felt like we were in a war. I just walked off that movie thinking, 'I hate this film, I hate everybody....' But it turned out pretty good. I like the Bride a lot, it's one of my favorite makeups that we've done."

With no time for vacations, KNB jumped into their next project, Paramount Pictures/Laurel's *Tales from the Darkside: The Movie*, as soon as *Bride* wrapped. The producers originally considered dividing the FX for the film's three segments among three different shops, but, relishing the opportunity, KNB convinced the company to stick with their lab only, with Dick Smith serving as a consultant (more for marquee value than anything else). The first story, "Lot No. 249," required a musty old mummy and his mutilated victims. The second, "Cat from Hell," called for a phony feline to survive a hitman's assault, in addition to a tasty scene in which the evil cat crawls down the throat of actor/musician David Johansen (or more precisely, his dummy head). KNB saved their most impressive effect, however, for "Lover's Vow," which needed an eleven-stage transformation of petite actress Rae Dawn Chong molting into a seven-foot gargoyle with a fifteen-foot wingspan!

For the gargoyle's fearsome debut, KNB spent a couple of weeks of prep, followed by three days of shooting. A vague script description allowed Kurtzman, Tavares, and Fuller free rein in designing the monster. Kurtzman took a week to sculpt the gargoyle's head in WED clay, and then sent it to the mold department. The producers reenlisted mummy actor Mike Deak to play the creature, thus enabling the

body to be sculpted off Deak's existing life cast. Bruce Fuller and Wayne Toth sculpted the legs in an unusual triple-jointed position, when in actuality Deak's legs went straight down.

Next, KNB molded the completed body in fiberglass. Engineers Mark Rappaport and Mecki Heussen mechanized the underskull of the creature. A foam-latex head was glued over the skull, and radio controls manipulated the eye and lip movements. (Deak could only see out of the creature's mouth.) KNB constructed the entire suit out of foam latex, backed with spandex for strength. To support the gargoyle's wings, Deak was strapped into a converted mountain-climbing rig. Rods were placed at the end of each twenty-pound wing and operated off-camera, giving the impression that they could unfurl and open out at will.

The transformation of Chong to the head-ripping creature involved several makeup stages for the young actress, which KNB storyboarded weeks in advance. The sequence begins with a "shock cut" of the gargoyle's hands tearing through Chong's own. For this bit, hollow fiberglass arms with foam-latex appliances on the backs of the "human" hands were pressed into action. Spring-loaded gargoyle hands were thrust out, shredding through the foam at just the right moment.

The next step placed Chong in the first-stage makeup, for which she wore a baldcap with bladders attached. The boys then applied another skin with the creature's texture on top of that to simulate her head expanding. A simple brow and cheek appliance was glued down along with a wig to begin the monstrous metamorphosis. During the take, technicians inflated the bladder as Chong reached up and pulled the outer layer of skin off.

For the second-stage makeup, Chong patiently sat in the makeup chair again for another three-hour endurance test, as the crew fit her into a custom-made body suit. Kurtzman then glued on the full-head appliance and blended it into the rest of the costume. Later, during the take, her chest expands via air bladders and her nightgown is ripped off, revealing the gargoyle's scaly epidermis. The leg transformation (sculpted by Brian Wade) consisted of several push-pull mechanisms that stretched the appendages, mimicking rending flesh and protruding horns.

In the final analysis, KNB's gargoyle transformation ranks as one of the finest movie-monster metamorphoses ever committed to celluloid, right along such '80s benchmarks as *An American Werewolf in London*, *Cat People*, and *The Fly*. "At

In the Mouth of Madness **featured a score of KNB monstrosities, including this miniature.**

the end of that show," Berger says, summing up KNB's *Darkside* tour, "Dick Smith was saying to us that he was sure that we'd never be able to do all the stuff for the amount of money and for the time we had. But we did."

After mastering the art of fantasy creatures, KNB next turned to real animals. For his epic period Western *Dances With Wolves*, director/star Kevin Costner drafted the shop to build twenty-four fake buffaloes for the movie's rousing stampede sequence. Of the twenty-four, three were mechanical. "One was fully pneumatic that lay on the ground, and we had pneumatic lines coming out of it," Kurtzman explains. "All four legs kicked, and the head moved up and down. We had air hoses hooked up to pistons so they could blow snot, smoke, or dust out of its nose. And we built two collapsible buffaloes and a wheelbarrow buffalo, too, with just the head for sliding-into-dirt shots. The rest were all prop buffaloes, for the dead carcasses."

For the comedy hit *City Slickers*, KNB returned to the animal kingdom to literally deliver "Norman," a baby calf, for the film's realistic cow-birthing scene. "We used the same molds from *Dances With Wolves*," Nicotero reveals. "The birthing cow was a buffalo rear, which we put udders on. Nobody notices our work on *City Slickers* and *Dances With Wolves*, which is a compliment. The cow wrangler [on *City Slickers*] even thought it looked real." More zoological research paid off on *Rudyard Kipling's The Jungle Book*; KNB created a tiger, bears, panther, and other animal props for the 1994 Disney adventure. And for the Arnold Schwarzenegger actioner *Eraser*, the shop ventured into the reptile world, building several hydraulic and pneumatic alligators. "We tested one of the gators in Greg's pool, and it swam," laughs Kurtzman.

The verisimilitude of KNB's special makeup FX came into play again on Rob Reiner's intense Stephen King adaptation *Misery*. A pair of hinged gelatin legs were strapped onto actor James Caan's knees (his real ones were hidden under the cutaway bed) during the infamous sledgehammer scene. To depict Caan's bruised legs, the actor wore foam-rubber boots, derived from his life cast, that displayed unsightly bruises, exposed veins, swelling, and copious black-and-blues. For tormentor Kathy Bates's violent comeuppance, KNB built four gelatin heads of the actress (each featuring a different pained or screaming expression) for her climactic brutal bludgeoning.

While *Darkside*'s gargoyle represented KNB's greatest technical feat, Sam Raimi's *Army of Darkness* (1993) emerges as one of the shop's largest undertak-

ings to date, demanding a staggering amount of work on a medium-size budget. Friendly with director Raimi, producer Rob Tapert, and actor Bruce Campbell since their *Evil Dead II* sojourn, KNB dove into the comic horror adventure with gusto. In all, they supplied *Army of Darkness* with four groups of skeletal "Deadite" warriors; a gargoyle-ish winged Deadite; two possessed Deadite pit monsters; a witch makeup; and an array of makeup props, armor, and "other dead stuff," according to Kurtzman. "Everything we did, Sam loved. We just kept bringing stuff to the set that he never paid for or saw," Berger laughs.

"The guys really gave us an opportunity to showcase what we could do," Nicotero says. "We knew going in what to expect from Sam with every shot, since we had worked with him before. We designed the show so that it would be easy and quick—bring it in, bring it out. They felt we were reliable; they'd ask for ten puppets one night, and we'd have them there, ready and suited up. You can get bogged down with overdesigning or overcomplicating an effect, and it will take an hour to set up. We designed everything knowing how Sam likes to shoot."

KNB utilized four methods to fill in the rows of undead warriors. "We had twenty close-up foam-latex body suits and heads. Those were the A suits," Nicotero explains. "The B suits were foam-fabricated skeleton bones over black spandex unitards with skull masks. For the C ones in the back, we created fifty silk-screen body suits with bones painted on." For the barely glimpsed D group, KNB simply covered up stuntmen in cloaks and helmets.

In addition to the costumed Deadite soldiers, KNB constructed ten mechanical fiberglass puppets—two cable-controlled, eight rod-puppeted. The crew devised different methods for operating the puppets: (1) a backpack puppet rig worn by the puppeteer, who, hidden in trenches, rod-puppeted the skeleton from below. (The flying Deadite's wings were rod-puppeted as well. For this creature, KNB perfected the use of arm extensions, which they first attempted on *Night Angel*.); (2) a go-cart that wheeled the puppets past the camera; and (3) skeletal puppets hooked up to a PVC-pipe dolly track that ushered them around. In similar low-tech fashion, stationary puppets were simply propped up against an apple cart. "If one system didn't work, we used the other," Kurtzman says.

KNB played with other dead things on *Jason Goes to Hell: The Final Friday*, for which the gang resurrected the body-count king for his last Crystal Lake rampage. The sequel begged for the expected slasher carnage (heads squashed into grates, brain-crushing beatings, heart munching, and skewered waitresses), as

well as a new visage for Jason Voorhees that combined the makeups developed for *Friday the 13th Part 2* (Carl Fullerton's misshapen head) and *Part VII* (John Buechler's exposed spine and bone concept). But besides the requisite slasher stuff, KNB also came up with several parasitic demon creatures that represented Jason's transferable evil.

One horned monstrosity, which slithers about near the film's end, was played by leg amputee Don Jackson in a full-body suit. "We needed a person like that in order to do the tail, which we sculpted tapered down so it wouldn't look like a guy with legs in a rubber suit," Kurtzman reveals.

The FX boys admit that what attracted them to this violent *Friday the 13th* entry was the opportunity to introduce new creature FX to the series, especially for the film's action-packed conclusion, in which "dirt demons" emerge from the earth to pull the reluctant Jason (Kane Hodder) to hell. The sequence consisted of tight editing that cleverly intercut between full-scale figures (including giant mechanical polyfoam hands painted like dirt) and tiny puppets that KNB built on a tabletop miniature to be shot in forced perspective on the actual set. "It looks great because you can't tell the difference," Nicotero says of *Jason Goes to Hell*'s cost-effective FX techniques. "I was there when we were shooting it, and when the people saw the dailies, they said, 'Is this the miniatures, or is this the live action?' "

The studio first began experimenting with miniatures on Avi Nesher's *Doppelgänger: The Evil Within*, a supernatural thriller starring Drew Barrymore. The ending of the film, in which the demonic double finally reveals itself, demanded 170 separate FX shots on a next-to-nothing budget. Instead of going full-size and blowing their entire fee on one twelve-foot mechanical monster, KNB instead talked the director into incorporating miniatures. In all, 35 percent of *Doppelgänger*'s FX scenes were shot with KNB's models and scaled-down creatures.

"What we've been finding lately is that producers and directors want more for less money," Nicotero says. "It's just the climate of the industry. They want to see a full-standing, walking creature stroll through a room, or a twelve-foot worm creature transforming on a couch. What we have been saying is, 'We can give you this, but this is the way you're going to get it.' "

Another monster mash awaited KNB with John Carpenter's Lovecraftian saga *In the Mouth of Madness*. Having previously worked for Carpenter on his Showtime anthology shocker *Body Bags*, the boys eagerly tasked themselves into designing the creature fest, which surpassed *Army of Darkness* in terms of vari-

ety of FX. In short order—just seven weeks!—KNB dreamed up a multitude of otherworldly horrors, the most prominent being an eighteen-foot Wall of Monsters that gave the illusion of a hundred multitentacled beasts. Operated by twenty-five crew people, the Wall was accomplished with just a dozen latex and urethane foam creatures standing in for the dimension-crashing brigade, shot in forced perspective to convey a much greater number. Other FX techniques entailed puppet work, freakish prosthetic appliances, and giant foam suits.

KNB topped their *Army of Darkness* and *In the Mouth of Madness* workloads with *From Dusk Till Dawn*, a project Kurtzman and buddy John Esposito had been developing as a feature film since 1990. The two hired then-unknown screenwriter Quentin Tarantino to flesh out their story, but it would be five years before the film became a reality when Tarantino hit it big

The much-hyped *From Dusk Till Dawn* emerged as KNB's biggest showcase to date.
(JOYCE RUDOLPH)

with *Pulp Fiction*. An action/horror pastiche, *Dusk* throws a group of mad dog killers and their hostages into a Mexican bordello run by a horde of vampires.

"*Dusk* had tons and tons of monsters, suits, and puppets," raves Berger, who previously jumped on the bloodsucker bandwagon with the failed 1995 Eddie Murphy vehicle *Vampire in Brooklyn*, for which KNB came up with the comic star's various incarnations (including four stages of vampire makeup and a white street hood disguise). "*Dusk* was much bigger than *Army of Darkness*. *Army* had ten puppets,

Dusk had a hundred times more than that. In *Army*, the scope occurs in the last reel; in *Dusk*, the minute all hell breaks loose in the bar, the effects do not stop."

Dusk found the boys on set eight weeks out of the shoot's twelve-week run, closely following their sixty pages' worth of storyboards that mapped out the film's horrific action. A few design variations were introduced as well. "Usually, when you get a script, you'll sit down and initially start doing sketches, which don't necessarily pertain to the actor who is playing the part," Nicotero explains. "But on *Dusk* we actually got head shots of the actors and utilized certain facial characteristics of theirs and accentuated them. Each individual vampire looks completely different, no two vampires look the same, each is unique. It wasn't your standard *Lost Boys* brow."

"I did Quentin's makeup with Wayne Toth," Berger says of the moonlighting scripter. "We had a lot of different designs, and we all looked at them, including Quentin. He was actually wonderful to do the makeup on because we know how much Quentin likes to talk."

Tarantino's only complaint was having to don contact lenses for his vampiric changeover, though none of the cast relished wearing the Dr. Richard Snell–designed eyewear. "All the actors hated them," Nicotero says. "On *Dusk* we had twenty-five sets of soft lenses. Each character had contact lenses which went along with the designs of the makeup. As with the ones we did for *In the Mouth of Madness*, the lenses were pretty standard, though we had to come up with different patterns for each set. Director Robert Rodriguez wanted really big eyes with tiny pupils. On Tom Savini's makeup we ended up using two pieces of lace to pull his lower eyelids down, and the lenses we made for him had really tiny pupils, so it looked like he had really big eyes."

Kurtzman, Nicotero, and Berger continue to make inroads into the entertainment industry. While Berger foresees the shop sustaining its own visual FX wing, Kurtzman has since made the leap into directing, having helmed the revenge thriller *The Demolitionist*. He's itching to do more and wants to bring his partners along with him. "We're going to have to go into making our own films," he says. "That's our main objective." In the meantime, KNB EFX Group remains fiercely competitive in the makeup illusions industry, chasing after both low- and big-budget films to keep their studio on the hot track.

"At a point, you can't compete with the people you used to compete with, but in essence that's OK because you've moved up the ladder," Berger says. "You're

now competing against Steve Johnson, Kevin Yagher, Tony Gardner. You're bidding on projects that have a little more money. We lose projects, everybody does, and it does usually come down to the money. But at least we're always in the running—it always comes down to us and somebody else. And that's nice. And even if the other person gets it, he's your friend, it's somebody who's going to do the show justice and do a good job. But it's hard to stay competitive. There's fewer and fewer of these films being made."

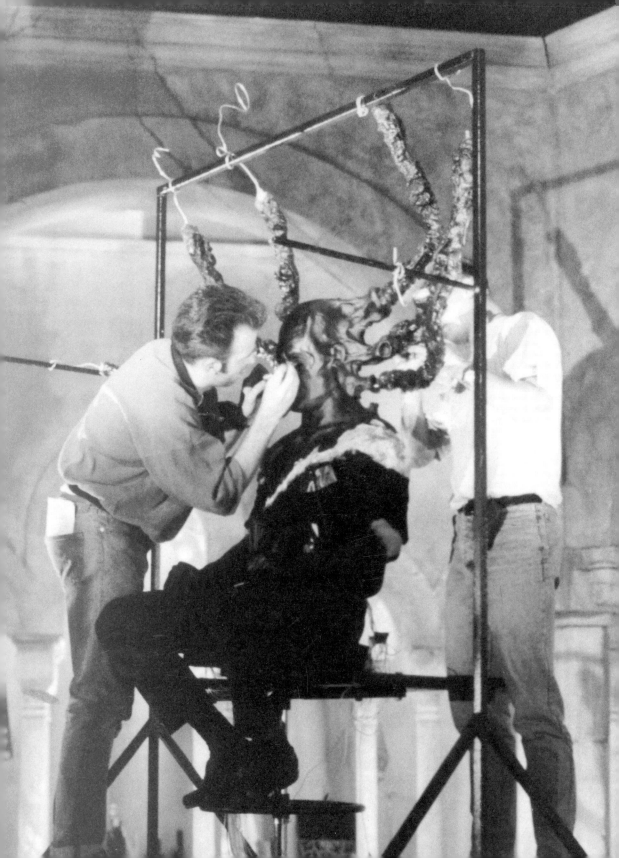

Bob Keen and Image Animation

Raising Hell

Loyalty is a rare commodity in the motion picture business, but the enduring creative relationship between author/director/producer Clive Barker and makeup FX designer Bob Keen is a fruitful exception. Through the production of the four *Hellraiser* films, *Nightbreed, Candyman*, and *Lord of Illusions*, Barker's dark vision has been transferred to the screen faithfully, its horrific beauty intact, thanks to his long-standing collaboration with Keen and his intercontinental Image Animation company.

"My working relationship with Clive is a joy," Keen says of their enduring professional association. "He's the kind of director a makeup effects artist—or anyone, really—dreams about. He's communicative; he can articulate his problems through drawings and in the way he speaks, the way he talks to you; he's supportive, and he's got this great, weird imagination."

The British-born Keen is speaking from Image Animation's main headquarters, located at Pinewood Studios outside of London. This historic lot has played home to several grand-scale James Bond and Superman films, in addition to Barker's first two *Hellraisers* and *Nightbreed*. Besides Keen, the only other employee in the shop today is his attractive Texan wife Sheila, who serves as the company's office manager. Keen's two-story workplace is experiencing a rare lull today; Image Animation has just finished a spate of international motion pictures—TNT's *Frankenstein* in Poland, a *Gremlins* knockoff in Canada called *Little Devils*, *Cyborg Cop* in South Africa—and is enjoying a brief slowdown prior to opening a Los Angeles branch. On American soil in 1992, Keen's shop orchestrated the makeup FX on two hit Clive Barker productions, *Hellraiser III: Hell on Earth* and *Candyman*; the Barker connection continued in 1994 when Keen's new Chatsworth, California–based division delivered FX to the auteur's *Lord of Illusions* and *Hellraiser: Bloodline* simultaneously. With all the overseas activity, it's not surprising that a healthy layer of dust has formed over the models, molds, and

Image Animation's Geoff Portass (left) and Steve Painter touch up Baphomet before shooting.

props from their past opuses found here in the British home base. Image Animation's non-Barker projects have included *Hardware, Warlock: The Armageddon,* and the two *Waxwork* films, as well as *Highlander* and its first sequel. Inside Keen's office, a bust of *Hellraiser*'s Pinhead and a maquette of the CD Cenobite loom prominently. Not surprisingly, these items are two of Keen's proudest accomplishments.

It is hard to imagine Barker's *Hellraiser* without its "sadomasochists from hell," led by the crown prince of evil Pinhead (Doug Bradley) and his malevolent minions, the Cenobites. Image Animation put the flesh onto the bones of the author's disturbing story. In one of the most ambitious genre projects of the last decade—Barker's fascinating but creatively shunted *Nightbreed*—Image Animation populated the fabled city of Midian with two hundred (!) fascinating and unique monsters. For the chilling *Candyman*, Keen's team devised a hook to replace the amputated hand of the movie's titular bogeyman, as well as his deadly mouthful of living bees. In a way, Image Animation's special makeup FX have become the fast track for Barker's cinematic horror rides. You could say it's a partnership made in hell, but in the best possible sense.

"Clive is still probably the only person with whom, mentally, it's a running contest to keep up with," Keen, thirty-six, says. Seated on his office couch, he is a husky, jovial chap who occasionally cracks up when discussing his bloody illusions. "Clive's incredible with his mental process. It's like Ping-Pong. You have an idea and it's knocked over the table, and Clive knocks it back. It's the speed with which it's knocked back at you that makes Clive who he is. And the accuracy of his imagery is incredible. We've had brainstorm conversations with him that are still some of the most enjoyable moments of my life, where you're completely brainstorming with someone who's so creative and so much on your side of things. It's a wonderful, enjoyable experience. That's been true on all the pictures we've done together."

The Hammer horror films stoked Keen's imagination while he was growing up in 1960s London. An early fascination with magic eventually led to makeup experimentation in which the young artist used his cooperative brothers as subjects. "It started off with my wanting to be a magician, and the main element of being a magician is to fool people into believing they're seeing something that they aren't," Keen says. "That grew into wanting to change people into werewolves, or making them look like they'd been beaten up, or they'd been in a road accident."

On school holidays, Keen spent his time practicing his craft and sneaking into

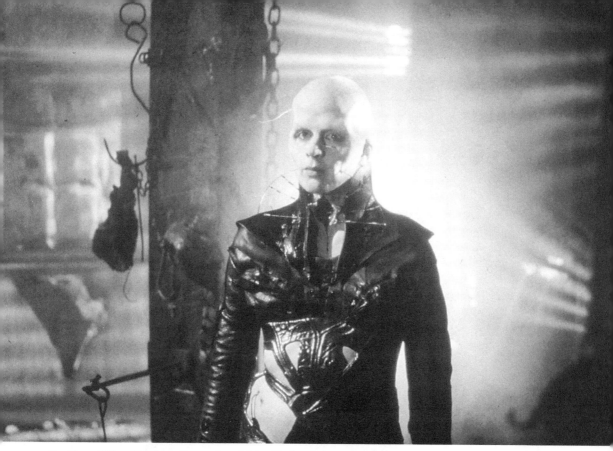

Author Clive Barker described his *Hellraiser* as a story about "desire." Who'd desire Female Cenobite Grace Kirby is anyone's guess.

Shepperton Studios to observe the wonder of filmmaking firsthand. Ignoring his guidance counselor's advice to join the military ("The army blows things up, just like special effects people do," the teacher told him), Keen instead directed his attention to finding a position as a modelmaker, which he did on a number of big-budget science fiction and fantasy films, including *Star Wars*, *Superman*, and *Alien*. A subsequent interview with special FX chief Brian Johnson for *The Empire Strikes Back* led to a chance meeting with that film's makeup FX creator, Stuart Freeborn, the legendary artist whom Keen calls "the British Dick Smith." Freeborn took the teenage assistant under his wing, enabling him to gain considerable makeup knowledge in a few short months. Keen subsequently abandoned modelmaking and visual tricks for makeup and monsters.

"I found very early on that building models and such didn't stretch my imagination," he says. "Unless you're building something like a spaceship, everybody knows what it looks like. If you're building a model tank or a model aircraft or a

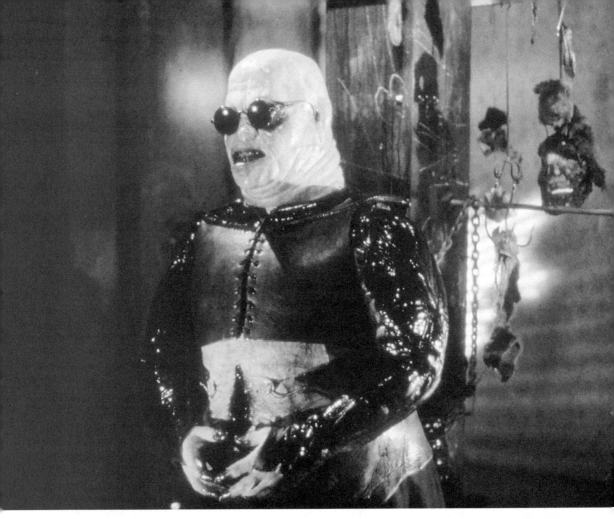

According to Barker legend, the insatiable Butterball (Simon Bamford) sliced himself open for an express route to his stomach.

model building, it's very exact, very precise work, but it doesn't involve an awful lot of imagination. I'd always had a yearning to do makeup effects."

On *Empire*, Keen met British makeup FX creator Nick Maley. Shortly after the George Lucas epic wrapped, Maley hired him as a chief assistant during a boom period of British-filmed fantasy and horror epics, including epics *The Keep*, *Krull*, *Lifeforce*, and *Highlander*. The sheer volume of work ran the gamut of makeup FX technology and proved to be Keen's essential learning experience.

"We just did a lot of movies," Keen recalls of this intensive period with Maley, who has since retired from the business. "And you get to a point where you've done a lot of effects and you have a lot of experience. The nice thing about that was, every single day, you'd be doing something different. So you could stretch

yourself, and you could learn through the diversity of the jobs. It wasn't all just prosthetics, it wasn't all just makeup effects, it wasn't all just killing people—it was a whole variety of effects and techniques. That's where I really learned the trade, and where I sort of set down what I wanted to do."

In 1985, Keen spent a little over a week supplying background makeup to a science-fiction horror film called *Underworld* (released in the U.S. as *Transmutations*), which just so happened to boast a script by Barker (who now disowns the otherwise botched effort). While Keen was decapitating animatronic dummies on *Highlander*, he received a call from Barker, who was starting up a low-budget shocker titled *Hellraiser* as his directorial debut. Unfamiliar with his fiction, Keen dashed off and picked up a volume of Barker's superlative *Books of Blood*, which turned him into a follower in no time at all. During their initial powwows, Barker and Keen clicked, and one of horror's most significant creative marriages took place. Shortly before Keen teamed with Barker, he and partner Geoff Portass founded Image Animation; *Hellraiser* would be their first major trial, an opportunity to put their company—and Barker—on the international fright filmmaking map.

"It became obvious to me that Clive was someone very special, and I wanted to do my best work for this man, whatever it took," Keen says. "Consequently, I put everything I had into *Hellraiser* and crossed my fingers, just hoping it worked. If it hadn't worked, then *Hellraiser* would have been a sort of nothing film and disappeared. Image Animation probably wouldn't be around today. I risked everything the company had on *Hellraiser*, and it paid off tenfold."

Described by its creator as a love story, *Hellraiser* tells the morbid tale of the adulterous Julia Cotton (Clare Higgins) and her infatuation with her late paramour Frank (Sean Chapman). A hedonist who had turned to the dark forces of Hades to satisfy his bizarre fetishes, Frank had solved a mysterious puzzle box that unleashed a quartet of demons known as Cenobites. Commanded by an imposing leader with a grid of pins protruding from his skull, the infernal creatures skinned the sadomasochist Frank alive. Julia still pines for him and ultimately resurrects him with fresh human blood, leaving stepdaughter Kirsty (Ashley Laurence) to fend off the lecherous, reanimated ghoul, as well as the returning Cenobite brigade.

To put flesh and latex on the bare bones of Barker's original "Hellbound Heart" novella, Keen met the author for several intensive design sessions, where they tossed around ideas over beer and pizza. Inspired by the film's motto, "There

Are No Limits," director and makeup creator sought to come up with unique makeup concepts that broke with the then-hot Rob Bottin and Rick Baker traditions, as well as the conformity of other horror shows. Keen and his sixteen-member staff drafted some two hundred drawings depicting *Hellraiser*'s perverse imagery and demonic denizens. Once filtered through Barker, the look of the Cenobites ultimately emerged.

The designs took their inspiration from a pain/pleasure principle, the idea that these beings were once mortals who abandoned their humanity in the pursuit of other "kicks." Barker and death-obsessed costumer Jane Wildgoose established an attire for the Cenobites that combined each's mutual interest in the Spanish Inquisition (the long coats) and leather/bondage themes. "We had unwritten laws and written laws, and it became very much, 'This is the world of the Cenobites,' " Keen explains. "Everything was established on that first film, and we've never really broken those rules since. And it's very important that we don't."

Pinhead, as the lead Cenobite came to be called in the sequels, went through a surprising transformation during these early design stages. Barker first conceived the character as a female in "Hellbound Heart," and his initial concept for the film was closer to *Nightbreed*'s sexy, porcupinelike Shuna Sassi. To lay out quills evenly across a human pate, the designers drew a grid onto a head. Barker liked the carved-in pattern idea, and then substituted nails for quills. Seeking a more elegant look, the nails were then replaced by pins. Once this concept was approved, Image Animation next faced the challenge of making hundreds of pins stand erect from the head of the lead Cenobite's makeup.

What brought the character to life, however, was the casting of actor Doug Bradley, an old chum of Barker's from their university days. According to Keen, Bradley's own facial features and persona dictated much of the character's look and attitude. "Pinhead is ninety percent Doug and ten percent the makeup and the costume," he says. "He brought an element to the character that became Pinhead."

The makeup itself, though, turned into a true endurance test for all concerned, a prime reason that the infernal gamemaster was limited to only six shooting days during production. "We started by life-casting his face first," Keen recalls. "And then the design slowly moved towards what we know to be Pinhead. But at the time, we were very worried about foam shrinkage and alignment and everything else, and we covered our ass by having a seven-piece prosthetic makeup. The downfall of that was, it took four to five hours to apply. So it was massively exhausting for Doug and for the makeup team who applied it. And the end result was that we'd start work at

four a.m. on it, and we'd get on set at nine or ten. And then we'd shoot through to ten at night. It would take an hour to take it off.

"The pins themselves each had a plate inside the latex to support them, with the pin going out," he continues. "The pins were regular straight pins, and painted brass tubes were then slid over that. They had a little tiny brass cap to make them stand up straight. There were hundreds of these bloody things on his face!" For *Hellraiser III*, Keen assistant Paul Jones substituted painted Q-Tip sticks for pins to speed up the application process. On the fourth *Hellraiser*, Image Animation's creative director Gary Tunnicliffe redesigned Pinhead's makeup a third time, returned it to the older style, and fashioned 108 pieces of round-headed plastic tubing to define the character's prickly features.

For Pinhead's gray-blue latex countenance, Image Animation applied a grease-paint color scheme made up of eight different hues to the actor. Another color shading went on the lips and around the eyes. In addition to the seven facial appliances, Pinhead sported four separate latex pieces for his body, and Bradley wore soft black contacts that increased the size of his pupils. On each day that Pinhead

Peloquin and Kinski are still waiting for their *Nightbreed* sequel.
(MURRAY CLOSE)

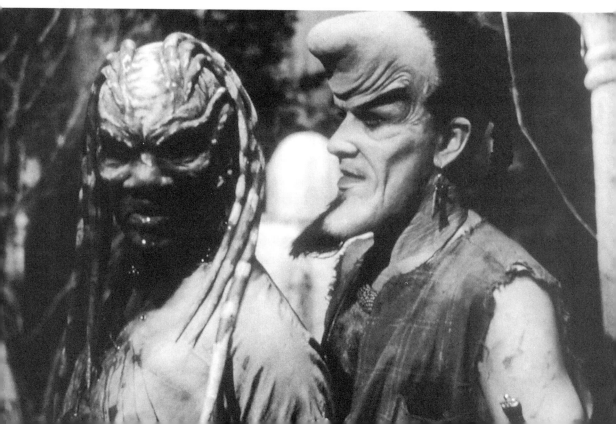

stalked the set, Image Animation spent two days beforehand preparing his pieces—foaming, painting, and "pinning" the multiple appliances. "It was a massive job," Keen understates of the Portass-sculpted and -applied Pinhead makeup.

Compared to Pinhead, the other Cenobites—Chatterer, Butterball, and the Female Cenobite—were a breeze to execute. Chatterer, whom the crew nicknamed "Poor Bastard" because of his inability to see, hear, or speak, was fairly easy to sculpt. Actor Nicholas Vince, who inspired the design of the Cenobite because of his chattering dexterity, wore a one-piece over-the-head appliance and denture piece featuring a splayed-open latex mouth section. Vince had a plate in his mouth; when he chomped his real teeth, the motion chattered the artificial dentures on the outside. The actor was completely blind in the makeup because of the separate latex piece that fit over his eyes, depicting Chatterer's skewered eyelids. Miraculously, the foam latex mask survived the entire shoot intact and took only a half hour to apply. "Once he was in it, he couldn't get out—he was blind for the rest of the day," Keen laughs. "Chatterer also had to be hand-fed through this complicated teeth mechanism. And he drooled! There was a constant problem with drooling, so eventually we decided the teeth could come out."

The equally sightless Butterball (Simon Bamford) compounded his sorry existence with slovenly eating habits. Image Animation fabricated a one-piece foam latex mask and a snipped-foam stomach for Bamford. "We made a fat suit for Simon to wear," Keen notes. "We wanted the feeling that this guy couldn't eat another thing if he tried, he had stuffed himself silly. And the idea of glasses on him was a nice touch, because all the way through the picture, this guy's got shades on and you don't know why. Then finally the glasses are removed, and his eyes have been sewn up. Also, the torn-open stomach was a fun idea: That someone that fat would have direct access to his stomach, he could probably reach in and pull out the nasty stuff."

The design of the Female Cenobite came out of Keen and Barker's *National Geographic* research. Flipping through back issues, the duo grew fascinated with tribal scarification and body piercing. Actress Grace Kirby's three-hour makeup consisted of an eight-piece appliance job for her face; a skull plate underneath the prosthetics to support her pierced cheeks; and a set of bars that penetrated her artificial throat in sadomasochistic fashion. Kirby, however, took no pleasure from the role, hating the extremely uncomfortable makeup that prevented her from even sitting down. "It was a very difficult makeup to wear," Keen admits, "and that was reflected in how she felt about it."

Though Pinhead is the one *Hellraiser* image that more people remember, the skinless Frank gets Keen's personal vote as the film's most accomplished and disturbing creation. Not unexpectedly, it was the toughest makeup job on Image Animation's roster as well. In the film's rousing recomposition scene, fresh blood on the floorboards reanimates and helps reconstruct the skinless body of the film's deceased antagonist, who reappears as if he had just stepped out of a medical textbook. Shot after the wrap of principal photography when distributor New World Pictures pumped more money into the production, Frank's eight-stage rebirth entailed a variety of FX techniques, specifically a combination of cable-controlled puppets, reverse puppeteering shots, and reverse meltdowns. The complete makeup (a mixture of gelatin and wax in different layers) was slowly melted so that the layers ran off as the cameras rolled. When the shot was run backwards on film, it gave the impression that the being is reconstituting itself, the flesh and blood moving up the form. Eight different model stages were used to create the scene, as well as close-up appliances to show the hands forming and the internal organs running up into the evildoer's chest. Time-lapse camera dissolves sold the illusion as one continuous sequence.

"We were destroying the end result to make it look like it was being created," Keen explains. "We melted it down to almost nothing with these four huge industrial blowers, and puppeteered it as it went down. And then, in reverse, this thing would come out of the slime. If you watch the sequence again, there are lots of cuts; there's a cut to a chest section where you see all the internal organs fill out, which is a combination of bladders, reverse meltdowns, and pumping goo through so that liquid would run up.

"We had a raised set, three feet above the floor, and we were using very simple rod techniques to puppeteer the spinal column and things rodding through the floor," Keen continues on the FX highlight, which took two days to shoot. "As the sequence begins, you see the floor vibrating and then the nails pushing themselves out. The nails were fired up through a tube, accompanied by a jet of air with dust mixed in. Next you see pools of slime come up; we pumped the slime from underneath the set to form that. You then see two puppeteered arms shoot up through the slime, and then fall down. Next the spinal column pulls itself out of the slime. A new puppet, which was fully articulated from the shoulders and again operated from underneath, would then pull itself up with these strange, wormlike finger appendages. We then formed the brain—which was hollow and made of wax—up out of a reverse meltdown, and we put colored string on it so

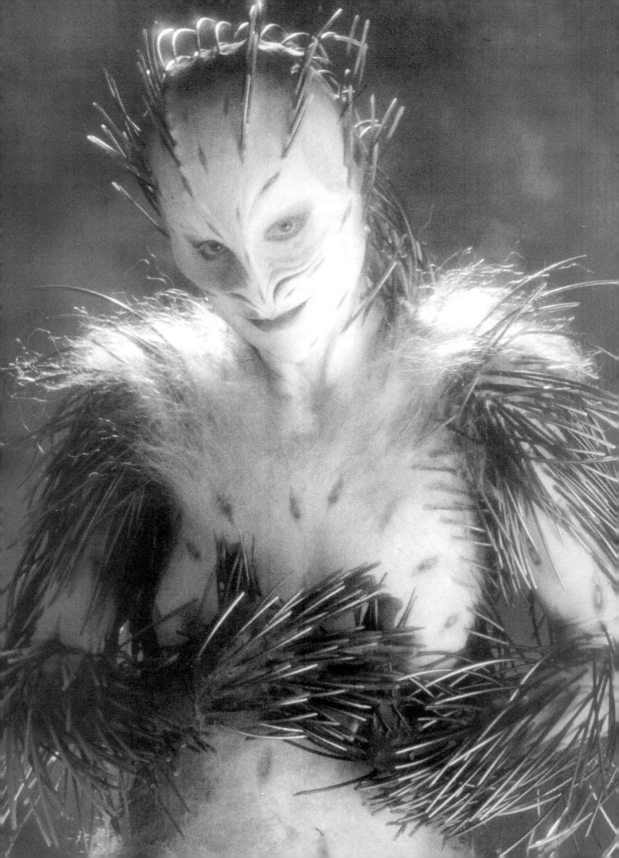

we could snake them up as veins. We then had another puppet made, which is where the brain lifts itself up out of the goo and looks around, and the face starts to form on the brain. We then cut to an interior shot, where all the internal organs start to form up, which was again a reverse meltdown. Then we cut to a puppeteered hand, with finger extensions built to come up through the floor and start moving around. There's another reverse meltdown where the flesh forms on the back. Then we cut to a new puppet, finally, for the last moment, where it leans back and screams."

In the course of the film, Frank is seen in three different stages of makeup as a skinless fiend needing the blood of fresh victims to reconstitute himself further. A head-to-toe body suit was created for extremely skinny actor Oliver Smith, who played "Monster Frank." The body suit, as a matter of fact, was constructed *on* Smith, who wore a thin leotard onto which thirty or so foam-rubber appliances were glued. For the first run, the patient stunt player had to stand for eight hours while this makeup wonder painstakingly came together. Once the suit was completed, it could be carefully peeled off and reused. The hands, arms, and tops of the feet were separate prosthetic appliances.

"Frank's face was almost an eleven-piece makeup," Keen says of the four-hour application job. "It had layers of muscle structure and a beautifully sculpted neck piece that went off into the suit, which was three-piece; it had a nose, forehead, separate lips, separate eye bags, a separate cranium piece, and two separate pieces for the back of the neck. It was a massively complicated makeup, but it was the only way of achieving that look, one in which you stick prosthetics on the outside of the actor and they look *thinner*, they look like they've lost something. So it was the toughest of all problems. A lot of it was clever paint jobs, clever lighting and everything else. Other people have tried, but I still think we've done the best skinned people—if that's a credit that I want!"

On the quickie sequel *Hellbound: Hellraiser II*, which went into production fourteen short weeks after *Hellraiser*'s successful American opening, Image Animation created the skinless Julia, utilizing the same technique accomplished with Frank. While Frank's design was closely researched from anatomy journals, Julia necessitated a bit of fanciful interpretation. "The actual look of what a skinned woman is like is not what we created," Keen says, "because it would not look like

Nightbreed's **Shuna Sassi owes her genesis to Barker and Keen's early Pinhead concepts.**
(MURRAY CLOSE)

that, particularly in the breasts and buttocks. We put them back in, where they wouldn't be if we'd done it the same way as Frank. It was more your mind leading you—you see what you expect to see—than reality. Sometimes, if you did what really exists, the audience wouldn't believe it. You have to give them what they expect to see. Julia is certainly an example of that."

Though Barker supplied the initial story and served as executive producer, *Hellbound*'s directorial reins were held by American Tony Randel, a postproduction consultant on the earlier film. Due to the sequel's rushed shooting schedule, Keen was not granted the opportunity to add to Barker's Cenobite ranks, except for the inclusion of Channard (Kenneth Cranham), a design Keen originally developed for the first film and then abandoned. Channard's "egg-slicer" prosthetic makeup featured tightly wrapped steel cables around the face that cut into the head. In the film, a colossal, phallic monster latches onto Channard's skull and carries him around hell's infinite hallways like a marionette. The demon, jokingly dubbed the "penisaurus," was fully mechanical and operated by puppeteers off-set. It was capable of twenty-seven movements, though not many were visible in the completed film. Portass executed Channard, with Rory Fellowes animating his toothy hand weapons via stop-motion.

Though *Hellbound*'s makeup and FX were pared down from the first *Hellraiser* due to time restrictions, the sequel was much tougher to shoot. The entire film finished production in just fourteen weeks, which was shorter than the time spent on *Hellraiser*'s preproduction! It is Keen's least favorite film of the series, mainly due to that impossible schedule. "*Hellraiser II* was a scramble up a hill, rather than the first process, which was a creative unfolding. It was an assault on us physically and mentally. It was just incredibly tough and not much fun to work on."

Keen partner Gary Tunnicliffe designed *Hellraiser: Bloodline*'s Angelique to be the sexiest of the Cenobites.
(ART COURTESY OF GARY TUNNICLIFFE)

During *Hellbound*'s lensing, Barker was busily formulating his next film, *Nightbreed*, a grand-scale creature feature based on his novel *Cabal*. Barker envisioned the Morgan Creek production as the "*Star Wars* of monster movies," but with a crucial difference. In Barker's story, the monsters are the heroes, while the humans—serial killer/psychiatrist Dr. Decker (David Cronenberg) and fascist lawman Eigerman (Charles Haid)—are the villains, out to destroy the mythical city of Midian, home to a lost tribe of shapeshifters. Prior to preproduction, Barker spent two weeks with Image Animation spelling out his creative guidelines on the project, and asking the FX visionaries to abandon many of their preconceived notions of what monsters should and shouldn't look like. Backed with an FX budget of just under $1 million, Keen and his crew (which fluctuated from fifty-one to eighty-five members) set about making Midian's scores of fanciful but fearsome Breed a reality. Everyone recognized *Nightbreed* as the chance of a lifetime.

"I was having the best time of my life—what a golden opportunity as a monster maker, to sit there and have hundreds of things!" Keen says. "It became very much that everyone became my 'hands'—the actual hands-on work I could do on the picture would be very little, but everybody else out there would be part of that. It was like a continual process, and there'd be this horde of people creating stuff. The feeling in the shop was great, that we were turning out some really great things, and we were coming up with these weird, wonderful designs."

Keen and partner Portass assembled a world-class crew of makeup specialists to meet Barker's enormous requirements. Individual artists were assigned *Nightbreed*'s key dozen creatures (Lylesburg, Kinski, Baphomet, Narcisse, Peloquin, Cabal, etc.) to visualize on paper and then in prosthetics and costuming. Keen delegated characters based on the strengths of his specific artists: Little John (the heroic Boone, played by Craig Sheffer), Simon Sayce (the dreadlocked Peloquin), Neill Gorton (crescent-headed Kinski and the face-peeling Narcisse), Mark Coulier (the gill-cheeked Lylesburg and the quilled Shuna Sassi), token American Tom Lauten (shape-shifting catgirl Babette) and Paul Jones (snake-belly Leroy Gomm and Ashberry's transformation), with Portass supervising Breed god Baphomet, a living, tentacled statue illuminated from within.

Barker stipulated that the Breed be fantastical, horrific, sympathetic, beautiful, and sexy, sort of a Salvador Dalí painting come to life. These bizarre Breed were eventually created through full prosthetics and animatronics, while the numerous background Breed were a combination of simpler prosthetics, pullover masks, costuming, or less detailed straight makeups. Many of the latter extras simply

wore garish and ghastly war and body paint, while others wandered around nude with feathers glued to their bodies or other unusual ornamentation tacked on. Keen estimates that 150 of the 250 Breed were designed to be shot in the foreground (though only about seventy-five actually turn up on screen), and the crew discovered which Breed worked best on film during shooting. To handle the mammoth workload, Image Animation updated many of their production techniques. For example, the company overcame common foam-shrinkage problems, allowing them to switch to smaller numbers of prosthetic pieces to cut down on application time. In addition, the shop changed over from the bulkier plaster molds to fiberglass. "*Nightbreed* released us from the shackles of conformity," Keen says.

To prepare the Breed for filming, eighteen of Image Animation's finest artists would start applying four to five makeups at three a.m. each day, while another group of assistants baby-sat the completed creations on set. Makeup application time ranged from three and a half hours (Kinski, Peloquin, and Narcisse on a good day) to six hours for actor Bernard Henry's transformation into the luminescent Baphomet, an elaborate makeup that consisted of hundreds of tiny fiber-optic cables. Reviewing his monstrous menagerie, Keen cites Shuna Sassi, Peloquin, Lylesburg, Vasty Moses, and Boone as his favorite *Nightbreed* creations.

According to the artist, Vasty Moses best symbolizes *Nightbreed*'s "way-out" approach, the kind of creature that had never been seen before. The corpulent being was designed by Image Animation's Little John as a huge foam suit. "I liked Vasty," Keen says, "because it disguises the human form really well. And the unpleasantness of it was that the guy had to walk around crouched. His real face went through a hole in the suit, then we put a baldcap on him. Little John did a superb job."

The alluring Shuna Sassi wound up being one of the more labor intensive makeups to apply and maintain, a task Keen assigned to Coulier. "We built the suit for her, which was as tight-fitting as a skinned suit, but we built it in such a way that you don't know if she's wearing a suit in any way, shape, or form," Keen explains. "It was a leotard with foam rubber appliances all stuck on, the same construction techniques as the skinned suit. The nightmare with her was that she had about eight hundred quills, and each one of these quills had to be applied and maintained through the day. It created a whole host of problems that you don't normally think about. For example, if you have a suit like that, how does someone go for a pee? What do they do if they can't sit down? How do they eat? How do you maintain this look with the quills? It seemed to be one of the harder creatures to deal with."

Shuna Sassi's quills were made of plastic tubing, which were cut off at angles,

curved by hand and hand-painted, and then glued into the foam latex. The femme fatale's face consisted of five rubber pieces—a big one at the back, a forehead, neck, and two chin parts.

Shuna Sassi designer Coulier also created the makeup for the ancient law-giver Lylesburg, played by prosthetics vet Bradley with ocular gill slits on his cheeks. "I was a little afraid that we'd end up with something like the Creature from the Black Lagoon, which would have been completely out of place," Keen says. "So instead of gills, it came out more like slits. And we thought, 'Wouldn't it be great if these slits were in fact eyes?' The eyes are always the souls of the creatures.

"Lylesburg, again, was a four- or five-piece prosthetic makeup. The pieces were designed to overlap, and they did so brilliantly. As a makeup artist, I admire what Mark did on a technical level, because the pieces were designed so well. You're always trying to achieve this blend, a piece of foam rubber off into the skin, in an invisible way. Lylesburg took it in such a way that you never know where the lines were; the difference between foam and skin is never visible. So, technically, that's why Lylesburg is such a great job. The design and the application of those pieces could hold up under a magnifying glass."

For the heroic Boone, who starts off as a human, is killed, and then is reborn as the Breed Cabal, it was essential that the makeup reflect Sheffer's all-American handsomeness, along with a hint of the Breed that infected him, the ferocious Peloquin. The one makeup worn most in the film and seen in three stages, Boone came out as a subtle seven-piece appliance makeup. Little John's design concept revolved around a patterned color scheme with tattoo markings etched into the face.

"Boone was difficult to create," Keen admits. "It was difficult to keep the actor's face and characteristics and still create a monster. We looked through a lot of African tribal markings, and we decided that was the way to go. We created the look relatively quickly. We then realized that our major problem with Boone was the transformation—to actually get cuts to appear in someone's face. We ended up with a mechanical makeup on the actor's face, with mechanics beneath it to open up the cracks."

Boone's appliances had tiny creases sculpted underneath, troughs in the shape of scars that would magically appear on the skin. To create a bladder effect, a second layer of rubber was then applied over the first, appearing smooth on the outside of Sheffer's face. Rigged to a vacuum pump, the bladders caved in, creating the trench effect (and later scars) in the makeup.

Keen singles out Peloquin as the *Nightbreed* creature he's most proud of and

the closest personification of Barker's vision of the bestial brethren. The character also represents Keen's strongest design contribution, especially the idea of its serpentine dreadlocks. "Peloquin is incredibly sexy and powerful," he says. "And as an image, he's as strong as Pinhead. He's one of the few characters I've been involved with that spooks me when I watch the film."

Peloquin appears in several makeup stages in *Nightbreed*, and at one point near the film's chaotic conclusion, a mechanical head was substituted that opened its maw wider than humanly possible. Peloquin's makeup application was a relatively simple one, and featured a stylized, sloped forehead appliance over a baldcap. Each one of the dreadlocks (including tiny ones for the face) was adhered separately, with another blending appliance placed over that. Small, jagged dentures and a distinctive paint job further complemented this winning makeup.

Nightbreed's unfortunate box-office fate, exacerbated by meddlesome studio politics and indifferent critical response, sullies Keen's memories of the film, though he's enormously proud of his shop's gargantuan accomplishments. "[Distributor 20th Century] Fox misread the picture—they completely and utterly misread what they had," Keen complains. "They had the largest fantasy piece anyone had put together as far as the number of creatures and anything else. And they turned it into a stalk-and-slash movie. David Cronenberg became the center of their focus, and they forgot the fact that this was a monster movie—one with over two hundred monsters! There's footage of the Nightbreed that no one has seen which is fantastic stuff, superb stuff.

"*Nightbreed* was an incredibly creative process with a whole bunch of difficulties," he continues. "But how could I not be pleased with the Breed? I'd love to have that opportunity again."

After a two-year break, Keen returned to Barker's Stygian universe for two projects the author executive-produced in 1992, *Hellraiser III* and *Candyman*. The long-delayed *Hellraiser III* brought Pinhead to America, or more precisely, High Point, North Carolina (standing in for Manhattan). Peter Atkins's script called for the creation of a new band of Cenobites, and the lull between *Hellraiser* sequels afforded Keen the opportunity to design personally the five new villains: Camerahead, CD Head, Barbie, and the J.P. and Terri Cenobites.

For this brood, Image Animation introduced mechanical components to their prosthetic appliances. These additions allowed Camerahead's radio-controlled lens to zoom out, and for the pistons in J.P.'s head (a fiberglass skullcap with a motor's mounting built in on one side) to pump rhythmically.

A close-up dummy head for Barbie enabled this marauding maniac to shoot flames from a gas jet hidden in his mouth, while CD Head pulled lethal discs from his noggin or discharged them from a special torso built for insert footage. For the Terri Cenobite, Keen enjoyed designing a more overt sexiness for the character, with fishnet stockings held up by piercing hooks and peeled-back opera gloves made from Terri's own skin. Because of casting delays, Keen's Cenobites had to be sculpted in England without the actors' physical specifications, then tailored with much difficulty on location. Image Animation also fabricated the hellspawns' bondage-inspired costumes, substituting foam material for the more expensive leather of the previous two films.

"The gap between *Hellraiser* movies had given us a lot of opportunities," Keen says. "I could probably now sit down and do Cenobites for the next ten years—they're great to work on, and there are a lot more ideas now. And the audience responds to them. With *Hellraiser: Bloodline*, we had a new bunch of Cenobites as well. Pinhead's the linchpin. As long as you've got Pinhead the general, you can go off into wild frontiers."

Unlike the earlier films, *Hellraiser III* enlisted the Cenobite king to take center stage in the film's action—almost three-fourths of the shooting schedule. Thus, Pinhead's makeup needed to be redesigned to shorten the lengthy preparation time. The number of prosthetic pieces was cut back from seven to just two, and the application time reduced from five hours to less than three. "The makeup was like a hood, and it separated above the eyes and around the mouth," Keen explains. "So we could apply it in a couple of hours and there was no noticeable difference."

Hellraiser III opens with Pinhead encased in a spinning stone obelisk called the Pillar of Souls. Image Animation's Paul Catlin tackled this job, sculpting the pillar as one piece and then molding it in four foam sections. For the shots of Bradley inside the pillar, a second three-sided version was constructed incorporating the width restriction of the actor's shoulders. Keen says that the film's "brilliant" sound FX sold the pillar sequences.

Image Animation's contributions to Bernard Rose's *Candyman* were less showy than their previous Barker associations, but no less disturbing. Based on Barker's *Books of Blood* story "The Forbidden," *Candyman* tells the tragic tale of modern-myth researcher Helen (Virginia Madsen), whose worst nightmare becomes a reality while investigating the legend of the titular ghetto specter (Tony Todd), a vengeful ghost with an enormous hook for a hand and a belly full of deadly bees.

For the sequences in which Todd releases the swarm of insects from his jaws, Image Animation first life-cast the inside of the actor's mouth. They then constructed a rubber bag that fit between his real teeth and a set of clip-on dentures. A funnel was placed inside the insulating bag and filled with three hundred tiny stingerless bees. A real trouper, Todd accomplished the gag himself without an insert head or stunt double.

Though director Rose sought to downplay the shock FX in deference to the romantic undercurrents of the story, *Candyman*'s deadly, artificial hook had to inspire fear and fright. Keen recalls that finding a manufacturer for the trademark appendage proved humorously problematic.

"We designed the hook on paper, and we sent it off to a blacksmith here in England, and had it made up," he recalls. "He gave us the hook, and just as we were leaving, he said, 'What's it for? It's a very interesting design.' And someone turned around and said it was for a horror film. And he snatched it back and wouldn't let us have it [*laughs*]! He said, 'I'm not having anything to do with devil worship!' We tried to persuade him that it had nothing to do with devil worship at all, but he wouldn't have any of it. So we ended up having it made again by a different blacksmith—who didn't mind working on a horror film. We made polyurethane and balsa wood versions of it; we made two real metal ones, which weighed fifteen pounds. In the scenes where he does all the destroying, he was doing that for real."

While film production is picking up in Great Britain, Keen has opened a second shop in L.A. (a third may follow in Toronto), joining fellow transplanted Brit Barker. The move has paid off; in 1994, his California studio was deep into production on a number of projects, two of which bear Barker's stamp yet again. For the L.A.-lensed *Hellraiser: Bloodline*, Image Animation furnished the pernicious Pinhead with a new lot of Cenobites, among them the sexy Angelique (with a disgusting peeled-back scalp head appliance) and stalking Siamese twins. After a five-year hiatus, Barker took the director's chair again for *Lord of Illusions*, which united the talents of several makeup FX shops (among them Image Animation, Alterian, Steve Johnson, and KNB) under the supervision of Thomas Rainone. For *Illusions*, Image Animation's L.A. chief Gary Tunnicliffe oversaw the creation of a voracious mandrill monkey. After this flurry of activity, Keen, who has directed several films of his own (including the SF thriller *Proteus*), looks forward to further cinematic excursions into the lurid mind of Clive Barker, and expects Image Animation to be part of them.

"I love the hunt with him, and the chase, and the running, because it's never so intense," says Keen of Barker's "endless creativity" that draws them together again and again. "There are a lot of other directors who are very, very talented, and very, very imaginative, but I've never found someone who I mentally have to play Ping-Pong with so hard to keep up. For me it's running to keep up with him, but he seems to stroll through it. The man has unlimited imagination. Over the next couple of years, hopefully, we'll see the other side of his imagination. There's so much more to Clive Barker than we've seen yet. And I hope to be there."

Tony Gardner (left) and Chet Zar smile with their tag-team creation, Darkman.
(COURTESY ALTERIAN STUDIOS)

Tony Gardner and Alterian Studios

Creepy, Kooky, and Spooky

When twenty-year-old Tony Gardner accepted the challenge of replacing a fired special makeup FX artist at the eleventh hour on *Return of the Living Dead*, he received the stereotypical ego-bashing producer's speech. But instead of being intimidated and falling on his face, the ambitious tyro recognized the career-making opportunity that had fallen in his lap and put in many sleepless nights to deliver the film's goofy but scary half-corpse puppet.

"The producer said, 'I don't want to hire you,' " recalls Gardner, who appears much younger than his thirty years. "'[Director] Dan O'Bannon saw your work and thinks you're excellent, but I don't trust you. If this doesn't work, I'll make sure you never work in this town again!' " Gardner stops and chuckles at the memory, before continuing. "At the time, I was so mad, I thought, 'I'll show you…!' It was actually motivating. I had two weeks to throw all this stuff together. I was working during the day on *Cocoon*, and I would do *Return* at night."

Four years later, Gardner would be keying up his first major motion picture, 1988's remake of *The Blob*, on which he supervised a crew of twenty-nine makeup FX technicians. Jump forward another four years, and he is at the head of two extremely successful companies. The first, Gardner's Alterian Studios, has supplied the big screen with a wide assortment of lovably zany creatures for the *Addams Family* films, *Mom and Dad Save the World*, *Freaked*, and *Hocus Pocus*, as well as the nightmarish visions of *Sleepwalkers*, *Darkman*, *Cast a Deadly Spell*, *Army of Darkness*, and *The Craft*. He also owns The Ghost Factory, a wholesale mask and novelty company that has lucratively mass-produced a line of monster costumes, Warner Bros. cartoon tie-ins, crew jackets, T-shirts, and much more.

Alterian is located east of Pasadena in the drab surroundings of Irwindale, California. This remote industrial area is enlivened by the fish people, dog boys, snapping bear rugs, and talking cats found in the ten thousand square feet of production space at Alterian. Scrupulously spic-and-span to such an extent that the place belies its busy pace, Gardner's five-year-old company is a hi-tech playground graced by life-size dioramas (Swamp Thing, Darkman, and even a bust of Jim

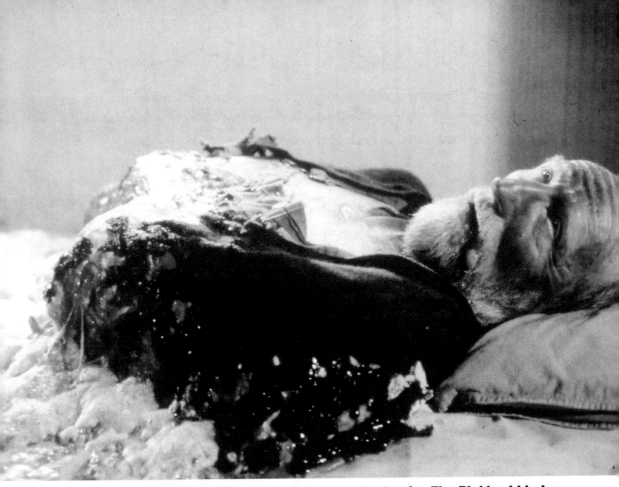

Tony Gardner came up with a truly gruesome demise for *The Blob*'s old hobo (Billy Beck), the film's first victim.
(COPYRIGHT TRISTAR)

Morrison from *The Doors*). A permanent staff of twelve go about their business, sculpting in clay and wiring various mechanical props, while the affable, boyish Gardner commences his tour. Long brown hair cascades over his shoulders, and he's dressed comfortably in T-shirt, sneakers, and sweat pants. Though his exuberant personality is closer to Bill & Ted than Rick & Stan, Gardner's sharp business savvy has given him the competitive edge over other FX houses. While some artists struggle to keep their shops afloat during slow production periods, Alterian runs full steam ahead, bolstered by the steady sales of its rapidly expanding promotional products and novelties division. Alterian's movie work, however, remains in the limelight.

"We tend to do a lot of things that are off the beaten path," Gardner begins,

pointing to *Freaked*'s Wormboy to make his point. "There are not too many old people manufactured here, there are not too many gorillas either; it's more chicken men, toad people, and dog people. There is a lot of the unusual and the absurd. At a certain point in Rob Bottin's career, he was doing a lot of stuff that was really far-out and cartoony, but still tied in to the real world. We went through a lot of makeup characters like Darkman, and stuff from *Mobsters* where there was a great deal of realism. But every other show seems to contain an *Addams Family* twist on reality, and as much weirdness as we can get away with."

Gardner's more normal formative years in Cleveland, Ohio, were not spent pulling latex from molds, but rabbits from hats! "It's weird, because I hadn't seen that many movies growing up," he recalls. "I started very late with this kind of stuff. I was a magician [as a kid], and I used to perform at kids' birthday parties and old folks' homes. I was totally into the art of fooling people. So when my parents got me a movie camera for my thirteenth birthday, I'd film some of these 'tricks.' That's when I realized, 'Here's a way to really fool people. I can stop the film and change or alter things, continue filming the effect and make things disappear or whatever.'

"So I started doing makeup effects on film, and then began shooting short films locally," he continues. "Then I moved out to California during my sophomore college year with the idea I'd do makeup *and* movies. The moviemaking aspect disappeared once I started doing makeup on student films and realized how much I truly loved it."

Gardner first hit the books at Ohio University as a theater major. While studying for his degree, he also created and taught makeup for the drama department. He later transferred to the University of Southern California as a fine arts major. What little makeup knowledge Gardner possessed he culled from books and magazines, which inspired him to duplicate a few of the frightening images he enjoyed from movies, like *Alien*'s facehugger and chestburster. The mild-mannered artist kept busy providing makeups for various student films, then eventually hooked up with FX genius Rick Baker. Though Gardner's portfolio was "very, very raw, as in nonexistent" at this time, his drive and personality impressed Baker enough for him to hire Gardner as a "runner" on Michael Jackson's $1 million music video *Thriller*.

"I started out not knowing very much," he admits. "I was hired based on ambition and a sense of ability. Rick offered me a couple of weeks and it turned into a couple of years. On *Thriller*, it was like a fantasy sort of thing: my first job! I was

doing a lot of stuff, and as the show progressed, they let me do more and more. We all got to do characters on ourselves, and be in it as well.

"Working for Rick, and knowing very little, was probably a great way to start. I didn't have any preconceived notions. And I learned pretty much everything from him. I went through a couple of different shops [working for Greg Cannom on *Lost Boys*, Stan Winston on *Aliens*, and Doug Beswick on *Evil Dead II*], for a period of time several years later, and tried to remember the best and worst of each shop and project. And I thought, 'If I ever have a shop of my own someday, this is what I want and what I don't want.' "

While at Beswick's, Gardner became more involved in the business end of the FX house, budgeting and scheduling for the shows that came in. The experience proved useful when Gardner free-lanced his solo talents on other projects and later laid out the welcome mat to his own studio.

In 1984, director Dan O'Bannon awarded Gardner the assignment to create *Return of the Living Dead*'s articulated half-corpse puppet. The opportunity presented Gardner his first big chance to prove himself and earn a significant movie credit. The catch: The hectic shooting schedule only allowed Gardner two weeks to come up with the complicated effect, and he was already toiling full-time on the crew of *Cocoon*. The artist forged ahead, so to speak.

"The half-lady was my deal," Gardner notes of his *Return of the Living Dead* sole contribution: a thrashing, reanimated dead woman tied to an undertaker's table. "And the director and producers were very specific: They wanted something very surreal, with bright blue eyes, a pink tongue, very blond hair—but a very rotten body. Everything was done in very broad strokes, per Bill Stout's production designs. It was really fun to build that thing. And then the performance was very broad, too: 'Brains, brains, give me brains,' with the spine flopping around and fluid leaking out of it. Maybe it burned into *my* brain or something, but from that point on, I've tried to design my creations with big broad visual strokes."

Relishing the high-pressure working conditions, Gardner pulled together his puppet with only ten minutes to spare before the character was called for on set. The "cartoony" half-lady required two sets of arms, one chest, two spines, a pelvis and two heads (one for screaming, and the other a mechanized head with a "drugged-out" expression and speech capability). Working for Beswick, Gardner carried on his "comic-book stylization" for the John Landis comedy *¡Three Amigos!* two years later, supplying a mechanically operated desert tortoise.

After *Return of the Living Dead*, Gardner pulled off a few tricks and makeups

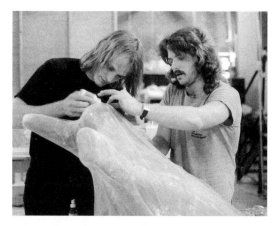

Alterian pros Andrew Kenworthy (left) and Mike Maddi drape the Blob shroud on top of a miniature mechanical puppet of actor Donovan Leitch.

on the minor films *Out of the Dark* and *Under the Boardwalk* in his spare time. During this same period, positions with Stan Winston's and Rick Baker's crews kept him busy nonstop. Though he resisted starting his own shop because of "the responsibility," Gardner reconsidered the possibilities as the scope of his offers changed dramatically, beginning with *The Blob*. The producers initially hired Gardner to supply "three or four minor effects, little things," but when the production suffered a few essential personnel changes in their FX department, he was asked by director Chuck Russell to take on the design and creation of the film's major special makeup FX. These two dozen gooey FX ranged from simple burn appliances to life-size animatronic blob victims. At age twenty-four, Gardner successfully climbed the next step in his career ladder, supervising a crew of as many as thirty-three (among them sculptor Chet Zar and "mechanical god" Bill Sturgeon) on an epic monster movie. "The scope of this thing was huge," Gardner recalls of his seven months with *The Blob*. "The entire makeup effects budget was about half a million dollars. And we got all our work done. We were always on time and under budget. We had the best time."

Russell granted Gardner and his assistants "total freedom" in envisioning the film's FX. During preproduction, Gardner presented key images instead of basic concepts of his makeup creations, impressing the director and gaining further confidence in his abilities from him. The film also enabled Gardner to experiment with mechanical FX and full-body puppets for the first time, as representations of the Blob's human prey, as well as to incorporate novel materials that helped give the film's growing gelatinous glob a translucency and shifting shape.

Besides crafting the Blob's snacks, Gardner and company had to fabricate the space goo itself during the fatal earthling interactions (a separate crew headed by Lyle Conway and Stuart Ziff handled the majority of the creature FX, while Dream Quest supplied various opticals and miniatures). Described by Gardner as a "giant, vampiric digestive organ, feeding on blood and flesh, and discarding bones and nonorganic materials," the Blob was composed of stitched-together clear silk

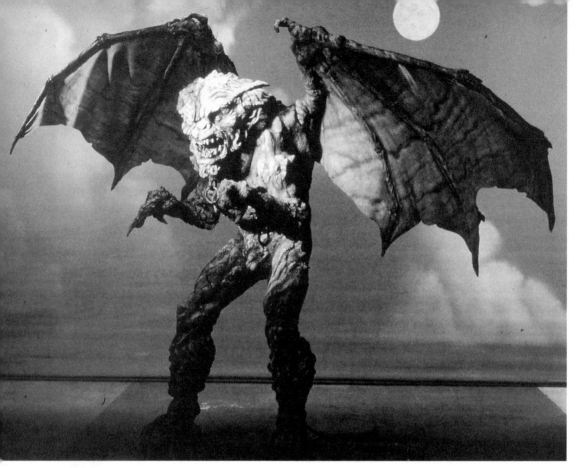

Cast a Deadly Spell's **impressive gargoyle spreads its wings.**
(RANDEE ST. NICHOLAS)

bags injected with various consistencies of Methocel (a gummy product that swells in water). The monster's casualties included heartthrob actor Donovan Leitch, who is completely engulfed by the maturing slime in a hospital room.

"Seven days before the shot, it fell on our shoulders that we had to build that sequence's Blob element, as well as all the Donovan heads, bodies, and miniature puppets of him and Shawnee Smith to operate on the miniature set," Gardner recalls. "Chuck kept saying, 'It's the sequence that sells that the Blob can kill and is violent and you should be afraid of it. It's the most important sequence in the story,' followed by, 'You have six and a half days to do it.'

"It's one of those scenes that starts out with the actor, and then gradually replaces him with puppets and puppet elements," he continues. "There were four stages of Donovan—at one midpoint, he was replaced entirely by a miniature puppet of both himself and the Blob that had to be capable of various precise functions.

"To create the Blob for this sequence, we came up with fiberglass under-structures and experimented with a lot of translucent materials attached to the fiberglass, basically overlapping clear vinyl bladders operated with a huge pneumatic system, to inflate and deflate the basic surface shape. Then there was a form-fitting transparent skin built up over that, that was water-clear, designed to protect Donovan from all the slime stuff. That went onto the body rig, and Donovan, who needed an air hose for certain scenes, went under that outer layer. Separate red and blue vein blankets were layered over this in a diagonal pattern. Layers of Blob quilt, airbrushed and painted with vein patterns, were laid over the vein blankets, and all the elements were pulled off in different directions at different speeds, so you had a sense of the bulk moving, the colors changing, and linear movement.

"We'd pull those layers of Blob quilt at different speeds, while Donovan would fight against them and try to push out from the main body quilt, which was partially supported by fiberglass. Because of these moving quilted pieces, you always had a sense that the Blob was pulling back away from him. We also had a rolling platform shifting rigs that stretched and pulled the different pieces that the entire assembly rode on. While Donovan acted, five or six people were just out of frame operating all this stuff with the Blob quilts and pneumatics. In order to 'sell' the whole effect in a wide shot, we went to the puppets in order to control everything with greater accuracy and artistry."

More FX inventiveness came into play as the Blob grows bigger, meaner, and hungrier. For the scene in which the deputy (Paul McCrane) is suddenly snapped in two and pulled through a bookcase by the rampaging slime, Gardner's goo crew built a pair of puppet legs for the actor. The FX team constructed an extra pair of articulated legs at right angles to the actor's own; McCrane sat on a sliding platform that ran undetected through the mock bookcase. In the film, it appears that the cop is standing against the makeshift fortifications, when in actuality the actor's real legs were hidden on the platform. On signal, the technicians pulled his legs on a small sled, and McCrane went crashing through a small hole in the breakaway shelf; the prop legs then folded up underneath him as he seemingly cracks in half.

Gardner persuaded his girlfriend Cindy to model as a Blob corpse in the theater sequence. The throwaway bit showed a half-dissolved dummy face (sculpted by Brian Wade, from Cindy's life cast) lying between the aisles. The blob residue

on the body was made of rubber, urethane, nylon fabric, and calcium turnings, the latter a substance that bubbled and smoked. In spite of the gross cameo, Tony and Cindy married immediately after *The Blob*'s lensing.

Another girl crumples away during a badly timed lover's lane tryst. The scene begins as the actress (Erika Eleniak), sitting in a car, turns her head; when she spins back, her once-pretty face caves in. In order for blob tentacles to whip out in a predetermined direction, a collapsible foam-covered mechanical head was substituted for a follow-up shot, with long, hollow Plexiglas tubes hidden inside sculpted channels. Off-screen puppeteers wielded four-way joysticks that moved the tentacles and activated a pneumatic arrangement from a keyboard to create the facial "bubbling."

"We worked backwards on that effect," Gardner reveals. "We first sculpted the deflated body with the twisted-in face, which had areas [sculpted inside] that allowed holes for tentacles to come out of. We then did a life cast of the actress in a sitting position. There was also a false chest of her so that the actor could reach into her torso if need be, or tentacles could come out from her abdomen. We took the end result's finished design and worked our way backwards from that.

"Chuck wanted to see her eyes roll up—yet the skull sockets were collapsing inwards and folding, so both mechanisms had to run independently but at the same time. We also had to rig the head and torso for goo and make it possible for puppeteers to get underneath it and behind it—and shoot it all in real time as well. It was pretty straightforward in regards to actual puppeteering."

Though *The Blob* failed to gobble up much box-office revenue, fans and press hailed the movie's astonishing makeup and creature FX. "It was the first time that a lot of these materials had been used to create something like the Blob," Gardner sums up. "We weren't using these materials to create individual puppets, they were being used in tandem with a person to create a desired effect. We also had to figure out how to keep a person alive inside of it at the same time. I don't know how technically innovative it was, but it was an exciting period."

Following completion of *The Blob*, Gardner decided to organize his own permanent company, which would eventually become Alterian Studios. For a while, the shop treaded water on a few forgettable projects, such as the Atlanta-lensed *Texas Chainsaw Massacre* ripoff *Blood Salvage*, the schlocky anthology film *The Willies*, and *The Dark Backward*, a cult wannabe that featured Judd Nelson wearing a mechanical third arm on his back. Other genre projects included the vam-

pire spoofs *Rockula* and *Sundown, The Vampire in Retreat*. On the latter, Gardner's crew populated a remote Western town with bloodsuckers and engineered their transformations and wild death scenes. Gardner himself directed *Sundown's* second unit while on location in Utah.

In 1990 director Sam (*Evil Dead*) Raimi extended Gardner and staff the opportunity to expand their catalog beyond special makeup and creature FX. Again learning as he went along, Gardner gained his first multiple-piece appliance-makeup experience on *Darkman*. The story details the exploits of a Phantom of the Opera–style avenger who is horribly burned in a lab fire; wearing a synthetic skin over his face, Darkman attempts to right the wrongs of the night.

"*Darkman* was our first 'character' show," Gardner says. "It wasn't just 'Create a makeup effect,' it was 'This is our character. He has to be sympathetic, but he has to be gross. These are the ranges he goes through. This makeup has to work through all these ranges.' That was pretty overwhelming."

Once the Universal production cast Liam Neeson as the hideous but sympathetic scientist, Gardner and co-worker Chet Zar began adjusting the actor's square face into a mostly skinless, charred, living skull. Due to the complexity of the makeup and lack of adequate preproduction time to refine and simplify it, Alterian's original prototype makeup wound up being used for the film.

Gardner and Zar began the thirteen-piece appliance process by working on Liam's face from opposite sides. They first applied a vacuform skullcap. Ear flaps cut from a more flexible and comfortable baldcap were glued down next. The one-piece neck appliance (from just below the collarbone to base of jaw) followed. The artists preglued the actor's neck, and the appliance simply unrolled up and over it. Acrylic teeth and jawbone were added before the facial appliances began.

"Burned-out" right ear and cheek appliances were adhered next, then a very thin forehead piece. The actor's left ear was kept uncovered and the rest of the face piece "built out" to it. Holes in the appliance displayed stained vacuform plastic that represented the exposed bone of the skull. After attaching the back-of-the-head piece, the teammates blended the overlapping edges of the seven appliances with Duo and surgical adhesive and allowed it to dry.

For the "good side" of Darkman's face, Gardner devised a giant rubber horseshoe appliance that wrapped around the actor's eye area and blended off into the burned area of his head. Likewise, the nose was designed as one whole piece. To complete the job, edges were sealed, the appliances painted, and a mixture of 355

adhesive, black acrylic paint, and granulated sugar was spread onto the darkened areas to achieve the makeup's "burned pizza crust" look. To help the stylized makeup colors "read" on camera, Neeson wore blue-tinted contacts.

The toughest part of the three-hour Darkman makeup, however, was the teeth. The artificial chompers had to resemble bone, be hard, inflexible, and attach *over* the actor's lipless mouth. "We had to create something out of a dental acrylic that would fit over his mouth, register to his face, stay where it needed to stay, and not flop around," Gardner explains. "And once we added an appliance makeup on top of the teeth, it could not look suddenly like Bucky Beaver, where he's got this huge built-out mouth. The surrounding foam had to be built out, too, to match the teeth. We had to blacken out Liam's teeth with a temporary dental stain and darken his lips, and then powder down with black powder, so that there was absolutely no shine inside the false teeth at all. The dental-acrylic teeth were fit onto Neeson's skin and the piece clamped to his chin."

In addition to the tragic hero's unsightly visage, Alterian's *Darkman* also fabricated special props, supporting character likenesses, full-body burn suits, on-camera blistering FX, and a slave-controlled animatronic Darkman figure with robotic arms. The makeup's popularity led Alterian to market their own Darkman latex mask, and its subsequent success prompted the founding of Alterian's Ghost Factory offshoot.

Alterian has continued to diversify. For Universal's *Mobsters*, the studio provided makeup accoutrements for actors Patrick Dempsey (prosthetic ears and facial scars) and Christian Slater (facial scars and appliances) to help transform them into real-life hoods Meyer Lansky and Lucky Luciano, in addition to various gunshot wounds, cuts, and other gangland mayhem. On Oliver Stone's *The Doors*, the shop fabricated a duplicate of Jim Morrison's tombstone bust, while Showtime's *Psycho IV: The Beginning* required minor makeup FX as well as several ever-worsening stages of Norman's embalmed Mother corpse. ("Tony created the best Mother of all the *Psycho* films," praised the sequel's director, Mick Garris.)

Following this period, Gardner segued to a procession of wacky, bizarre, and sometimes frightening creature creations in a number of hit films and cable programs. HBO's *Cast a Deadly Spell* movie, for example, depicted an H. P. Lovecraft–inspired world of gremlins, werewolves, unicorns, gargoyles, and demons. Alterian created animatronic puppets to portray the gremlins, while prosthetic makeups added bite to the werewolf and zombie players.

One of *Spell*'s simplest FX on paper, the unicorn, turned out to be the most troublesome. To keep the fantastical animal's horn from bobbing (a telltale FX give-

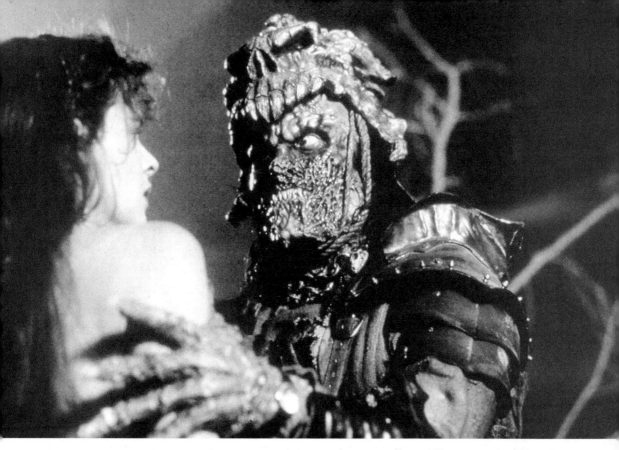

Alterian's Evil Ash from *Army of Darkness* was so popular that a Halloween mask version proved very successful.
(MELISSA MOSELEY)

away), Alterian devised a special tiny plate that could support a lightweight, hollow horn. The horse's real mane was tightly braided underneath an artificial one with three-foot-long hair that flowed down the animal's neck, which gave the back of the plate weight and prevented the horn from bouncing, even when the stallion reared up on its hind legs.

While *Spell*'s climactic Cthulhu demon (a one-sixth animatronic miniature subbed for the thirty-foot tentacled monstrosity), the movie's most fully realized creature remains the nimble, winged gargoyle, the wings of which were designed by one of Alterian's mechanical aces, Dave Penikas.

"We accomplished several technical innovations on *Cast a Deadly Spell* that were never seen or done before," Gardner says. "The main one would be the gargoyle. The actor was wearing a foam latex suit which covered a tank on his back, and the tank pneumatically controlled a set of back wings to fold up and out from his body via a radio-control unit that someone else operated on set. No wires, no

cables, no tubes, *nothing* coming out of this guy. He could fly around on wires with his wings out, the wings could fold in, he could come through the door, they could fold back out, and we could get five or six repetitions off each compression in one take. And that has never been done. People have created wings operated via rods, or static wings that just unfold and remain stationary. Filming an actor from the waist up because you don't want to see the cables controlling the wings is also standard. Ours were totally self-contained."

Like *Spell*'s gargoyle, the titular fiends in Stephen King's *Sleepwalkers* were played by actors in Alterian-designed foam-rubber suits. The *Sleepwalkers* script described the lifeforce-draining monsters as "slick, sleek reptilian mixed with feline and hairless." In other words, no place to hide the zippers or suit seams! Gardner's team designed a full-body creature suit (including pre-attached and pre-blended hands and feet) up to the base of the neck that the slender performer slipped into in about twenty minutes. A revealing shoulder-blade joint was then sealed up. The mechanical head, which contained the various servo motors that allowed the creature to snarl, went on separately. Alterian adapted many of these same suit design techniques on another King project, the ABC miniseries *The Tommyknockers*. For this New Zealand–lensed tale of extraterrestrial infestation in a small town, Alterian sent over five seven-foot-tall "barracuda/lizardlike" alien costumes. The popular underwater space visitors from NBC's *seaQuest* boasted similar Alterian suit construction as well.

Gardner reteamed with Sam Raimi and his *Darkman* collaborators for the *Evil Dead* adventure *Army of Darkness*. Splitting the film's workload with KNB, Alterian's responsibilities entailed corrupting the nice-guy features of the heroic Ash (Bruce Campbell) into a malevolent twin, the despicable Evil Ash (also Campbell). The company also handled the movie's other animatronic Ash and possessed Evil Sheila FX.

To conceive this vain, decomposing piratelike warrior with misaligned body parts, Alterian designed the Evil Ash facial makeup as a simple five-piece foam-latex job, including a Darkman-style "underbite" with dental acrylic teeth. The wardrobe department collaborated closely with Alterian in creating a spandex body suit to be worn underneath the character's costume, which incorporated the makeup lab's elbow-length foam gloves, prosthetic body scars and exposed ribs.

For a bit where miniature Ashes bedevil the hero, Alterian made up eight stunt doubles to resemble actor Campbell. Later, Evil Ash's eyes—and then a tiny head—peek out of Good Ash's shoulder. To accomplish this goofy sequence,

Alterian built three mechanical heads (each encompassing different expressions) and attached them to the actor with a shoulder harness. (Campbell tilted his body to one side with his arm hidden inside the harness.) The two-headed Ash had strap-on body harnesses to fit either side, allowing Campbell to play either the good or evil persona.

One of *Army of Darkness*'s comic highlights tracks Ash's battle with the Book of the Dead. In one sequence, the hapless hero's arms and face are sucked into the terror tome. For the stretching arm, Alterian fabricated a mechanically articulated close-up hand, followed on film by latex and polyfoam arms over an aluminum armature. Campbell put on a fiberglass body harness, with his real arms hidden behind the cape on his back. The two elongated Ash faces were one-piece foam appliance makeups blending into the face from the eye-bags down. Meanwhile, Ash's climactic confrontation with his now-skeletal doppelgänger necessitated the building of several elaborate animatronic puppets, one of which could spin its eyes like a slot machine and pop its top on cue.

"The majority of the skeleton's head and body were all [made of] hard fiberglass with foam latex used just where we needed it for movement, like in the neck," Gardner reveals of the Ash puppet, which functioned via a combination of radio-control (the head) and slave-driven (the arm movement) methods. "The principal puppet fit into a stand and held a sword. The arms didn't weigh much, so we could control it with a puppeteering system on a one-to-one ratio and have it work in real time. This puppet was built from the base of the pelvis on up. All the cables came out the pelvis to a slave system that we had to stand behind in order to puppeteer. Then there were some large motors at the base of a rolling platform that operated a few of the heavier functions in the head. The rest of the motors for facial expression were self-contained in the head itself.

"We built insert legs for scenes where the legs would move into frame in close-up, or the camera angle would be low and you'd see the skeleton's feet walk through. The legs had ankle movement, similar to what Stan Winston had done for *Terminator*. We also had insert heads for specific sight gags, like the one where the top of the skull itself flips up. The back of the head was hinged, so that the skull flipped up. Bill Sturgeon was responsible for all the skeletal effects and also created a vacuform piece of a shriveled, rotted brain that fit over and hid the mechanics inside the skull, but also was fun to look at, too."

Friendlier ghouls took center stage when Alterian filled in the extended clan of *The Addams Family* and its sequel, *Addams Family Values*, the macabre

movies derived from the blackly humored cartoons of Charles Addams. On the first hit film, Gardner supervised the manufacture of numerous creepy miniatures (a mechanized model clock of the Addams mansion); kooky props (the Chinese finger trap); and spooky mechanical FX (like Cleo, the meat-eating orchid, an attacking rose bush, and the puppeteered, jaw-snapping bear rug, operated by radio-controlled servo motors).

Wednesday and Pugsley's bloody *Hamlet* duel and the Addamses' festive Fester ball win out as the movie's showstoppers, courtesy of Alterian. On the latter, the shop filled the ranks of the Addamses' ooky extended clan, a few of which they achieved in the following fashion: a one-armed musician (a mechanical limb sprouting from his chest, connected with a harness) plucked a string bass; the 18-digit Fingers Addams (Steve Welles) played a (secretly) mechanical clarinet, with the actor wearing prosthetic appliances on his hands—the loose fingers were glued

Alterian's Cousin It (John Franklin) from *The Addams Family* almost stole the show.
(MELINDA SUE GORDON)

to the clarinet keys, which moved the digits up and down while "playing"; and to portray the charming Siamese twins Flora and Fauna, sisters Maureen Sue and Darlene Levin were costumed inside a huge full-body harness to accomplish the illusion.

Of all the background character makeups in the Addamses' initial screen outing, only the hirsute Cousin It garnered major screen exposure. "I thought Cousin It was going to be the simplest, and he turned out to be the toughest," Gardner says. "First of all, we had to keep a specific shape in mind, and it wasn't just layered hair, it was *hair*. Producer Scott Rudin said, 'Imagine someone who has all

their hair growing out of one spot on top of the head, it's all one length, and it comes down to the floor.' So we built this weird body sleeve/suit with snaps that could close up around a rigid ring on the bottom—with layered flexible rings attached with fabric to control a shape all the way up to the crown of the head. A headpiece, which was a little bit larger than the guy's head, spread out the surface hair evenly. The actor [John Franklin] needed to wear a neck brace because of the costume's substantial weight, which was impossible to distribute evenly. It was on the top of his head. The volume of hair [a synthetic weave] needed to appear four and a half feet long, even if it wasn't. So we layered it from the inside out, like shingling a house, only each progressive layer that we added onto the body sleeve still had to reach down to the floor."

In similar fashion, Alterian populated the Planet Spengo with fanciful aliens of many stripes and colors for Warner Bros.' failed sci-fi spoof *Mom and Dad Save the World*. These included: a wise-cracking animatronic rat puppet; the Lublubs, ambulatory mushroomlike critters with double rows of razor-sharp teeth, brought to life via a combination of hand puppetry and mechanical assistance; and armies of bulldog and fish people, performed by little people in costumes with five-pound heads that relied on radio-control mechanisms for expression and emotion.

Prior to gearing up for *Addams Family Values* in 1993, Gardner and his cohorts performed FX duties on *Hocus Pocus*, another darkly themed, Halloween-set extravaganza. Using an amalgam of radio and cable-controlled animatronic puppets, Alterian fabricated the practical version of the Bette Midler film's chatty cat mascot, Binx. Utilizing up to six operators at once, Alterian's magic feline could talk, sit, gesture with its paws, and do other feats the film's real cats were incapable of performing. The Rhythm and Hues company contributed computer FX to help the feline mouth dialogue. For a ghoulish touch, Alterian transformed lanky actor Doug Jones into a three-hundred-year-old zombie with straightforward appliance makeup.

Alterian's contributions to *Freaked* turned into another monster rally in a humorous vein. The company's roster included a variety of human oddities, among them Cowboy and Ortiz the Dog Boy. The bovine mutant Cowboy came complete with working udder bag and wore a Western-style hat that allowed for more space to hide the servo motors that articulated his facial expressions. As eight different design concepts were bandied about, the hirsute Ortiz evolved from a bulldog gangbanger to the point where he resembled a half man/half Doberman. In the three-hour makeup process, unbilled actor Keanu Reeves ended up with acrylic

Freaked's Worm (Derek McGrath) is one invertebrate that you won't find in any garden.
(COURTESY ALTERIAN STUDIOS)

teeth, facial and ear-tip appliances, a wig, a butt pad with clipped tail, and foam slip-on gloves and shoes for the hands and feet. Reeves's face was prepainted with Pax makeup before the synthetic fur was applied, beginning at the base of the neck.

Sockhead, performed by five-foot-four-inch actress/dancer Karyn Malchus and voiced by funnyman Bobcat Goldthwait, seemed like a breeze on paper. However, Alterian found just the opposite to be true when it came time to realizing the character. What easily works as a stationary puppet for close-up shots in this case had to stand, walk, sing, have a nervous breakdown, and get machine-gunned to death, all on camera in real time. An oversized mechanical body was built for the petite performer, who wore a skullcap helmet with a mechanical hand on top. The motions of the sock hand were controlled by an off-camera slave unit, while Malchus filled in the rotational movement. Her arms merged into Sockhead's at the mid-biceps, with the sleeves of the costume designed baggy enough to hide the fact. The shoulders were built to the height of Malchus's head. Shoe lifts, oversized glove hands, a butt pad and built-up rigid kneecaps added additional proportion to the costume.

Alterian overcame *Freaked*'s greatest technical difficulty on the Worm (Derek McGrath). The appliances for the Worm's head were sculpted to spread out the actor's facial features, making his brow, cheeks, nose and chin more pronounced and broadening the physiognomy to represent the giant invertebrate's top part.

The rest of the body was segmented, while the bottom half of one Worm version could expand and contract and thus propel itself across a flat floor!

"Because of time limitations, Loren Gitthens started sculpting the head, while Brian Penikas and Chet Zar started on the tail, which contained all the pneumatics and hydraulics," Gardner explains. "As we progressed forward and built all the body pieces, the two crews met in the body's middle, then had to make a joining piece. There were also different tails; one was a 'cart' Derek could sit on, which had a support device that held up his chest and a linear actuator [a forklift-type machine] that ran down between his legs, with handles for his hands and support rods for his ankles. With the linear actuator, we could raise and lower the front of the worm.

"His whole lower body fit into this machine, and around him were the fiberglass rings that pneumatically expanded and contracted proportionate to each other, with spikes on the base of the rig that drove down into the ground and would help propel him forward. He also had a four-way tail to give a sense that there was more body behind him in close-ups. It was insane!"

Alterian has turned their brand of madness into a very profitable occupation. In just five years, Gardner's company is in an enviable position as one of the top special makeup FX houses in operation. Rarely does a week go by that the shop has not signed a new motion picture or television contract, recent examples being *Full Eclipse, Cabin Boy, Ghost in the Machine, Lord of Illusions, The Rock*, and *Tank Girl*. And in those rare moments of inactivity, Alterian moves forward with research and development on future FX innovations and personal film projects, while Ghost Factory creates new Halloween masks or fun stuff for the Warner Bros. store chain. On a personal level, Gardner has graduated from a hands-on FX designer to a full-fledged entrepreneur.

"The manner in which the mask business is starting to run itself is something I'd like to see Alterian emulate, to be able to carry itself independently a little bit more," Gardner says. "If I die, I'd like to know there's a group of people who work well together, who are in sync, who can keep going and make a living, keeping this business going as a corporation and not need me. Most people say they want to be invaluable, but I would like to set up Alterian Studios as something that can continue to produce quality, and still give me the freedom to do some of the other things I want to do. Or perhaps drop off the face of the Earth, or produce a film, at the same time."

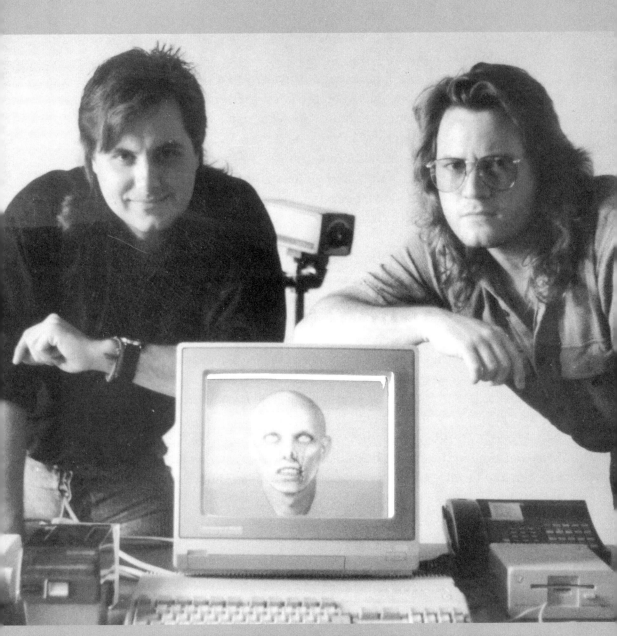

John Vulich (left) and Everett Burrell drafted their Amiga computer to design zombies for *Night of the Living Dead*.
(ALL PHOTOS COURTESY OPTIC NERVE)

Twelve

Optic Nerve Studios

Eye on the Cutting Edge

In 1993, *Jurassic Park* had audiences shaking in their seats all over the world. For the first time, dinosaurs rampaged across the screen through the miraculous artistry of digital computer FX. Many fearful makeup and special FX artists shivered in their shoes for another reason: Would this startling new technology—which enables computer programmers to create flesh-and-blood animals more realistically than stop-motion or animatronics ever could—make their jobs obsolete?

While one well-known makeup artist confessed that he openly wept during a screening of the Steven Spielberg blockbuster, the young upstarts at Optic Nerve Studios in Sylmar, California, smiled. Several years *before* the digital revolution, Everett Burrell and John Vulich had been embracing these new computer tools, sensing change in the wind.

"There's still a need for makeup effects, but now computers are certainly taking over," begins the thirty-year-old Burrell softly, seated in front of his Amiga computer in Optic Nerve's cramped office. Burrell and thirty-six-year-old partner Vulich have created FX for such films as 1990's *Night of the Living Dead* remake, *Batman Returns, The Dark Half, Mighty Morphin Power Rangers: The Movie, Castle Freak, Dracula: Dead and Loving It*, and *Necronomicon*, while for TV's sci-fi show *Babylon 5*, the two took home a Best Makeup Emmy in 1994. "Computers are thought of as something to play games on—which I constantly do," Burrell continues. "But it's also a strong tool, and it's amazing how much stuff you can get out of a little box."

"In using computers, we're showing people that we're trying to be progressive and forward-thinking," adds Vulich, lounging on the floor in worn dungarees. The less-talkative Burrell frequently defers to Vulich to explain the philosophy and particulars behind Optic Nerve. The duo teamed up in 1989 to form their own shop, after many years of serving as crew people for Stan Winston, Kevin Yagher, John Buechler, Greg Cannom, and Tom Savini. Separately and together, the two had contributed FX to nearly fifty films before joining forces.

After establishing Optic Nerve, Burrell and Vulich added an Amiga with 2.0

From the start, the Optic boys have used the computer as a design tool. (pictured: a CG vampire)

Video Toaster software to their modest studio space. Instead of experimenting with blood formulas or foam consistencies, the Optic Nerve guys prefer to spend their time at the keyboard. This enables them to remain on the cutting edge and, admittedly, to give their shop a fresh wrinkle.

"In some respects, it was a gimmick in that we wanted to use computers before anyone else did," Vulich says. "But we really wanted to use it, before we thought of applying it as an idea, like a positioning tool. Company-wise, we had been playing around with it anyway, always with the notion that this may not be the finished thing that we wanted to do with computers, but it's part of the learning process. It's still applicable to what we're doing." "It's a real serious application," Burrell adds.

At first, Burrell and Vulich viewed the computer as an extension of a sketch pad, but foresaw its inherent capabilities for future FX use. When Vulich examined an IBM setup at a plastic surgeon's office that showed clients' facial enhancement possibilities, he realized that his Amiga could do the same in reverse for horror films— show directors and producers how *ugly* their villains or ghouls could be! By digitizing faces with the use of a video camera, design changes could be rendered faster and simpler than with old-fashioned drawings. The procedure saves on pre-production time, too; instead of spending hours in meetings and going off to come up with assorted sketches, the producers can sit down next to the makeup men as they whip up successive designs in an instant. "On *The Dark Half*, we went through dozens of hairstyles in fifteen minutes or so," Vulich notes, "so we saw how they looked without having to actually do makeup tests. And you get a lot more photographic results than you do with a pencil sketch, and there's less time involved.

"It's really similar to drawing with a pencil and paper; a lot of guys seem to criticize computer graphics, as if you're cheating by doing it, but you're not," Vulich continues. "For probably two or three years, I never touched pencil and paper, I did it strictly on a computer. Then for some reason I went and did a pencil sketch, and I could see that my style had progressed, that without ever touching pencil and paper I'd still learned something over the past three years from the computer that I could apply to pencil drawings. When you draw, it's form, highlight, and shadow, and that applies to oil paint, pencil sketch, charcoal, computer—you still have to put those attributes into it."

"For one thing, when you're dealing with a [digitized] photo of an actor as a starting point, right off the bat you're ten steps ahead," Burrell adds. "You'd have to trace it using tracing paper; why not use a computer? Also, anyone—the producer,

director, actor—can actually grab the mouse and can be more *involved*, can actually be part of the process."

As with most of the Young Turks in the FX industry and those profiled in the preceding chapters, the Orange County-raised Burrell and Fresno native Vulich grew up with a love for monster movies and began experimenting with Super-8 filmmaking in high school (today's kids have the option of video for shooting their own amateur projects). "It wasn't makeup, it was more just effects in general," says Burrell on what sparked his interest in the field. "I thought a special effects man did everything. I didn't realize that they had makeup guys, miniature guys, etc."

"*Planet of the Apes* is the classic film that got me interested in doing makeup effects," says Vulich. "It had these characters that you believed, a suspension of disbelief with these ape characters."

Vulich eventually began a correspondence with Tom Savini, who kept a promise and hired the twenty-three-year-old to assist him on *Friday the 13th: The Final Chapter*. Burrell, meanwhile, hooked up with John Buechler for a few cheapies on the order of *Hard Rock Zombies*. In 1984, Burrell caught up with Vulich on the Savini crew for *Day of the Dead*. "It was a big turning point," Burrell says, "meeting Tom and the gang. Tom respected us, especially John, who sculpted a lot of stuff for *Day of the Dead*."

Savini hired the two again to head his FX department for the George Romero films *Monkey Shines* and *Two Evil Eyes*, on which the artists impressed the film's director with realistic monkey props (for the former) and a gelatin corpse (for Dario Argento's *Eyes* segment). While slinging latex for the separate FX teams of Kevin Yagher and John Buechler on 1989's *Phantom of the Opera* in Budapest, Burrell and Vulich made their minds up to go into business for themselves. Thus Optic Nerve was born. Determined not to be "just another makeup shop," Burrell and Vulich have gone the extra mile on their films, spending countless hours in research and development and showing a tremendous level of dedication to their craft.

"I don't quite know that we've gotten to a point where we have a certain definitive style or anything yet," Vulich says. "We try to be a little bit more naturalistic and subtle about certain things, and we've certainly gotten a lot of work lately doing puppets of real creatures and animals. That kind of shows our research and attention to detail. That's probably the hardest thing to do: copy a living creature, especially under the kind of circumstances you're generally thrown into. Especially a TV show, where you have a *week* to do something."

"We try to do the best quality work," Burrell states simply. "We try to do Stan

Optic Nerve was one of the first FX houses to begin experimenting with computer-generated imagery.

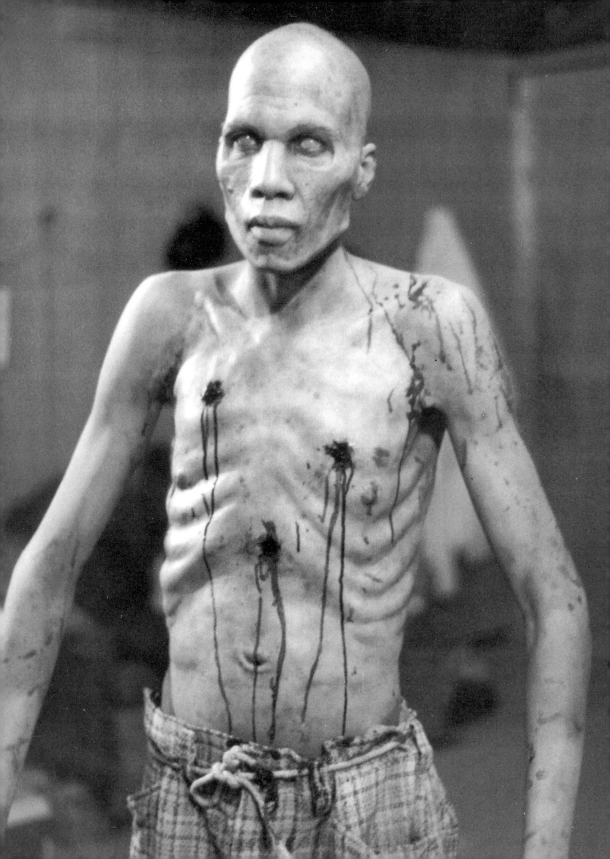

Winston quality for a lot less money. It takes just as much time to sculpt something good as it does to sculpt something bad. You take a week on a sculpture: You can make it bad in a week or you can make it really good in a week [*laughs*]! Like on *Night of the Living Dead*—we tried real hard to make those things as different as possible. We knew that if we just did 'whatever,' we wouldn't get any attention."

First-time director Savini and screenwriter/executive producer Romero had a tall order to fill topping Romero's own *Night of the Living Dead* twenty-two years later with a remake, as did the newly minted Optic Nerve Studios. Working on their first major solo project, Burrell and Vulich accepted the challenge of making zombies that were unique and scary-looking, following two decades of ripoffs, spinoffs, and spoofs of the 1968 trendsetter. The boys dove into the Pittsburgh-based project with an almost religious fervor.

"Right off the bat, we felt that we had a lot to live up to, considering how classic the first film was," Vulich says. "We really wanted to do it justice. We felt like this had been done so much before, what *could* we do to make this stuff look any better or scarier? So we adopted a 'less is more' approach. After things like *Thriller* and some of the stuff that Rick did in *American Werewolf* where corpses are totally rotten and shriveled and eaten, we just felt, 'How much further can you go with that kind of look?' Just because it's bloodier or more eaten-up *isn't* what's gonna make it scarier. We looked at the first film, and we realized that what made that one scary was that it was believable. In the original *Night*, they're like your friends next door, they weren't shriveled, ugly monsters. We tried to adopt that. If anything, we just wanted to do it as originally as we could."

"Tom hired us for *Night of the Living Dead* because we would try new things, and try to make him see some new, interesting ways of doing things," Burrell says. "He liked the fact that we would go out of our way to try and make something look good."

Burrell and Vulich tactfully began their zombie research by studying books and documentaries on the Holocaust, figuring that the gaunt concentration camp prisoners were the closest thing to the actual living dead on record. Strong stomachs prevailed when the two reviewed pathology textbooks and paid a visit to the morgue to witness an actual autopsy. "It was just what we thought a morgue would be like," Burrell deadpans.

With the *Night of the Living Dead* remake, the FX pros strove to create the most realistic and disturbing walking corpses ever.

 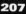

The twosome took photos of the morgue corpses, seeking to match the yellow-gray skin color of the bodies to their realistic as opposed to stylized *Dead* makeups. Observing that a dying person's face begins to shrink in and the skull and jaw protrude more noticeably, the Optic team created appliances that built out the forehead and cheekbones of their zombie players. In addition, they inserted dentures over their subjects' teeth to make the mouth stick out farther. The two carried this style over into the design of the jawbone, ears, and nose, too. Other inventive touches for a few of Optic's 17 zombie creations were hand-punched hair, translucent gelatin appliances that gave off a waxlike appearance, and dental acrylic eyes which were cast on top of the life casts and masked the actors' real eyes. The phony orbs, which neither moved in the appliance nor allowed the ghoul players to see in most shots, gave the undead a "soullessness" that the artists sought.

"We wanted *Night* to be kind of classy, a little bit more believable, not just a monster movie," Vulich explains. "We tried to approach the zombie makeups more like character makeups than just monsters." In this same regard, Savini and his FX team developed back stories for their ghouls; the corpulent Uncle Rege, for example, was denoted a recently deceased cancer sufferer, so Optic designed a horrific, cyst-encrusted, chemotherapy-marred face for the revived stiff.

Night also allowed Burrell and Vulich the opportunity to experiment with their brand-new Amiga during preproduction. Using the programs Digi-View and Deluxe Paint, Vulich began altering photos of bald-headed people that he had found in a book called *Heads*. When production got closer, he scanned in glossies of a few of the zombie extras to test out the paint schemes, hairstyles, and even ear sizes.

Did all the research and attention to detail pay off on *Night*? Not exactly, according to Burrell and Vulich, who feel that their FX were not shot or edited properly. Vulich wishes he had stuck closer to the forensic photos they had collected. He adds that the "less is more" approach may have hurt Optic in the long run, since audiences and prospective producers were not aware of the amount of work that went into the realistic makeups. Just the same, Vulich considers the film a valuable learning experience.

"You never get all of what you want," he says. "I went in for an interview with Tom Burman once and made a lot of excuses about my work, and he said, 'Stop making excuses for why your work isn't perfect. One thing that, as an artist, you've got to realize is that you're never gonna be happy with what you do, and that's part of what propels you: To always do better.' Otherwise you're pretty much stuck.

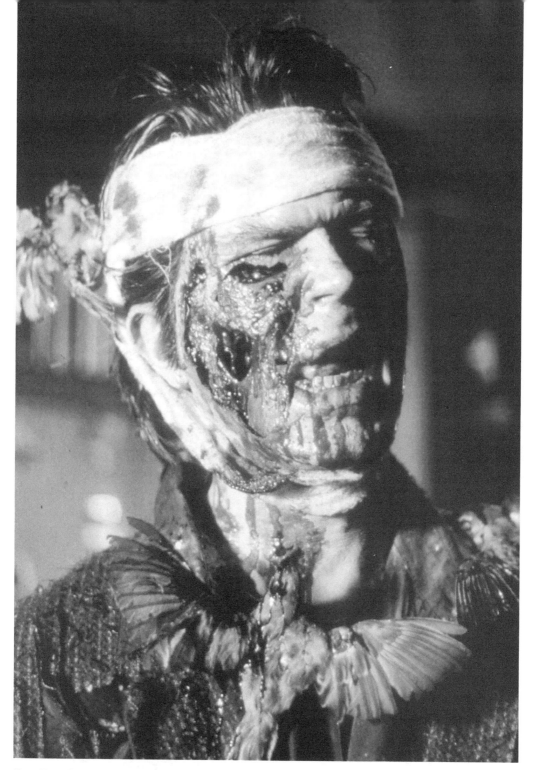

For *The Dark Half*'s death-by-sparrows, Optic Nerve built George Stark mechanical puppets to achieve the grisly scene.

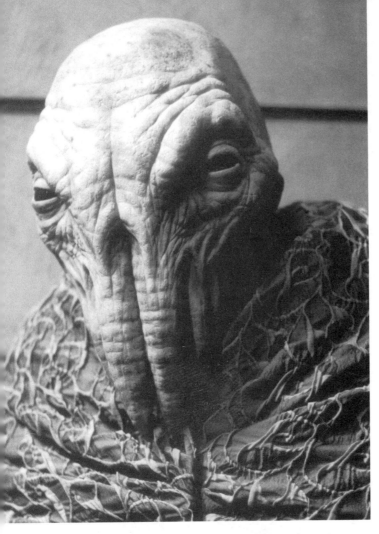

Work on TV's *Babylon 5* opened a new universe of opportunities for Vulich and Burrell.

And people who *are* happy with what they do don't really grow at all."

Burrell and Vulich returned to Pittsburgh in 1991 to begin work on George Romero's adaptation of *The Dark Half*. Based on Stephen King's best-seller, the story concerns the plight of Thad Beaumont (played by Timothy Hutton), an author plagued by his fictional alter ego, George Stark, whom he "killed off" after "Stark's" last novel. For the film, Optic needed to create an assortment of makeup FX: mechanical birds, splatter gags, and two cable-controlled head/upper torso puppets for the movie's end, where Stark is pecked to death by a flock of sparrows. Their greatest concentration, however, was devoted to the appearance of the slowly rotting Stark (also essayed by Hutton). The shop again espoused the less-is-more philosophy. "We felt the makeup should be a little more subtle and not quite as monstrous," Vulich says, "a little bit more believable, because it was a higher-class film."

The two FX honchos delved into anatomy books and photographs of various skin diseases to arrive at a makeup concept to depict Stark's "losing cohesion" infection. Abandoning the novel's "Doc Savage, blond-type" Stark, an old black-and-white photo of a weather-beaten cowboy eventually inspired the evil twin's "white-trash" guise with sideburns, ducktail, and greased-back hair. A bone of contention came up over whether or not the maniac should wear a mustache—a debate

Optic's Amiga helped solve. Hutton used the tool to test out various hairstyles and mustaches, and soon opted to play Stark without the lip rug.

While in Stark's early scenes, Hutton only wore fake eyebrows and forehead and cheek appliances, the character soon begins to decompose subtly during six stages of makeup. A series of darkened cysts and blood blisters appear on his face, which pop open to reveal yellow sores underneath. For the gross pus-oozing scenes, thin facial appliances hid tiny bladders that were attached to tubing snaked through the actor's hair. Since the rot affects Stark's whole face, Hutton sported dental acrylic black gums, plus dark-colored teeth and tongue. Stark's eyes did not escape unscathed from the progressively worsening character makeup. Fashioned by optometrist Dr. Mitchell Cassel, four sets of "piggyback" contact lenses were inserted over Hutton's eyes in asymmetrical combinations of "veiny" reds and foggy whites, mirroring the facial deterioration. At its worst, Stark's makeup took up to four hours to apply on Hutton.

Stark's rotting eyes are just another example of how Optic Nerve gives 110 percent on every project. "When you do makeup, you don't just do makeup, you cover the whole entire person," Vulich says. "That means contact lenses, teeth and hairpieces. You don't just do an appliance on somebody's face, you try to add as much as possible. It's amazing how much contact lenses add to a character. It's almost like the icing on the cake. *The Exorcist* is a clear example. Linda Blair's makeup would be nowhere near as frightening if she didn't have those real green, creepy-looking lenses. It's a cliché, but the eyes are the windows of the soul; it's certainly another part of the canvas you can paint on as a makeup artist."

Optic's mechanical sparrows in *The Dark Half* led the boys to a position on *Batman Returns* for a similarly conceived scene in which a gaggle of bats attack the Penguin (Danny DeVito). Optic Nerve enlisted technical whiz Larry Odien to help create the radio-controlled flying mammals, as he had for *Dark Half's* less complicated birds. With their computer, the shop was able to test the bats' motion patterns and various size scales.

The company's NewTek computer graphics equipment continues to transform their two Amigas into efficient work stations, with Toaster programs Texture Map (for "cutting and pasting" faces) and Toaster Paint (to darken and lighten images) getting the most play. Optic Nerve's makeup jockeys are currently knee-deep in foam and latex, populating a galaxy of aliens for *Babylon 5*. This steady gig, besides winning the shop its first Emmy, has given Burrell, Vulich, and a crew of eleven the chance to expand their imaginations and makeup portfolio even further.

"You've got to have something else," Burrell says of what appeals to prospective producers over blood-and-guts footage. "You've got to have a whole repertoire—an alien, a 'cute' thing, something kind of artsy. They really don't know what kind of work goes into a zombie makeup, where if it's an alien puppet or something, they kind of say, 'Oh, wow, that must have been expensive and animatronic.'"

Burrell's work on the digital-heavy *Babylon 5* motivated him to reevaluate his future in the business, so much so that the makeup partners "divorced" themselves in August 1995. Preferring gigabytes over gelatin appliances, Burrell left Optic Nerve to join Flat Earth, an L.A.-based computer FX outfit that has supplied a slew of CG monsters to the popular fantasy series *Hercules: The Legendary Journeys* and *Xena: Warrior Princess*.

"My waning interest in makeup and growing interest in computer graphics forced me to leave makeup," says Burrell in postscript. Contentedly, he now works out of his home, creating a new brand of FX magic with the aid of six computers. "I have more control than ever before with computers, not having to rely on cinematographers, costume people, or actors. Doing computer effects has rekindled my love of film. Gluing rubber noses on people just wasn't fun anymore."

Regarding the outlook for makeup artists in the digital age, the question arises whether computer-generated FX will replace latex monsters. Burrell has already made the transition, while Vulich bides his time.

"I don't know," Vulich answers. "One of our reasons for getting into computers was because of that. Not only that, but I like playing with computers—we're both kind of techno-nerds in that respect. Technology is not going to stand still because of our desires or whims, so whatever the market will bear, whatever's affordable, whatever gives you the most dramatic effect is what people are going to use. It might take a few jobs away, but at the same time, if the makeup artist is willing to put some effort into it and not be afraid of how to use it, he can also use it as part of the arsenal of tools that he has."

Appendix I

Glossary

Acetone: A highly volatile liquid that is one of the primary solvents of adhesives, sealers, and prosthetic plastics. Sometimes used for making baldcap material.

Airbrush: A tiny, hand-held paint-spraying instrument used to paint or "fog" makeups with graduated tonal or color schemes. See *Predator*.

Animatronic: A puppet likeness of a human, creature, or animal whose movements are directed by electronic, mechanical, or radio-controlled gadgets. Animatronic figures were first developed for Disney theme park attractions. See *Child's Play*.

Armature: The skeletal insides of a large-scale or stop-motion puppet. Made up of chrome-plated ball-and-socket joints and machined steel bones.

Cable Control: A crew-operated system utilizing levers and cables for animatronic life.

Cabosil: A lightweight, silica-based powder used as a thickener or matting agent for most urethanes, resins, and latex.

Collodion: Nonflexible or rigid collodion is a brush-on liquid that dries on the skin and is employed for the creation of scars.

Duo Adhesive: Mild, latex-based surgical glue employed as an appliance sealer or adhesive on sensitive areas of the skin and for blending foam latex appliances.

Fiber Optics: Thin transparent fibers of glass or plastic that are enclosed by material and transmit light throughout their length. Mostly used for modelmaking. See *The Abyss*.

Gelatin: A glutinous substance adopted as a base for makeup appliances. See *The Fly II*.

Glycerin: A 99 percent pure substance employed to create tears and perspiration. Sometimes mixed in blood and gelatin formulas. Applied with stipple sponge or manual spray bottle.

Hero Puppet: The principal puppet used most during shooting, capable of the most movement.

Hydrocal: A medium-strength cement primarily used for making life casts and nonessential "waste" molds. (A waste mold is one that is broken off of a model.)

Maquette: A small clay model created as a guide for a larger sculpture.

Methylcellulose: A gummy substance that swells in water and is used as an emulsifier and thickener. Good for the creation of slippery liquids, gels, and assorted thick pastes and solids. See *The Fly*.

Morphing: Popular in films, television commercials, music videos, and TV shows, this is a computer graphics technique of melding one image into another by progressively altering the size and physiognomy of the original image. See *Terminator 2: Judgment Day, Sleepwalkers*.

Mortician's Wax (aka Plasto Wax): A soft, pliable wax used to remodel or build up facial features such as noses and cheekbones. Outdated today.

Negative: The mold surface which contains a reverse three-dimensional imprint of the positive sculpture.

Pax Paint: A smudge-proof appliance paint (best for painting foam latex) comprised of a combination of Pros-Aide and either cosmetic-grade pigments or Liquitex (an acrylic-based paint).

Pneumatics: A branch of mechanics that uses air drivers and compressors for movement. See *Jurassic Park*.

Positive: Any sculpture or model used to create the negative mold.

Pros-Aide: A very flexible and strong acrylic-emulsion prosthetic adhesive that has numerous applications. In liquid form, Pros-Aide can be thinned with distilled water or thickened with Cabosil into a paste.

Prosthetic Makeup Appliance: A piece of latex rubber that has been sculpted and formed to fit the face of an actor to alter his features or create wounds.

Roma Plastilina: An oil-based, brand-name clay that is the most popular sculpting medium for prosthetics and small- to medium-size sculptures.

Scleral Lenses: Thin contact lenses that cover the entire eye, as opposed to regular contacts, which only fit over the cornea. See *Innocent Blood*.

Servo Mechanism: A small motor controlled by remote units to create life-like movements, especially facial expressions for animatronic puppets.

Spirit Gum: A rosin-based adhesive useful for gluing lace hair pieces, laying beards, and disguising edges of foam latex appliances. Supplanted by 355 Adhesive.

355 Prosthetic Adhesive: Developed by the medical profession, this is the most popular prosthetic adhesive—clear, flexible, and very strong.

Ultracal 30: A gypsum cement product adapted from the tool and die industry. Popularly drafted as molding material to create very hard, long-lasting mask molds.

Wed Clay: A water-based modeling clay known for its smooth, fine texture and soft pliability. Perfect for large sculptures requiring fine detail.

Appendix II

Makeup Schools and Instructors Directory

California
JOE BLASCO MAKEUP ARTIST TRAINING CENTER
1708 Hillhurst Avenue, Hollywood, CA 90027 (800) 634–0008

CALIFORNIA STATE UNIVERSITY, LONG BEACH SCHOOL OF THE ARTS
THEATER ARTS DEPARTMENT
1250 Bellflower Boulevard, Long Beach, CA 90840 (310) 985–5356

CINEMA MAKEUP SCHOOL
3345 Wilshire Boulevard, Suite 1111, Los Angeles, CA 90010 (213) 368–1234

CINEMA SECRETS/MAURICE STEIN
4400 Riverside Drive, Burbank, CA 91505 (818) 846–0579 (Extension 116)

ELEGANCE INTERNATIONAL ACADEMY OF PROFESSIONAL MAKEUP
4929 Wilshire Boulevard, Suite 520, Los Angeles, CA 90010 (213) 937–4838

RESEARCH COUNCIL OF MAKEUP ARTISTS/VINCENT J-R KEHOE
PO Box 850, Somis, CA 93066 (805) 386-4744

WESTMORE ACADEMY
15445 Ventura Boulevard, Suite 27, Sherman Oaks, CA 91403 (800) WESTMORE

Florida
JOE BLASCO MAKEUP ARTIST TRAINING CENTER EAST
7340 Greenbriar Parkway, Orlando, FL 32819 (800) 252–7261

DICK SMITH'S ADVANCED PROFESSIONAL MAKEUP COURSE
5313 Siesta Court-F, Sarasota, FL 34242 (professionals only)

New York

SPECIAL EFFECTS WORKSHOP

410 West 47th Street, New York, NY 10036 (212) 245–3624

Ohio

THE MONSTER MAKERS

7305 Detroit Avenue, Cleveland, OH 44102 (216) 651–SPFX

Pennsylvania

THE ART INSTITUTE OF PHILADELPHIA

THE ART INSTITUTE OF PITTSBURGH

The Art Institutes International, 300 Sixth Avenue, Department 6, Pittsburgh, PA 15222 (800) 525–1000

(Art Institutes International also offers classes in Dallas, Denver, Ft. Lauderdale, Houston, Seattle; call general 800 number above)

Tennessee

JOE BLASCO MAKEUP ARTIST TRAINING CENTER

2817 West End Avenue, Suite 116A, Nashville, TN 37203 (800) 553–4430

Canada

COMPLECTIONS INTERNATIONAL LTD

482 Wellington Street West, Toronto, Ontario M5V 1E3 Canada (416) 340–2661

Sweden

THE EUROPEAN INSTITUTE OF MAKEUP

(languages: Swedish, Finnish, and English)

Rådmansgatan 74, 113 60 Stockholm, Sweden (phone: 46 8 30 66 91)

or Kaserntorget 6, 2tr, 411 18 Göteborg, Sweden (phone: 46 31 11 17 14)

United Kingdom

CHRISTOPHER TUCKER PROSTHETIC WORKSHOP

Christopher Tucker, Bere Court, Pangbourne, Berkshire RG8 8HT, United Kingdom (phone: [44] 734 84 23 93)

Appendix III

Best Makeup Academy Awards

1964
The 7 Faces of Dr. Lao, William Tuttle (honorary Oscar)

1968
Planet of the Apes, John Chambers (honorary Oscar)

1981
An American Werewolf in London, Rick Baker
 Heartbeeps, Stan Winston

1982
 Gandhi, Tom Smith
Quest for Fire, Sarah Monzani and Michele Burke

1983
No award given

1984
Amadeus, Dick Smith and Paul LeBlanc
 Greystoke: The Legend of Tarzan, Lord of the Apes, Rick Baker and Paul Engelen
 2010, Michael Westmore

1985
 The Color Purple, Ken Chase
Mask, Michael Westmore and Zoltan Elek
 Remo Williams: The Adventure Begins, Carl Fullerton

*winner

1986

The Clan of the Cave Bear, Michael Westmore and Michele Burke
**The Fly*, Chris Walas and Stephan Dupuis
Legend, Rob Bottin and Peter Robb-King

1987

Happy New Year, Bob Laden
**Harry and the Hendersons*, Rick Baker

1988

**Beetlejuice*, Ve Neill, Steve LaPorte, and Robert Short
Coming to America, Rick Baker
Scrooged, Tom Burman and Bari Dreiband-Burman

1989

The Adventures of Baron Munchausen, Maggie Weston and Fabrizio Sforza
Dad, Dick Smith, Ken Diaz, and Greg Nelson
**Driving Miss Daisy*, Manlio Rocchetti, Lynn Barber, and Kevin Haney

1990

Cyrano de Bergerac, Michele Burke and Jean-Pierre Eychenne
**Dick Tracy*, John Caglione Jr. and Doug Drexler
Edward Scissorhands, Ve Neill and Stan Winston

1991

Hook, Christina Smith, Monty Westmore, and Greg Cannom
Star Trek VI: The Undiscovered Country, Michael Mills, Edward French, and Richard Snell
**Terminator 2: Judgment Day*, Stan Winston and Jeff Dawn

1992

Batman Returns, Ve Neill, Ronnie Spector, and Stan Winston
**Bram Stoker's Dracula*, Greg Cannom and Michele Burke
Hoffa, Ve Neill, Greg Cannom, and John Blake

1993

Mrs. Doubtfire, Greg Cannom, Ve Neill, and Yolanda Toussieng
 Philadelphia, Carl Fullerton and Alan D'Angerio
 Schindler's List, Christina Smith, Matthew Mungle, and Judith A. Cory

1994

Ed Wood, Rick Baker, Ve Neill, and Yolanda Toussieng
 Forrest Gump, Daniel C. Striepeke, Hallie D'Amore, and Judith A. Cory
 Mary Shelley's Frankenstein, Daniel Parker, Paul Engelen, and Carol Hemming

1995

Braveheart, Peter Frampton, Paul Pattison, and Lois Burwell
 My Family/Mi Familia, Ken Diaz, and Mark Sanchez
 Roommates, Greg Cannom, Bob Laden, and Colleen Callaghan

Bibliography

Books

Arnick, Donna J. *Creative Theatrical Makeup*. Englewood Cliffs, New Jersey: Prentice-Hall, 1984.

Baygan, Lee. *Makeup for Theater, Film & TV*. New York: Drama Book Publications/Publishers, 1982.

____ *Techniques of Three-Dimensional Makeup*. New York: Watson-Guptill, 1982.

Blake, Michael F. *Lon Chaney: The Man Behind the Thousand Faces*. Vestal, New York: Vestal Press, Ltd., 1993.

Brandler, Nadia. *Makeup Artistry*. Toronto: Complections International, 1989.

Buchman, Herman. *Film & Television Makeup*. New York: Watson-Guptill, 1982.

Corson, Richard. *Stage Make-up*. Englewood Cliffs, New Jersey: Prentice-Hall, 1973.

Gagne, Paul R. *The Zombies That Ate Pittsburgh: The Films of George A. Romero*. New York: Dodd, Mead, 1987.

Kehoe, Vincent J-R. *The Technique of the Professional Make-up Artist for Film, Television and Stage*. Boston: Focal Press, 1985.

Russo, John. *Making Movies*. New York: Dell, 1989.

____ *Scare Tactics*. New York: Dell, 1992.

Salisbury, Mark and Hedgcock, Alan. *Behind the Mask: The Secrets of Hollywood's Monster Makers*. London: Titan Books, 1994.

Savini, Tom. *Grande Illusions: Special Make-up Effects*. Pittsburgh: Imagine, Inc., 1983.

Sheppard, John. *Anatomy: A Complete Guide for Artists*. New York: Watson-Guptill, 1975.

Smith, Dick. *Dick Smith's Do-It-Yourself Monster Make-up Handbook*. Pittsburgh: Imagine, Inc., 1985.

Taylor, Al, and Roy, Sue. *Making a Monster*. New York: Crown Publishers, 1980.

Westmore, Frank, and Davidson, Muriel. *The Westmores of Hollywood*. New York: J. B. Lippincott, 1976.

Westmore, Michael G. *The Art of Theatrical Makeup for Stage & Screen*. New York: McGraw-Hill, 1973.

_____ and Nazarro, Joe. *Star Trek: The Next Generation Makeup FX Journal*. New York: Starlog, 1992.

Young, Douglas. *Create Your Own Stage Faces*. Englewood Cliffs, New Jersey: Prentice-Hall, 1985.

Magazines

Cinefantastique (7240 West Roosevelt Road, Forest Park, IL 60130)

Cinefex (PO Box 20027, Riverside, CA 92516)

Fangoria (475 Park Avenue South, New York, NY 10016)

Starlog (475 Park Avenue South, New York, NY 10016)

Index